LOOKING
AT TOTEM
POLES

LOOKING AT TOTEM POLES

Written & Illustrated by

HILARY STEWART

With a Foreword by

NORMAN TAIT

Douglas & McIntyre
Vancouver/Toronto

University of Washington Press
Seattle

Published in Canada by
Douglas & McIntyre
1615 Venables Street, Vancouver, British Columbia V5L 2H1

CANADIAN CATALOGUING IN PUBLICATION DATA
Stewart, Hilary, 1924-
 Looking at totem poles
 Includes index.
 ISBN 1-55054-074-2
 1. Totem poles—Northwest Coast of North America. 2. Indians of
North America—Northwest Coast of North America—Sculpture.
I. Title
E98.T65S73 1993 731'.7 C93-091074-5

Published in the United States of America by
University of Washington Press
P.O. 50096, Seattle, Washington 98145-5096

LIBRARY OF CONGRESS CATALOGING-IN-PUBLICATION DATA
Stewart, Hilary
 Looking at totem poles / Hilary Stewart; with a foreword by
Norman Tait.
 p. cm.
 Includes index.
 ISBN 0-295-97259-9 (pbk.: acid-free paper)
 1. Totem poles. 2. Indians of North America—Northwest
Coast of North America. I. Title.
E98.T65S74 1993
730'.89970711—dc20 93-14724
 CIP

Editing by Saeko Usukawa
Design by Barbara Hodgson
Front cover photograph: Haida Mortuary House frontal pole by Bill
Reid (Haida) assisted by Douglas Cranmer (Kwakwaka'wakw), 1960-61.
Courtesy of University of British Columbia Museum of Anthropology.
Photograph by J. Gijssen
Printed and bound in Canada by D. W. Friesen & Sons Ltd.
Printed on acid-free paper ∞

Published with assistance from the British Columbia Heritage Trust.

CONTENTS

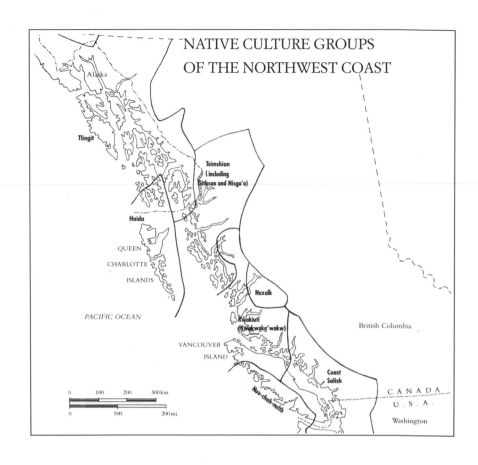

NATIVE CULTURE GROUPS
OF THE NORTHWEST COAST

Alaska

Tlingit

Tsimshian
(including
Gitksan and Nisga'a)

Haida

QUEEN

CHARLOTTE

ISLANDS

Nuxalk

PACIFIC OCEAN

Kwakiutl
(Kwakwaka'wakw)

British Columbia

VANCOUVER

ISLAND

Coast
Salish

C A N A D A

Nuu-chah-nulth

U . S . A .

Washington

0 100 200 300 km

0 100 200 mi.

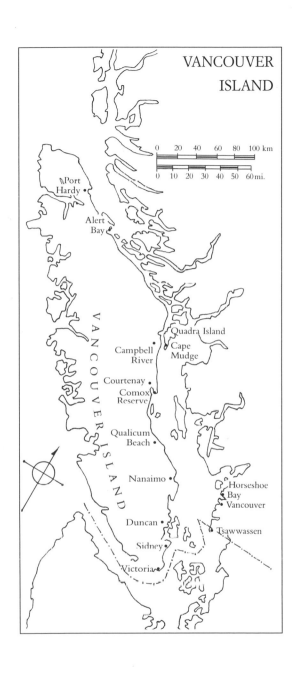

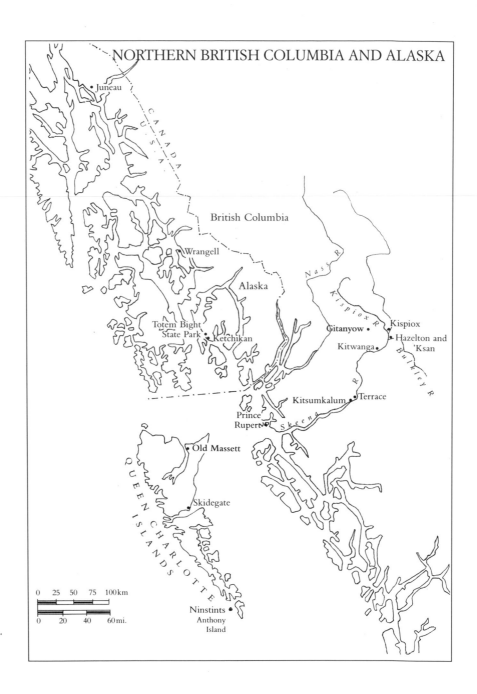

NORTHERN BRITISH COLUMBIA AND ALASKA

Juneau

CANADA
U.S.A.

British Columbia

Wrangell

Alaska

N a s s R

Kispiox R

Totem Bight
State Park
Ketchikan

Gitanyow

Kispiox

Kitwanga

Hazelton and
'Ksan

Bulkley R

Kitsumkalum

Terrace

Prince
Rupert

Skeena R

Old Massett

QUEEN CHARLOTTE ISLANDS

Skidegate

0 25 50 75 100 km

0 20 40 60 mi.

Ninstints
Anthony
Island

FOREWORD

Totem poles are all about cultural identity. They are a way of native people saying, "We're here. We're still here and our culture is still here." I'm glad when I carve a pole because I want people to know that we still carve totem poles and that stories go with the poles.

You treat a totem pole with respect, just like a person, because in our culture that's what it is. A pole is just another person that is born into the family, except he is the storyteller. So it should be treated with respect and honour.

The figures on a pole are an outline of the story that goes with the pole. If it's a serious traditional story that is family history and belongs to your uncle or grandfather, for instance, you have to check with them to get their permission. That tradition is still there, although it's not always followed as fully as it used to be hundreds of years ago. Nowadays many carvers use a general story, a public story, because the poles they're doing are carved for everybody.

When I'm carving a pole, people often come up to me and ask questions. Some are simple questions like what kind of wood we use, but sometimes the questions are more elaborate. "What are you carving?" "What does it mean?" "Where are you from?" A lot of people want to find out who carved the poles. They approach me and ask if I'll tell them the story of those poles. Just one person coming up and asking is an education to the public regarding totem poles.

When people ask, "Where are you from?" I tell them what part of British Columbia I'm from. I explain that the whole coast is made up of native groups who are all different. They don't speak the same language. They don't carve the same way. Then I describe the style I carve in. Totem poles are our identity, and each group wants to be recognized. They don't want to be generalized.

In the old days, when you travelled through each territory, sometimes you'd suddenly run into a carved figure or rock. And bingo, you'd know you were in somebody's territory. When I go up from Vancouver to Prince Rupert or to Kincolith where I come from, I can still feel myself going through all those different native territories. I'm always aware of the totem poles when I get off the ferry at Nanaimo or pass by the U.S./Canada border cross-

ing. There they are again, just like in the earlier days, identifying themselves and identifying the people whose territory you're coming to.

What annoys me is that a lot of totem poles that go up have no plaque or information. People who come by wonder, "Who did this? What's it all about?" Every time I carve a totem pole, there's always a kind of signature to identify my family or my nation, the Nisga'a. But people who don't know the various native nations or their carving styles can look at a book like this. *Looking at Totem Poles* gives an outline of what each pole is all about, where it's from, who carved it, what for, and when. Hilary Stewart's book has in it just about every important outdoor pole. There's quite a bit of information in this book, quite a few poles to study. She pays attention to detail and that's very important to native people. A few groups, for their own reasons, don't want their poles documented, and Hilary respects that.

I like it that this book tells more than the facts. Hilary's talked to a lot of the carvers or their families to get some behind-the-scenes stories. It's like the pole we just put up in London, England. The top figure is an Eagle, but we weren't going to attach it until just before raising the pole because it was very fragile. Since I'm Eagle clan, traditionally the Eagle leads the pole. We gave the honour of carrying the Eagle to two people in the crowd, since the carver's family is not allowed to touch the pole once it is carved. Then we invited everyone to pick up the pole and walk with it, and the family followed. We got to the site, went through the ceremonies and on to raise it. It was halfway up when my brother said, "Norman, we forgot to put the Eagle on."

I just casually turned around to the crowd, hoping nobody had heard, and announced, "The Eagle goes on last. Meanwhile, it goes right here," pointing to a spot near the base of the pole. And then I turned around, muttering, "Now, where the heck is that Eagle?"

Well, what happened was that when the two men carrying the Eagle walked ahead of the pole, they went into some bush and just kept on walking. They didn't realize the pole had stopped. Then photographers spotted them and started taking pictures. They were so proud and were standing there posing for pictures while the pole was going up! We got a ladder afterwards and put the Eagle on the pole, so it wasn't a major mistake because it was corrected. But that's what really happened.

Every pole has its stories of things that happened when it was being carved. Some of them weren't meant to be funny. But in the end, when the pole is up and it's all over, those are the things that the artists will talk about and laugh about. We encourage that part of it, just so we don't get to feel so important we're not part of the people any more.

And that happened in the old days also. When a big chief got up and he

was getting so important, the ladies were all ready for him. They'd come out dancing a ridicule song and making fun of him. They'd really put him down, and yet everybody would have fun about it. Today that kind of humour still has its purpose—to remind you that you're not so important that you don't make mistakes, that you're not above the ordinary person. You may have raised the totem pole, but look at what you did while you were doing it.

Totem poles are recognized all over the world. When I'm in Europe, I see pictures of totem poles in travel agents' windows. They advertise travel to Canada: "Stop off in B.C. and take a look at the totem poles." And in my travels I've run across a lot of people who say, "Oh, I've been to British Columbia and I saw the totem poles." They're so happy to reel off what they've learned. A lot of it is generalizations, of course, because they don't have that much time to study. Some people are just happy they passed through and know a little something about it. But others will say, "I didn't realize there was so much in that culture. And I've since bought this book, that book, and read about it." They've gotten into it with both feet.

I'm always glad when people want to see totem poles and are eager to find out more about them. A lot of the early books were badly misinformed because the native people weren't really involved. But now we are. So we're getting books that are more and more accurate—and educational. That's what I like about new books like this one coming out.

Norman Tait
Nisga'a carver

PREFACE

The totem pole has become the very symbol of Northwest Coast native people and their art. Although the name "totem" for these carved monuments of cedar is actually a misnomer—a totem is a creature or object that a person holds in great respect and religious awe—many years of common usage and the want of a better word have made it acceptable.

Visitors to the Northwest Coast from all parts of the world often stand in wonder before these carved poles, which are some of the largest wood sculptures ever created, astounded by their height and girth. They are perplexed and intrigued by the bold, complex designs and the extraordinary creatures that emerge from the logs with such vitality, and they ask, "What are they, and what do they mean?" Most poles are accompanied by the barest information or none at all. Questions about what kind of wood, who the carver was, how long it took to carve, how old it is, how it was raised and what the figures represent are mainly left unanswered.

This book attempts to satisfy that curiosity while adding cultural and historic background as well as human interest. The totem poles illustrated are grouped geographically, from southern British Columbia north to Alaska.

All the poles in this book are situated outdoors, are readily accessible (with one exception), and for the most part are in places frequented by visitors.

A great many of the totem poles on view today are not in a traditional context. Many have been placed along highways, at ferry terminals; in parks, gardens and shopping plazas; outside hotels, public buildings, tourist bureaus, schools and, of course, in museums.

Three years of travel and research revealed a large number of outdoor poles along the Northwest Coast—far too many to include all of them in this book. Due to space limitations, many that I would have liked to include have been left out.

In the drawings, poles whose paint is badly weathered are depicted as though newly painted. A pole's height is shown with a scale or diagrammatic figure representing 1.8 m (6 feet), which does not include the base, unless it is illustrated.

Courtesy requires that no one should lean against, sit on or climb totem poles—much less carve initials, pry off a souvenir, or in any way deface a pole or its setting. While native villages are in fact restricted property, gener-

ally the residents do not mind visitors who are respectful and considerate of their surroundings. Photographing the totem poles is usually permitted, but some villages have restrictions on commercial use of the photos. Check with the band office if photos are not for personal use.

Throughout this book, I refer to the people long known as the Kwakiutl by that name, as it is the word most familiar to the general public, for whom this book is intended. However, as many Kwakiutl now prefer to be called Kwakwaka'wakw, which means "those who speak Kwakwala," I use that name as well.

Totem poles, whether old or new, in their original setting or not, make a statement that goes beyond the carver's art and the history they embody. The message is timeless, for such is the commitment to continuing growth and strength by the First Nations of this land—the people of the totems.

As always with my books, research was a lengthy and time-consuming process that relied on the kindness and generosity of a broad spectrum of people. I am particularly indebted to the carvers who discussed their work with me, as well as to the individuals and officials who gave me permission to include their totem poles in this book. And to the many people who gave of their assistance, knowledge and expertise, I would like to offer my appreciation and gratitude:

Roxana Adams, Director, Totem Heritage Park; Dempsey Bob, Tsimshian carver; Cliff Bolton, Band Manager, Kitsumkalum; Lee Boyko, Museum of Northern British Columbia; Steve Brown, carver; Simon Charlie, Coast Salish carver; Terri Clark, Vancouver Parks Board; Mary Clifton, elder, Comox Band; Dora Sewid Cook, Cape Mudge Band; Bill Cranmer, Band Manager, Alert Bay; Joe David, Nuu-chah-nulth carver; Claude Davidson, Reg Davidson and Robert Davidson, Haida carvers; Sarah Davidson, Masset; Freda Diesing, Haida carver; Paul Donville, City Administrator, Duncan; Bill Ellis; Mary Everson, Comox Band; Scott Foster; Margaret Frank, elder, Comox Band; Deborah Griffiths, Director, Courtenay Museum and Archives; Walter Harris, Gitksan carver; Jim Hart, Haida carver; Bill Henderson, Kwakiutl (Kwakwaka'wakw) carver; Bill Holm, curator emeritus of Northwest Coast Indian art, Thomas Burke Memorial Museum; Dorothy Horner, Gitksan carver; Calvin Hunt, Richard Hunt and Tony Hunt, Kwakiutl (Kwakwaka'wakw) carvers; Joy Inglis, anthropologist; Jamie Jeffries, Coast Salish carver; Doreen Jensen, Gitksan carver; Vickie Jensen; Norman John, Nuu-chah-nulth carver; Aldona Jonaitis, American Museum of Natural His-

tory; Michael Kew, anthropologist, University of British Columbia; Pamela Knapp, Manager, Alaska State Museum; Suellen Liljeblad, Curator, Ketchikan Museum; Jim McDonald, Assistant Curator, Ethnology, Royal Ontario Museum; Bud Mintz, Potlatch Arts Ltd., Lyn Miranda, Curator, Vancouver Museum; Earl Muldoe, Gitksan carver; Pete Muldoe, elder, Kispiox; Phil Nuytten; Sandra Parrish, Campbell River Museum; Duane Pasco, carver; Thomas Paul, Chief, Sechelt Band; Tim Paul, Nuu-chah-nulth carver; Rose Point, Musqueam Band; Jay Powell, Professor of Linguistics, University of British Columbia; Bill Reid, Haida carver; Chris Robertson, Band Manager, Musqueam Band; Laura Robertson, Historical Photographs Division, Vancouver Public Library; Irene Ross, Campbell River Museum; Polly Sargent; Dan Savard, Anthropological Collections, Royal British Columbia Museum; Jessica Stephens, Nuu-chah-nulth teacher; Jay Stewart, Director, Campbell River Museum; Peter Stewart; Norman Tait, Nisga'a carver; Art Thompson, Nuu-chah-nulth carver; Margaret Vickers, Band Manager, Kispiox; Rodney Ward, Vancouver Museum; Gloria Cranmer Webster, Director, U'Mista Cultural Centre; Charlie Wesley, elder, Skidegate; Ellen White, Coast Salish elder; Alice Wilson, elder, Kispiox; Jane Wilson, Canadian Broadcasting Corporation; Stanley Wilson, elder, Kispiox; Don Yeomans, Haida carver; Joan Zamluck; and many others.

THE BACKGROUND

THE NORTHWEST COAST
THE LAND AND THE PEOPLE

A vast area of extraordinary beauty, the Pacific Northwest Coast of North America extends some 2000 km (1,300 miles). Its coastline, rugged and spectacular, is deeply indented and broken by countless inlets, channels, bays and rivers, as well as scattered with hundreds of large and small islands. The temperate climate clothes the steep mountains and valley bottoms in a rich profusion of plant life, creating a lush, evergreen rain forest that sweeps to the edge of the sea. Along the foreshore and the banks of the rivers that flow to it, the sea-oriented aboriginal people have made their homes for thousands of years.

Hunters and gatherers, they harvested their food from land, sea and intertidal zone, taking a variety of fish, sea mammals, molluscs, land mammals, wild fowl and vegetation. The wood of coniferous and deciduous trees; grasses, rushes, bark and roots; animal furs, hides, bones and antlers, as well as shells and stones, provided the raw materials for all their daily and ceremonial needs. Sea-going and river canoes assured access to most of the resources, while a network of trade increased the availability of other foods and materials.

The native people were, in fact, several distinct nations, belonging to seven different language families and speaking many dialects; their customs, practices and art styles varied from north to south, but they also held much in common. They were a civilization with an elaborate social and ceremonial structure, and with traditions that went back to the beginning of time. They usually located their villages in sheltered bays and inlets, and lived in large, sturdy post and beam houses that provided warmth and comfort. Each household generally consisted of several families, all related, and each family had an assigned place in the house. Boxes of stored foods, wealth goods and ceremonial regalia, as well as tools and implements, were stacked against the walls.

Wealth and prestige, achievement and high rank, were linked to family lineage, history and the possession of rights. Marriage between various groups strengthened the bonds of alliance, adding security from the threat of belligerence. The head of a household was a chief, and his close relatives were the nobles. More distant relatives and any others in the group were the commoners, with slaves and their offspring ranking last. The most powerful, highest-ranking chief of all the households was chief of the village.

16

The people's understanding of the interconnectedness of all living things and their dependence on certain animal and plant species fostered belief in the supernatural and spirit world. Life forms, especially those taken for food and other uses, each had their own spirit. To show these spirits respect ensured their continued return or regrowth in the years ahead.

Certain birds and animals were associated with particular behaviours, powers or skills, and people sought their help to achieve success in endeavours such as fishing, whaling or hunting. But evil spirits and mythic creatures with powers to harm and bring death also roamed abroad. Spirit experiences and encounters held great significance, and tales of these were recalled and passed on to each generation.

In the dark of long winter nights, when fires burned in the centres of the big plank houses and smoke rose up through openings in the roofs, then the spirits drew close the village. It was a time of ceremonies, speeches, singing, dancing and feasting; of reaffirming family identities, rights and properties. The people's spirituality ran deep, and their sense of identity was strong. Through costumed spiritual transformations and re-enactments, they brought past

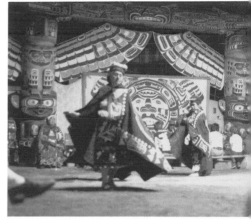

Dancers in button blankets circle before a painted screen flanked by two carved and painted house posts, Alert Bay dance house, 1981. HILARY STEWART

histories and adventures into the present. Thus, the carved beings of crest and legend portrayed on the totem poles, often recreated in masks worn by dancers, sprang to life.

When the dances and ceremonies ended, the sculptured poles in front of the houses continued to confirm the identity and rank of those who dwelt there.

The raising of a totem pole—and other important events such as birth, marriage, death, the completion of a new house, the acquisition of a new crest, the transfer of property, or the succession of a new chief—were marked by the giving of a ceremony called a potlatch. The word "potlatch," now used by all the native groups along the entire Northwest Coast, originated with the Nuu-chah-nulth word *pa-chitle*, meaning "to give." But giving was only one aspect of this most important and complex social occasion around which the culture revolved.

While the potlatch commemorated an event, it was also a time to mourn

deaths since the previous potlatch, repay outstanding debts, bestow heredi-
tary names, and in some groups to initiate novices into "secret societies." For
a people who had no written documentation, the potlatch was a way of pub-
licly acknowledging and validating events before witnesses. Invited well
ahead of time, people came from many villages, often travelling long dis-
tances by canoe.

A potlatch was expensive in terms of labour, foodstuffs and material goods
given out, and it often took years of preparation by the host family, with sup-
port from relatives, to accumulate the necessary supplies. Thus only a
wealthy family could give a potlatch.

A high-ranking person could maintain or increase his power and status
through the lavishness of his potlatch, especially if it surpassed that of a rival
chief. He displayed his wealth, which took the form of crests, names, stories,
songs, dances, masks, heirlooms and other properties, as well as certain rights
and privileges. The ownership of natural resources also indicated wealth:
salmon streams, hunting lands, berry-gathering places, stands of cedar, clam-
digging beaches and so on, and ownership of these would be confirmed in
lengthy speeches.

Feasting on a grand scale formed an important part of the potlatch, with
hundreds of guests being fed and housed for days, sometimes weeks. The
giving of gifts to most of those present not only represented payment for wit-
nessing but also served to reaffirm each guest's rank and status, since the
value of a gift had to be in proportion to the recipient's social standing. At
the conclusion of the potlatch, the obligatory food surplus was distributed to
guests to take home.

A lavish potlatch would be talked about for a long time, enhancing the
status of the host and his family—and it is much the same today.

Some poles raised long ago are still in place. Others, more recently raised,
stand in a drastically changed world. But all of them proudly and publicly
proclaim family history, achievements and rights.

TOTEM POLES
A HISTORICAL OVERVIEW

The first white men to set foot on the shores of the Pacific Northwest Coast, in what is now called British Columbia, were invited into the large plank house of a high-ranking Mowachaht at the village of Yuquot (Friendly Cove) on Nootka Sound. The year was 1778, and explorer Capt. James Cook went ashore with his ship's officers and the expedition's official artist, John Webber. Webber, intrigued by the extraordinary carved wood columns inside the house, set to work drawing them. His illustration, published as an engraving in Cook's three-volume *A Voyage to the Pacific Ocean,* was the first glimpse that Europeans had of the carved cedar poles of the Pacific Northwest Coast native peoples.

Describing these huge carved posts, Cook wrote in his journal that "many of them are decorated with images. These are nothing more than trunks of very large trees . . . set up singly, or by pairs, at the upper end of the apartment, with the front carved into a human face; the arms and hands cut out upon the sides, and variously painted; so that the whole was a truly monstrous figure."

Another sighting appears in the journal of Capt. George Dixon's explorations of the Queen Charlotte Islands in 1787. He described native art as "figures which might be taken for a species of hieroglyphics: fishes and other animals, heads of men and various whimsical designs, are mingled and confounded in order to compose a subject . . . yet they are not deficient in a sort of elegance and perfection."

In 1791, José Cardero, a Spanish artist with Alejandro Malaspina's scientific expedition, made drawings of carved posts at Yakutat, the northernmost Tlingit territory.

That same year, seaman John Bartlett, on board the sailing ship *Gustavus* trading in the Queen Charlotte Islands, wrote in his journal: "We went ashore where one of their winter houses stood. The entrance was cut out of a large tree and carved all the way up and down. The door was made like a man's head and the passage into the house was between his teeth." So impressed was he by the carved tree in the Langara Island village that he later made a sketch of it—no doubt from memory—to support his description. This crudely done sketch is the first known drawing of a Haida totem pole.

Although explorers and early traders kept journals, often with detailed descriptions of their observations of the land and the native people, few mentioned carved monuments of wood, which suggests that such artworks were not abundant at the time. Nor has the antiquity for carved poles, either inside or outside the house, been established; but certainly they held significance for the house and its occupants.

The first known illustration of a Haida totem pole, drawn by John Bartlett after a visit to the Queen Charlotte Islands in 1791.

AUTHOR'S COLLECTION

These carved monuments were the prerogative of distinguished nobility. The trade in sea otter furs brought increased wealth, in the form of European goods, to the native villages; and with that wealth came the means and the opportunity for nobles to achieve greater status. As newly rich chiefs competed with one another for prestige and status, skilled carvers were in demand to create taller and more complex poles. Totem poles and the concept of this type of wealth display spread inland up the Skeena River and south down the coast, but Haida villages, more than anywhere else, bristled with an astounding array of these monumental artworks. Many houses had several poles, while some major villages boasted over seventy.

This surge of wealth and the accompanying burst of creativity peaked in the mid-1860s. By then, the trade in sea otter furs had long ended, but epidemics of the new devastating European diseases (particularly smallpox), drastically reduced the native population along the entire coast and inland areas. Many villages, their populations decimated, were abandoned. Missionaries moved in, and their Christian indoctrinations increasingly persuaded the people to relinquish their old beliefs and traditions. As a result, totem poles were felled or sold; some were destroyed or even cut up for firewood.

In 1884 the Canadian government banned the potlatch. While some villages defied attempts to suppress their ancient traditions, others did not, losing the very heart of the culture and with it the need for feast bowls and ladles, masks, headdresses, all manner of dance and ceremonial regalia and props, and the display of wealth goods. Children, wrenched from their families, were sent off to residential schools and forbidden to speak their own language. Carvers died without passing on their knowledge to the next generation, and the art reached a low ebb. A few people made miniature totem poles to sell to visitors or to stores. Some of the early pieces were of high

quality, but later carvings lacked the dynamic principles of the traditional art style. There were some exceptions. Because potlatching had gone "underground" in many Kwakiutl (Kwakwaka'wakw) villages, the arts and traditions there fared better than elsewhere—a circumstance that became of vital importance in later years.

The great museums of Europe and America sent collectors to the Northwest Coast to reap all the ethnographic artifacts they could persuade the native people to part with, and dealers competed with each other in the scramble to acquire the best pieces at the cheapest prices. Between the 1870s and the 1920s, hundreds of poles were purchased or simply removed from seasonally vacant or abandoned villages without permission or payment. Totem poles were shipped to Washington, D.C., Chicago, New York, London, Berlin, Paris and even to New Zealand. Museums in eastern Canada, in Ottawa, Montreal and Toronto, also acquired a share of the treasure.

In 1925 the Canadian government and the Canadian National Railway began a restoration project for totem poles in several Upper Skeena River villages. For the benefit of railway passengers, many leaning and fallen poles were painted in bright colours and set up straight to face the tracks instead of the river, as before. A United States government project in Alaska from 1938 to 1940 moved many poles from the old abandoned villages; repaired and repainted, the poles were clustered in groups for tourists to view and photograph.

By the late 1920s, anthropologist Marius Barbeau wrote of the poles he had been documenting in the Upper Skeena River: "This art now belongs to the past . . . totem poles are no longer being made."

In British Columbia, the final harvest of standing—and fallen—poles took place in the 1950s, when several fine poles were purchased from their native owners at Tanu, Cumshewa, Skedans, Ninstints and Gitanyow. Although these went to museums in Vancouver and Victoria, they at least remained on the Northwest Coast. In Alaska, a good number of old poles from the abandoned village sites of Tongass, Village Island (Cat Island) and Old Kasaan were collected in 1970 and are now in Ketchikan's Totem Heritage Centre.

Defying an unjust law, some Kwakiutl (Kwakwaka'wakw) had continued to potlatch in secret, in remote villages away from government authorities. A few carvers had continued to create masks, feast dishes and other items required for potlatches. One such carver was Charlie James, born in 1867, who taught his skills to his stepson, Mungo Martin. Mungo Martin, Willie Seaweed and many others were actively carving, dancing and singing from the late 1940s into the 1960s, maintaining the old traditions and customs. Charlie James also taught his young granddaughter Ellen how to carve in cedar, and

by the age of twelve she was making little totem poles to sell to tourists. Married and living in Vancouver in the late 1940s, Ellen Neel developed a thriving business carving miniature totem poles for the tourist trade. When she and her family carved several full-size poles on commission, they made newspaper headlines. But in general, the arts and skills of other Northwest Coast cultures were in decline.

An old pole at Skedans in the Queen Charlotte Islands in 1983, tilting back with age though it could remain standing for many more years. HILARY STEWART

In 1950, a major and far-reaching renewal of the art began with a totem pole restoration project at the University of British Columbia's Museum of Anthropology in Vancouver. It employed Mungo Martin to replicate old and decaying Kwakiutl (Kwakwaka'wakw) poles. The slender thread of continuity, held by one of the last master carvers, was largely responsible for pulling Northwest Coast native art back from the brink of extinction. Mungo Martin continued this work at the British Columbia Provincial Museum (now the Royal British Columbia Museum) in Victoria, working with his son David Martin, his stepgrandson-in-law Henry Hunt and later Hunt's young son Tony. They replicated Tsimshian and Haida poles as well.

Another significant name in the revival of the art is that of Bill Reid, Haida artist and jeweller, who with Doug Cranmer, a Kwakiutl (Kwakwaka'wakw) carver from Alert Bay, undertook the massive project of recreating part of a Haida village for the University of British Columbia Museum of Anthropology. Bill Reid had diligently studied early Haida works of art and created superb pieces in silver, gold, argillite and wood, as well as high-quality silk-screen prints, providing a strong impetus to the revival of Northwest Coast native art. Adding to that stimulus, Haida artist, jeweller and carver Robert Davidson brought back and revitalized many aspects of the early traditions of his people, and in 1969 he raised the first totem pole on the Queen Charlotte Islands in half a century. The event, with its accompanying feast and ceremonies, aroused a new pride in the Haida nation.

Other young artists, notably Norman Tait of the Nisga'a (a division of the Tsimshian); Tony Hunt, Richard Hunt and Calvin Hunt of the Kwakiutl (Kwakwaka'wakw); Joe David and Art Thompson of the Nuu-chah-nulth,

and Nathan Jackson of the Tlingit, studied the early masterpieces of their forebears to learn the art styles of their particular cultures. All of them carved totem poles.

When the ill-conceived law banning the potlatch was finally deleted from the revised Indian Act of 1951, potlatching came into its own again, especially to mark major events such as the raising of a totem pole. Native elders reached back into their early memories to provide the new generation with information on ceremonies, crest use, rights and privileges, legends, regalia, songs, dances and other aspects of their traditions.

From the 1960s onward, awareness and appreciation of Northwest Coast art and its traditions grew steadily among non-natives, as did a renewed sense of self-identity and pride among the First Nations themselves.

On the Upper Skeena River, in Hazelton, a school of art was established to teach Northwest Coast native design, carving, jewelry and printmaking. Out of it grew an art style that, while reflecting the traditions of the Gitksan, made use of imaginative innovation. Many good artists and carvers had their start at the school. A few years later, in 1970, the recreated Gitksan village of 'Ksan was built near Hazelton.

A growing awareness of and interest in the sophisticated art form of the Northwest Coast has led to an expanding market in well-crafted items made by native artists. Quality gift shops and art galleries offer gold and silver jewelry, argillite carvings, drums, basketry, exquisitely carved and inlaid masks and headdresses, various ceremonial regalia—and many other items, including such contemporary works as silk-screen prints, carved plaques and bronze castings. And totem poles.

Now, more and more totem poles are being carved and raised with varying degrees of ceremony, and so strong has interest become in this specialized art that perhaps the majority of poles are commissioned for nontraditional purposes. Museums, corporations, governments, education centres, gift shops and private collectors often commission carvers to create new poles, several of which have gone to eastern Canada, the United States (other than Alaska), Mexico, England, Denmark, West Germany, Argentina, China, Japan, Australia and elsewhere.

The rekindled fires of Northwest Coast native culture burn brightly. Several villages have been or are involved in programs to replicate their old poles or to add new ones, often to affirm a chieftainship or as a memorial. So long as there are old-growth forests to supply the cedar logs, totem poles will continue to be raised, radiating the power of the legendary and crest figures, proclaiming the people's pride in their past and the strength of their culture, now and in the future.

TYPES OF TOTEM POLES

Several types of totem poles served different functions in the nineteenth-century villages of the coast, but not all cultural groups had all types.

Traditionally, the Coast Salish did not have freestanding totem poles, though they did have large cedar planks carved with fairly realistic high-relief figures of humans and animals on the walls of their ceremonial dance houses. They also had beam support posts and grave figures carved in human form.

The Nuu-chah-nulth set up a welcome pole near the village beach. This single, larger-than-life human figure, with arms outstretched, stood near the beach to welcome visitors arriving for a feast or potlatch.

The Nuu-chah-nulth and Kwakiutl (Kwakwaka'wakw) had pairs of house posts inside the houses of high-ranking chiefs. Carved with the emblems of family histories, singly or in pairs, these posts were generally an integral part of the house frame construction and added splendour and prestige to the house and its owner.

The house frontal pole of the Haida stood up against the outside front of the house, with the doorway to one side of the pole.

The house portal pole was similar but had an oval entrance cut through the base. Although mostly a Haida feature, some portal poles existed among the Kwakiutl (Kwakwaka'wakw), Gitksan and Nuxalk. This special entrance was used on ceremonial occasions and gave particular significance to the guests and the processional entry into the house.

The memorial pole, found in Haida, Tlingit, Tsimshian, Kwakiutl (Kwakwaka'wakw), Nuu-chah-nulth and Nuxalk villages, stood before the house but was not attached to it. This pole could consist of a single crest at the base and/or top, or it could be elaborately carved along its full length. Raised a year or more after the death of a chief, the memorial pole displayed crests and figures that depicted special achievements or events in the deceased person's family history. The succeeding chief gave the memorial potlatch, which also served as validation of his new position. The time span of at least a year was necessary to give the host family time to prepare and accumulate the gifts and food for the potlatch.

Another distinctive type of pole, found among the Haida and Tlingit, rarely among the Tsimshian, was the mortuary pole for those of high rank. Generally carved with crests of the deceased, the mortuary pole had a large

cavity cut into the upper end. To allow maximum space for the cavity, the log of the mortuary pole was inverted, to provide greater width at the top.

The Haida placed the body in an elaborately painted chest or box, which was then put in a mortuary house. A year later the remains were placed in a smaller, undecorated box and deposited in the cavity of the mortuary pole. A cedar board, shaped to resemble a large chest with lid and base, covered the open cavity at the front. Termed a frontal board, it was usually painted and sometimes carved with the main crest of the deceased. Additional planks covered the top, with rocks placed on them for security against the wind.

Among the Tlingit, a high-ranking person's body was often cremated. In early times, the ashes were put in a box set on top of a plain mortuary pole. In later times, a carved crest figure, placed horizontally, replaced the box; and the ashes, in a small container, were placed in a niche at the back of the mortuary pole.

Probably a good hundred years old, this mortuary pole at Skedans lies fallen amid forest growth, the victim of a windstorm.

HILARY STEWART

There is yet another category of pole, but examples of this type exist only in museums. It is the shame pole. This was carved for a chief who wished to ridicule or shame another—often his rival. Some misdeed, a long-standing unpaid debt or other incident worthy of scorn or ridicule, was publicly proclaimed by raising such a pole, which usually represented the person in question in some unflattering attitude. When restitution was made, the carving came down.

Contemporary times have brought a new category of totem pole into being—the commercial pole. These are commissioned from sources outside the culture, such as governments, corporations, institutions or private individuals. Generally the art and carving follow tradition, and such poles are often raised with ceremony, but their significance takes on a new role. Poles in untraditional places are a strong reminder of the First Nations people and their long-standing presence on the land.

The variation of art styles found in the carved monuments from north to south is due to the different cultural backgrounds of the artists. The cultural style is identified in the heading for each totem pole illustrated.

The function of totem poles varied somewhat among the different peoples, but overall they were historical monuments, or documents, of great meaning

and value to the cultures that carved them. They displayed images that represented a people's origins and lineages, their rights and privileges, their supernatural experiences, their exploits and achievements, their acquisitions and territories, their marriages and memorials. These recorded histories gave the people cultural identity, and proclaimed their wealth and status in the village and within their nation. Many poles, old and new, still serve the same purpose.

CARVING AND RAISING POLES

Almost without exception, totem poles were (and still are) each carved from the trunk of a single western red cedar (*Thuja plicata*).

In early times, it took a person of knowledge to find and choose the right tree—one straight of grain, without convolutions, with a minimum of knots and preferably as close to the sea or a river as possible for ease of transport. Before bringing down the tree, the faller ritually addressed its spirit in prayer, asking it to fall in the right direction and for the wood not to split.

There were several different ways of felling a tree: by controlled burning at its base, by placing red-hot rocks in a deeply chiselled cavity in the trunk, or by splitting out the wood from between two grooves circling the trunk. Once felled, the top section of the tree carrying the branches was removed by burning through it with red-hot rocks. The log was then skidded down to water and towed by canoe back to the village. Men, supervised by a specialist, carried out all the preparation work. (Now, especially if a very large log is required, it is bought from a logging company and delivered to the carving site by truck.)

With the log horizontal, the carver and his assistants, often apprentices, first stripped off the bark and then adzed away all the sapwood. Any damaged wood, large knots or other defective areas were cut out and replaced with sections of good wood, which were pegged in place.

A wealthy chief who wanted to raise a memorial pole, for instance, would commission an artist-carver with a good reputation, perhaps from another

village. The chief told him what crests and other figures he wanted on the pole, and in what order, but the design and representation were up to the carver. He drew on the design with charcoal. After adzing, chiselling and splitting away the wood to give form to the figures, he brought out the final shaping and detailing with curved knives and incising tools. Elements such as outstretched wings, sun rays, dorsal fins, large beaks or anything extending out from the girth of the log required separately carved pieces to be added and joined by mortise and tenon or by pegging. (The carving process is much the same today, though some artists use a chainsaw in addition to traditional tools.)

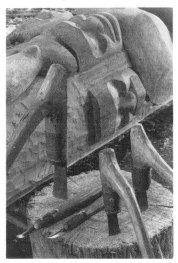

The finished carving then had paint applied; the areas painted and the choice of colour depended on the tradition of the area. Prior to European contact, pigments were made from grinding various minerals and mixing the powder with a binding agent, such as the glutinous part of salmon eggs. (When commercial paints became available, these were readily used instead, and in fact broadened the palette of the painter.)

Adzes and curved knives, in varying sizes, are two of the carver's most used tools.
HILARY STEWART

If the making of the totem pole took place close to the village, sometimes a screen of brushwood or matting kept the work in progress hidden from view, so that no one should see the pole until the time came for raising it.

Raising a pole, especially a large one, required a great deal of preparation and skill. Many people helped to dig a hole before the pole was ceremonially carried to the site. It took perhaps a hundred or more men to carry the pole, which lay on crossbars supported on the carriers' shoulders. The uncarved base of the pole went into the hole, while the upper part leaned out at an angle, resting on supports. Under an ex-

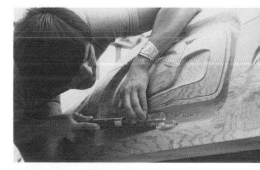

Carver Robert Davidson carefully wields a specialized cutting tool to shape a pole. HILARY STEWART

pert's direction, many people hauled on strong ropes made from twisted cedar withes (or ship's rope acquired in trade) to raise the cedar column. Others pushed it up from beneath, using long poles, while still others took the tension on two more ropes to prevent the carved log from swaying to either side. The pole was raised in stages, resting on a log crutch between each stage. Drumming, singing and dancing punctuated the stages until the pole was standing vertically. (The carrying and raising of a pole are still done as much as possible by hand.)

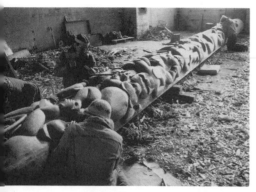

Carvers at work on Norman Tait's 16.7-m (55-foot) totem pole, Big Beaver, now in front of the Field Museum of Natural History in Chicago. HILARY STEWART

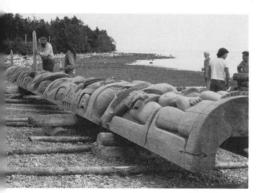

This Haida house frontal pole, carved by Bill Reid, had a Dogfish spine and Whale dorsal fin added before being raised at Skidegate in 1978. HILARY STEWART

The hole in the ground around the base of the pole was filled in with rocks and dirt, with men tossing in boulders as large as they could carry. These rocks contributed to good drainage, which helped prevent the wood from rotting; their mass also kept the pole from falling long after it began to lean.

Different groups had (and still practice) varying traditions for the pole-raising ceremonies; a popular Haida one is for the carver to dance with his tools tied around his person. Among all groups, the owner of the pole (or a speaker representing him) explains in detail the stories and meaning behind all the carved figures, and those assembled to witness the event are expected to remember what they see and hear. A particularly fine pole calls for praise, criticism and comparison, enhancing the status of the owner and the reputation of the carver.

Feasting and potlatching follow in celebration, as one more carved monument stands tall and splendid against the sky.

As with so many significant possessions of the Northwest Coast culture—houses, canoes and feast bowls, for example—totem poles had (and still have) names. The name may refer to a legend depicted on the pole, to the owner, or to the person for whom a memorial pole was raised.

The height of poles varies considerably, with the tallest (in the nineteenth century) being an extraordinary 24.4 m (80 feet). Modern pole-raising equipment has enabled this limit to be extended considerably; a pole of 30.5 m (100 feet) stands in Vancouver, another of nearly 39 m (127 feet) towers in Beacon Hill Park in Victoria, and in Kake, Alaska, a tremendously tall pole rises over 45 m (150 feet). In the village of Alert Bay, the world's tallest totem pole soars an astounding 53 m (173 feet) into the sky. (Its very height, however, has made it impracticable to include in this book, since reducing the drawing to fit the page would diminish the crests beyond recognition.)

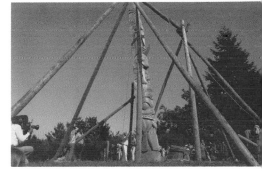

The traditional rigging used by the Gitksan people to raise a free-standing pole. HILARY STEWART

Wind and weather, fungi, insects and plant life all contribute to the decay of an old pole. A leaning pole may sometimes be propped up, but once fallen, it is generally left to return to the earth; to raise it again would require another potlatch.

Some poles last sixty to eighty years, and a few have stood much longer. Cracks and splits in totem poles are natural for an organic material such as wood, and should not be seen as a disfigurement or flaw in the carving.

A contemporary pole raising may include traditional elements such as a full-blown potlatch that involves the feeding of many hundreds of people at a lavish sit-down dinner.

To haul on the ropes that raise a bright new pole, to witness, to feast, to hear speeches in a language still preserved, to receive gifts, to watch masked dancers while smoke from the central fire billows up and out through the smoke hole, is to be a part of that pole's history. It is also a privilege.

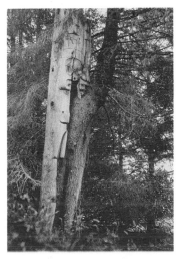

A spruce tree, growing in a crevice in a pole at Cumshewa, has split the pole asunder. HILARY STEWART

29

PART 2

THE IMAGES CARVED
ON POLES

FIGURES

Although artistically unique and visually splendid, totem poles may at first appear to be bewildering because of their maze of complex imagery. It is important to remember that the pole shape dictates that (with a few exceptions) all the figures be portrayed vertically. Humans and humanlike beings may be carved standing fully upright, but more often they are depicted in a crouched position. Four-legged animals, especially Bear and Beaver, are shown in similar attitudes. Birds are usually shown as perched, with wings folded at their sides or outstretched; legs have clawed feet, and beaks extend out horizontally or are tucked downward against the chest.

The bodies of almost all creatures face the front, but some are portrayed as if seen from above, with the head either uppermost or downward on the pole. Figures best suited to this treatment are Whale, Dogfish, Salmon, Frog and Wolf.

Small, secondary creatures may be shown as complete, or with head and limbs emerging from behind some other figure. There may also be overlapping or interlocking of various beings, which makes it more difficult to unscramble the different figures.

In this book, poles are described from the top down. The top figure on a pole, perhaps Raven, Eagle, or Thunderbird, may identify the clan or lineage through the crest. Contrary to popular belief, the "top man on the totem pole" is not necessarily the highest ranking or the most important—often he carries the least significance. It is the largest figure, generally the one at the base of the pole, which is usually the most prominent, with secondary smaller figures having less importance. Quite small creatures serve to fill in areas such as ears and the chest of large figures. Their presence carries some meaning, but on old or replica poles the significance has been lost to antiquity; the creatures themselves may be identified, but not the context.

CRESTS

There is Sea Bear, the Cannibal Bird Huxwhukw and the Two-headed Sea Serpent Sisiutl. There is Flying Frog, One-Horned Mountain Goat and Five-Finned Killer Whale. There is Split Person, Fog Woman, Running Backwards and a whole host of other supernatural beings that have become the crests of the various cultures of the Northwest Coast peoples.

Singly, or multiply with one above other, these images embellish the carved wooden monuments to proclaim a people's beginnings, history and lineage. The figures record the past, display it in the present, and preserve it for the future.

Many of the crests have their origins in the ancient myth time before the world was as it is now, a time when animals could transform into humans. A family may come to own its "origin" crest through an ancestor who had a memorable adventure or encounter with a supernatural creature. This adventure often entailed the ancestor's overcoming and killing the creature, or the creature becoming human to establish the lineage. The ancestor and all his descendants then have the right to use that creature's likeness on totem poles, house fronts, interior screens, boxes, feast dishes, ceremonial regalia and any other property. If the ancestor received a song and a dance at the time of the encounter, his descendants inherit the right to perform that dance wearing a mask in the likeness of the creature, and to sing that song; no one else has the right to that song or that dance.

However, a crest could also be acquired through marriage, obtained by the conquest of an enemy, traded, received in compensation for special services, or appropriated at the extinction of a family. Outstanding episodes of family history, migrations and settlement, war adventures, resource ownership, or special visions could generate new crests, which would be validated by a potlatch.

As well as supernatural beings, there were crests such as birds, fish, mammals, insects, plants, celestial bodies and other natural phenomena: Mosquito, Woodworm, Starfish, Fireweed, Fern, Sun, Moon, Stars, Rainbow and Sundog are some of these. The rich array of crests on carved poles does not portray the ordinary creatures of nature, but spiritual, supernatural beings. To clarify the difference, their names, when written, are capitalized in this book. In addition to displaying individual crest figures, a pole may depict

some of the additional characters of an encounter story, together with objects that are a part of the story. These may be a cave, a glacier, a spear, a string of fish, a talking stick, a box, a canoe, twin cubs, a child and so on.

The list of crest figures to be found on poles is quite lengthy and includes some rather cryptic beings as well as supernatural personifications. The following, though brief, covers most of the beings illustrated in this book, and others are pointed out as they appear.

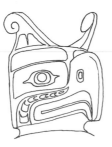

Thunderbird

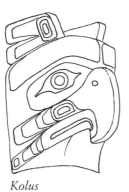

Kolus

Mythical Beings

THUNDERBIRD: A huge and mighty creature, Thunderbird is one of the most powerful of all spirits. It appears mainly on Kwakiutl (Kwakwa̲ka'wakw) poles, rarely on Haida or Tlingit poles, but all the coastal peoples include Thunderbird in one form or another in their ancient lore and attribute various powers to this supernatural bird. He is known to swoop down from the sky to capture a surfacing whale in his huge talons, then to fly off to the mountains to eat it. Thunder rolls from the great bird's wing beat, and lightning flashes from his blinking eyes.

Thunderbird has curled appendages (sometimes referred to as horns) on his head; these may represent tufts of curled feathers. The bird is often dramatically depicted with outstretched or uplifted multifeathered wings atop many a pole.

KOLUS, KULUS, OR QUOLUS: Kolus, another supernatural bird, also has tufts on its head; but instead of curling, they are straight and horizontal. A Kwakiutl (Kwakwa̲ka'wakw) crest, Kolus is described in myth as being covered with dazzling white down that causes him to become greatly overheated. To overcome this, he can remove his coat of down, revealing his human image. Like Thunderbird, Kolus is endowed with great strength. He is credited with lifting into place house beams too heavy for humans to raise and with moving house frames into position.

HUXWHUKW, HOKW-HOKW, OR HOK-HOK: A very long straight beak distinguishes Huxwhukw, the Cannibal Bird, a crest of the Kwakiutl (Kwakwa̲ka'wakw) and Nuxalk. This fabulous bird-monster is one of three servants in the cannibal

spirit Bakbakwalanuksiwe's great house in the sky, at the north end of the world. Under the control of the cannibal spirit, a series of extraordinary mythical beings play a vital role in the ceremonies initiating a novice into the Hamatsa dancing society of the Kwakiutl (Kwakwaka'wakw). During the complex rituals, dancers wear the appropriate masks, fringed with shredded cedar bark, to dramatically portray these creatures.

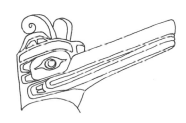

Huxwhukw, with his extraordinary long chisel-shaped beak, cracks open the skulls of men and devours their brains. During the dance of Huxwhukw, the mask's beak is manipulated by the dancer to repeatedly open and snap shut, making a loud clacking sound.

Huxwhukw

SISIUTL, SISIOOHL, OR SISIYUTL: A supernatural creature, Sisiutl is a scaly double-headed sea serpent with the power to bring both good and evil. It is a crest of the Kwakiutl (Kwakwaka'wakw) and Nuxalk. Flakes of shiny mica found on beaches and elsewhere were thought to be the discarded scales from this awesome sea serpent's body.

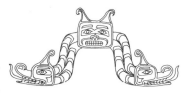

Sisiutl

Sisiutl can change itself into various forms, including a self-propelled canoe. Touching the serpent, or even looking at it, or a glare from it, can cause death, and yet it is a source of magical powers. It can bring wealth and, when painted over a doorway, it serves as guardian to the house. The two-headed sea serpent is closely associated with war and strength, and with death and revival; its blood rubbed on a warrior made him invulnerable, and wearing a headband or belt in the image of Sisiutl afforded protection from harm.

Sisiutl is generally depicted with a profile head, teeth and a large curled tongue at each end of its serpentine form; in the centre is a human head. Fins run along its back, and curled appendages, or "horns," rise from all three heads. The body is sometimes painted to represent scales. Sisiutl may be carved horizontally, or formed into a U shape, or coiled into a circle.

DZUNUKWA, DZOONOKWA, DZONOQUA, OR TSONOQOA: A fearsome giantess of the dark forest, this not-quite-human female is also known as Wild Woman of the Woods and Property Woman. A crest of the Kwakiutl (Kwak-

wa<u>k</u>a'wakw), she is often the subject of prints, paintings, masks and other carvings, including totem poles. She is always painted in black, with pendulous breasts, heavy eyebrows, deep-set eye sockets with half-closed eyes—and pursed lips to indicate her cry of "Ooh-ooh, ooh-ooh."

By character, Dzunu<u>k</u>wa is stupid, clumsy and sleepy—hence the slit or crescent eyes. She captures children who are crying or who venture into the forest, carrying them away in a basket on her back to devour them.

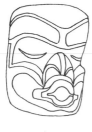

The house of this awesome giantess is filled with wonderful treasures such as boxes of food, coppers, canoes and more. Through special encounters with her, a person could acquire some of this wealth and supernatural power.

Dzunu<u>k</u>wa

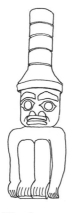

Watchman

WATCHMEN: Elaborately carved Haida house frontal poles often carry at the top one to four (generally three) small, crouched human figures, wearing hats with high crowns. Known as Watchmen, they have supernatural powers; from their lofty position atop the pole, they look out in several directions to keep watch over the village and out to sea. They protect those within the dwelling by warning the chief of the house of any approaching danger, alerting him to canoes arriving or anything else he should know. The high-crowned hats worn by the Watchmen symbolize the status of the chief whose house they guard.

Other Beings

Often, creatures of the supernatural world include sea mammals with land associations and physical attributes. Thus, a totem pole may have a depiction of Sea Bear, Sea Wolf, Sea Grizzly or a legendary sea monster of some type. Generally, but not always, such a creature may be portrayed both with land animal characteristics and with marine characteristics such as fins, flippers or a fluked tail.

Several guidelines can help to identify other beings, but, as with most rules, there are always exceptions. The birds are depicted with similar bodies, but their heads have differing characteristics. All the birds are generally shown with eyebrows and have ears atop their heads. Raven has a straight (but not overly long) beak, Eagle has a short beak downturned at the tip,

while Hawk (or Mountain Hawk,) has a beak that is downturned and recurved inward.

Bear is distinguished by prominent ears, round or flared nostrils, and generally a menacing display of teeth that includes pointed canines. This very humanlike animal is usually shown sitting upright in a human stance, with large clawed paws on all four legs.

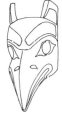

Beaver is readily identified by two large incisor teeth, round nostrils and a cross-hatched tail that often has a human face where the tail joins the body. Beaver often is shown holding a chewing stick in its front paws.

Raven (beak down)

Wolf has tall ears, a long snout and a lot of teeth. The tail may be bushy and curled, or straight and black-tipped, depending on the cultural tradition.

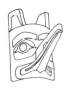

Mainly seen on northern poles, though not very often, Mountain Goat has hoofed feet and two slender curved horns. Also found frequently in the north is Frog, who displays a wide mouth with no teeth. It has no ears, but it does have large round eyes and toed feet.

Raven (beak up)

One of the most often depicted crests is Whale. Killer Whale carries a long dorsal fin and short pectoral fins and is often shown with teeth. Humpback (or Grey) Whale is distinguished by a minimal dorsal fin and long slender pectorals; it often has spots painted on its back—perhaps representing the large barnacles found on the back of this sea mammal. All Whales have rounded snouts, large mouths,

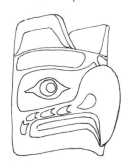

Eagle

pectoral fins, symmetrical tail flukes and blowholes that may appear as human faces. The tail may be shown flat or curved back over the creature.

Fish generally take their natural shape, with Bullhead (or Sculpin) having a very large head and many spines. Frequently seen on Haida poles is Dogfish (or Shark), unmistakable with its high, domed forehead, gill slits and pointed teeth in a large downturned mouth, which may have a labret in the lower lip. Asymmetrical tail flukes identify this large fish, which may also have small dorsal fins and spines.

Mosquito may take a humanlike form, or have several legs, but is recognizable by its long, narrow proboscis.

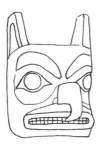
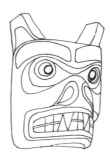
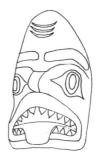

Hawk (or Mountain Hawk) *Bear* *Dogfish (or Shark)*

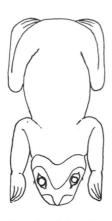
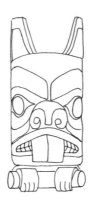
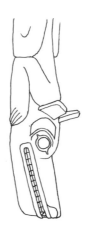

Frog (head down) *Beaver* *Wolf*

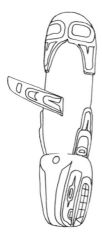

Killer Whale *Humpback (or Grey) Whale*

A human face, carved or painted on a bird or mammal, may represent its duality. Sometimes the transformation from one to the other is portrayed by the depiction of body parts from both, on the same figure.

Sun is easily recognized by the rays around its circular face, while Moon has a round rim but no rays.

CEREMONIAL AND EVERYDAY OBJECTS

The High-Crowned or Ringed Hat
The tall hat with several rings around the high crown is a representation of the hats worn by high-ranking Haida and Tlingit people. Finely woven of split spruce roots, the wide-brimmed hats have several woven cylinders topping the crown. These cylinders are called *skils* by the Haida. It is thought that the number of cylinders, or rings, represents the number of potlatches given by the owner, thus the term "potlatch rings" or "potlatch cylinders."

Another theory is that a specific number of rings or cylinders was, in itself, a crest. This seems quite probable, since some of these hats, painted with family crests, were crests themselves. Certainly, the high-crowned or ringed hat points to chiefly status and high rank, and poles that include these hats symbolize the status of the chiefs on whose poles they are carved.

Occasionally, a plain column of such rings was carved on a pole, in association with a figure, human or animal; or a whole section of a pole was carved to represent the stacked cylinders.

The Head Ring and Neck Ring
Made of inner cedar bark, the head ring was worn by a person taking part in certain ceremonies, dances or rituals. The bark, shredded and dyed red, was woven or braided or otherwise formed into a crown-

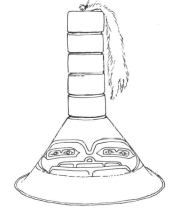

High-crowned (or ringed) hat

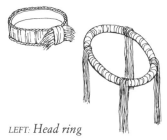

LEFT: *Head ring*
RIGHT: *Neck ring*

like ring for the head, and sometimes it was decorated with fur and/or abalone shell.

Similarly, the neck ring, also made of inner cedar bark, was worn at special functions, hung around the neck or at times worn across one shoulder. The neck ring varied in size, and often had sections of long fringes of cedar bark twine hanging from it. Head and neck rings are still worn in present-day ceremonies.

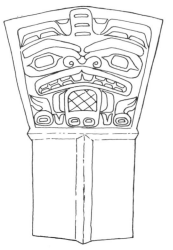

Copper

The Copper

The copper, which derives its English name from the metal of its manufacture, is an item that represents great wealth and prestige among the people of northern Vancouver Island and northward to Alaska.

The copper's characteristic shape has a flared upper half, which may carry a design; the lower half has ridges hammered into a T shape. With an average height of about 70 cm (28 inches), excluding miniatures, coppers of the past were made from sheet copper—often of the type used for sheathing the wooden hulls of sailing ships—and were acquired in trade.

The metal itself symbolized wealth and high rank. Northern chiefs proclaimed their rank and lineage by displaying coppers at a potlatch. Each copper had a name and a history, and represented a specific value.

Among the Kwakiutl (Kwakwa̱ka'wakw), a chief could take revenge on anyone who had insulted him or his family by publicly and ceremonially breaking off a section of a copper and presenting it to the offender. A copper could be broken several times and repaired, adding to its history and value. Throwing a copper into a fire or into the sea was a conspicuous gesture of disregard for one's enormous wealth. Coppers of great value could be used towards purchasing slaves, a stand of fine cedars, hunting lands, or other food resources or property.

One or more coppers might be carved or painted on a pole to proclaim a person's rank and status or, more rarely, be nailed to a mortuary or memorial pole.

The Labret

The labret was an ornament worn in a perforation through the lower lip. In the north, labrets were oval in shape, generally made of wood or stone, sometimes inlaid with small flat pieces of shell or bone. The wearing of a labret signified high rank. Eighteenth-century explorers and traders commented on this ornament, and nineteenth-century photographers recorded women wearing the labret. In southern coast areas, however, labrets fell out of use long before European contact.

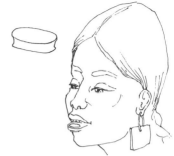

Although no longer worn, labrets are sometimes depicted on masks, totem poles and other carvings that show high-ranking women.

Labret and woman wearing labret

Talking Stick or Speaker's Staff

When giving a speech at a formal gathering, a chief or his speaker holds in his right hand a long wooden staff that resembles a miniature totem pole. It may have a single crest at the top, or be partially or fully carved. The talking stick represents the chief's authority to speak, and often he will thump it on the floor or against the ground, or manipulate it in other ways, to emphasize his words or make a point. This ceremonial item is still used today, and contemporary carvers sometimes include it on poles.

THE DEPICTION OF LEGENDS

The use of the word "legend" does not imply that a story is fictional. A legend is, to quote *Webster's Dictionary*: "a story coming down from the past, especially one handed down from early times by tradition, and popularly regarded as history"—and, in *Collins' Dictionary*: "a marvellous story of ancient times, a traditional tale."

Certain legends repeatedly appear in carved form on totem poles, and may be readily recognized by the depiction of figures central to the story. While details of most stories vary from one coastal culture to another—even from one village to another—the basics remain constant.

Some aspects of these legends may seem mystifying in today's world, but that does not negate their reality to a people whose culture encompasses a spiritual and cosmic understanding of their environment. Traditional knowledge lies behind these marvellous stories handed down from early times, and belief in them is as closely held as those of any other deeply rooted culture or religion.

Nanasimget and Killer Whale

A long and complex Haida story is that of Nanasimget, a young man who married a wealthy and very beautiful woman. As he set out to go seal hunting one day, his grandmother pointed out a white sea otter among the kelp. After a long hunt he managed to spear it beneath the tail so the pelt would be unmarked and perfect. In skinning it, the old woman got a spot of blood on the fur; the wife offered to clean it in a tide pool, but she slipped on a rock and the otter pelt fell into the sea.

The young woman went in after the skin; just as she touched it, Killer Whale rose up from beneath, lifting her out of the water, then swam off across the sea while she desperately hung onto his dorsal fin. Nanasimget gave chase in his canoe, but Killer Whale dove and did not surface again.

After preparing himself ceremonially, Nanasimget returned to the place where his wife and Killer Whale had descended, and dove into the sea. On the sea bed he found a trail and followed it. After encounters with three geese, a heron and a Watchman with wooden legs, he was told that his wife was to marry Killer Whale as soon as a dorsal fin was made for her.

In a bid to rescue his wife, Nanasimget conspired with the slave who was making the fin. Thus, when the slave entered Killer Whale's house with a container of water for steaming the fin, he spilled it on the fire. With clouds of steam filling the house, Nanasimget dashed in to where the slave had told him his wife was sitting, grabbed her and ran out. Together, they raced along the trail to the kelp stem to which his canoe was tied, climbed up it into the canoe and paddled back to the village, foiling Killer Whale's attempts to pursue them.

Many a carved pole records this narrative by depicting Killer Whale, with a woman on his back or clinging to his fin, and Nanasimget, who gave chase. Other Northwest Coast people have variations on this legend of Killer Whale abducting a woman.

How Raven Stole the Sun

Perhaps the best-known legend on the Northwest Coast, and the one with the most variations, tells how Raven the trickster stole the sun—as well as the moon and the stars—and brought daylight to the world. Details of the story differ from one culture area to another or from one village to another, but the basic components usually remain fairly constant.

The Haida people tell of a time when all the world was in darkness because a greedy chief kept the sun, the moon and the stars in three wooden boxes in his house. He would occasionally lift the lids and let the light spill out for a short while, but he jealously guarded these treasured possessions.

Hearing about the boxes, Raven was determined to bring daylight to the world, but since no one was allowed to touch the boxes, the wily bird devised a cunning plan. Knowing that the chief's daughter went to the stream for water every day, Raven transformed himself into a hemlock needle and floated down the stream. When the young woman filled her box with fresh, cool water, the needle slid unnoticed into the box and Raven was carried to the house.

The chief's daughter drank some of the water, swallowing the hemlock needle, and as a result became pregnant. Eventually she gave birth to a dark, beady eyed child, who grew at an astounding rate. He also cried a lot, mostly for the box with the bright, shiny ball inside, but the chief refused to allow him to play with it. Daily the child wheedled and whined and cried even louder and longer, until the chief could stand it no more and allowed his grandson to play with the ball of light—just this once.

Seizing his long-awaited opportunity, Raven quickly transformed himself back into bird form, picked up the ball in his beak, and in a flash of feathers flew up and out through the smoke hole. Higher and higher and farther and farther he flew, spreading light all around the world for everyone to enjoy. Then he flung the shining globe into the sky, and there it remains—even to this day.

Carved or painted depictions of this story may show Raven, the chief, his daughter and the sun (which sometimes appears as a face with rays emanating from it, sometimes as a disc). On occasion, the box that held the sun is also included, but in its most minimal form the sun may simply be shown as a ball or disc in Raven's beak.

The Bear Mother

One day, a Haida woman of high rank was helping to harvest the luscious red salmonberries when she accidentally slipped on a pile of bear dung. The indignity of spilling the berries caused her to hurl insults at the one responsible. Bear, feeding on salmonberries on the nearby bushes, overheard the tirade and kidnapped the woman, taking her back to his village.

Imprisoned in a small wooden structure with a barricaded door, the captive was alone and upset. Presently, tiny Mouse Woman appeared and said to her: "You must break your copper bracelet in half. After the Bears feed you, they will allow you out into the forest to empty your bowels, but they will be guarding you. Scrape out a hollow for the excrement, cover it over, and secretly drop the half bracelet on top. Do the same again the next day."

The woman did as Mouse Woman bade her. Now, when Bear Chief was informed that the woman's dung was in fact copper, he was very impressed and apologized for mistreating her. Her request to return home was denied, but eventually she was persuaded to marry Bear Chief's nephew. In time the woman gave birth to twin cubs and settled down, resigned to her new life.

Eventually, however, the woman's two brothers came with dogs to search for her, and not wanting a confrontation, Bear Father fled with his family to hide in a cave. But the pursuing search party discovered the family, and after a discussion, reached an agreement with them: the brothers could establish a Bear clan if they would not smoke Bear out of his den, but instead kill him ceremonially and sing a special mourning song afterwards. And this they did.

The brothers returned home with their sister and her twin cubs, and took Bear for their crest. Soon after, the cubs went home to their own village; the mother remarried and had human children to further propagate the Bear clan, whose crest is seen on many poles.

Thus, whenever a bear was killed for its meat and its hide, the special mourning song was always sung.

A GUIDE TO OUTDOOR TOTEM POLES

1 LOCATION: *Douglas border crossing*
CARVER: *Mungo Martin*
CULTURAL STYLE: *Haida*

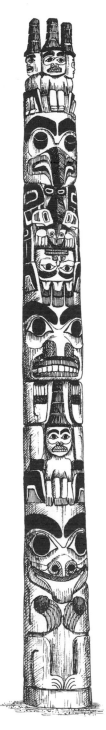

6 ft.
1.8 m

This exceptionally fine house portal pole greets people who enter British Columbia from Blaine, Washington.

The original of this pole was collected in 1954 from a badly decayed house in Skedans village on the Queen Charlotte Islands. This and other poles were taken to the Royal British Columbia Museum in Victoria for restoration and replication by Kwakiutl (Kwakwaka'wakw) master carver Mungo Martin.

In 1957 Haida artist Bill Reid, who had not yet attempted working on a large scale, joined Mungo Martin to experience carving a totem pole. When Reid cut himself with a carving knife, he asked, "Mungo, where are the Band-Aids?" The old-time carver replied simply: "We don't use 'em," implying that he never cut himself.

Topped by three Watchmen, the figure below is probably Mountain Hawk (the Haida version of Thunderbird), who was actually a supernatural man wearing a feathered coat and had talons strong enough to catch whales. Notice the small Whale, head down, between Mountain Hawk's wings, and the bird's tail personified by a face (shown upside-down).

Next is a mythical animal holding a man wearing a high-crowned hat, probably the owner of the pole. At the base, Grizzly Bear guards the entrance to the house; the original pole had an oval opening in it for a doorway.

47

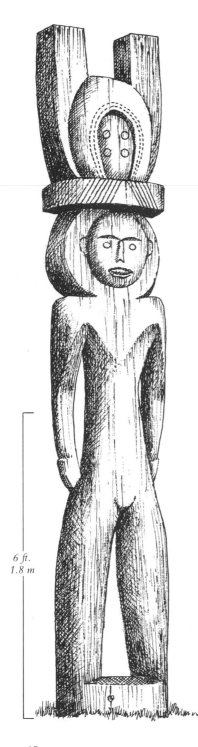

6 ft.
1.8 m

2 LOCATION: *Vancouver—Heritage Park on Musqueam Indian Reserve*
CARVER: *Stan Greene*
CULTURAL STYLE: *Coast Salish*

The carved figure on this and the next page are not in fact totem poles in the sense of displaying crests, which the Coast Salish did not have. However, these two figures are included so that large wood sculptures of all the major culture groups are represented.

This single standing figure is a replica of the original beam support post from a ceremonial dance house in the village of Musqueam, on the Fraser River. The stylistic carving, typical of large Coast Salish sculpture, once held a house beam in the slot at the top.

This post, and the original of the house board on the next page, were purchased by the University of British Columbia's Graduating Class of 1927 and donated to the university's Museum of Anthropology.

The two carvings were displayed outdoors and eventually rotted beyond repair. In 1986 the post was replicated by Stan Greene, a Coast Salish carver, who worked from early photographs and fragments of the original. It was displayed at Vancouver's Expo 86 and later acquired by the village of Musqueam.

Skeletal remains uncovered during an archaeological excavation upstream from Musqueam were reburied alongside burial boxes discovered during building excavations. This plot of land became Heritage Park, where the replicated post now stands as a monument to the deceased and as a link between past and present.

3 LOCATION: *Vancouver—*
Totem Park Residences, 2525 West Mall,
University of British Columbia
CARVER: *Simon Charlie*
CULTURAL STYLE: *Coast Salish*

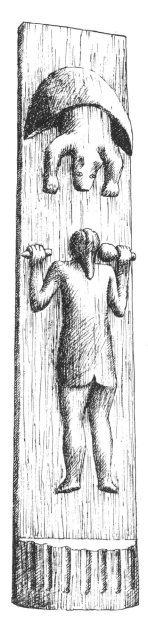

6 ft.
1.8 m

The post on the previous page has long been associated with this house board. In situ, the board would have been part of the wall of a house, along with other such boards. Both carvings were photographed at Musqueam in 1898, and are believed to be the only surviving specimens of their kind for the Coast Salish.

For many years the house board stood at the entrance to a student residence, named Totem Park, at the University of British Columbia. The decaying board was taken in to the university's Museum of Anthropology, and in 1974 it was replaced with a replica carved by Coast Salish artist Simon Charlie. A plaque at the base incorrectly calls it a welcome pole. The high relief sculpture depicts a man with a knife in one hand and a rattle in the other, facing a bear coming out of a cave.

In 1936 Chief Jack of Musqueam told anthropologist Homer Barnett that it depicted a supernatural power of his grandfather, who could mesmerize bears and other animals by singing a special song and shaking a rattle, thus making an easy kill.

The original house board does not have the adzed texture that Simon Charlie gave to the replica. Many years previously, he had bought a set of tools and used one of them to finish a sculpture with a technique he calls "feathering." "It changed my style," he said, "I don't like a smooth finish any more."

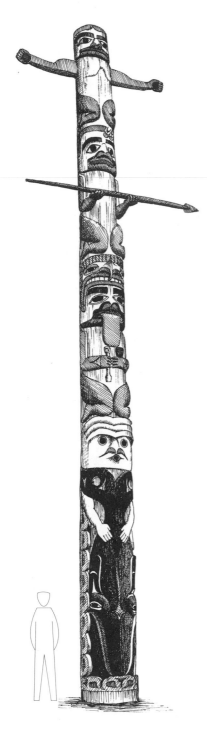

4 LOCATION: *Vancouver—*
Psychology Building, 2136 West Mall,
University of British Columbia
CARVER: *Art Thompson with Joe David*
CULTURAL STYLE: *Nuu-chah-nulth*

Although it is certainly not a house frontal pole, this tall carving nevertheless clings to the north face of a building on the University of British Columbia campus.

Art Thompson cut the log on the Nitinat Reserve and worked on it at the village of Iithloo, his home, at the northwest end of Nitinat Lake on Vancouver Island. The pole was to fulfil a commission by the university's Museum of Anthropology for a Nuu-chah-nulth pole. The innovative work depicts aspects of the whale hunt, an ancient tradition unique on the Northwest Coast to the Nuu-chah-nulth (and to their relatives, the Makah, of Washington State's Olympic Peninsula). "I carved the pole for all the Nuu-chah-nulth people," Thompson said, "and for their ancient whaling tradition."

The top figure depicts the harpooner (also called the whaler), a high-ranking chief who holds in his hands the tips of the dorsal fins from two whales. When brought to shore, the sea mammal was divided up among the whaling crew, and the chief received the dorsal fin; thus, this harpooner has taken two whales.

Beneath him is the man who holds second position in the seven-man crew and who sits behind the whaler. He ties inflated sealskin floats onto the harpoon line that holds the whale and pays out the line as the creature dives. He also retrieves the harpoon, which he is shown holding.

The next figure is that of the shaman, holding a baleen rattle in his left hand and a magical wand in his right. Shaking the rattle and singing a special song, or touching a harpooned whale with the wand, could cause it to turn in the right direction—towards the village rather than out to sea. The shaman wears a Hawk frontlet (or headdress) to indicate high rank, while the Lightning Snake emanating from his mouth symbolizes his strong inner powers. Notice the use of copper on the shaman's mouth and frontlet.

Puk-ubs is depicted beneath the shaman. He is the reincarnation of a drowned whaling crew member who was washed ashore, a man who had reached complete purification. Puk-ubs is represented by white, wrinkled skin and pursed lips, as he calls "Buk Buk."

At the base of the pole is mighty Whale itself, head down, with a wave design signifying the shore. The pattern on the tail flukes represents the slashes cut in them to slow down the sea mammal's retreat out to sea. Similarly, red paint inside the pectoral fin shows that it too has been cut, forcing the creature to turn in the desired shoreward direction. Red in the blowhole indicates the target of the spears, which follow the harpoon for the final kill. "Sewing" the whale's jaw closed, to prevent water from entering the carcass and thus sinking it, is represented by the long thin line along its mouth.

Art Thompson said that he felt he could not bring himself to create a ceremony for a pole raising outside of his people's territory, so the carving went, instead, to enhance the newly finished Psychology Building. After two years in storage, the pole was installed in 1984.

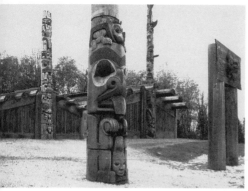

POLES AT THE MUSEUM OF ANTHROPOLOGY

UNIVERSITY OF BRITISH COLUMBIA
VANCOUVER

A Haida house, mortuary house and carved poles on the grounds of the Museum of Anthropology.

BILL MCLENNAN, MUSEUM OF ANTHROPOLOGY, UNIVERSITY OF BRITISH COLUMBIA

The fine display of poles on the grounds of the University of British Columbia Museum of Anthropology in Vancouver began in the late 1940s with some carved house posts from nearby Musqueam. The plan called for a collection of carved poles to represent the province's main coastal native groups, in a natural setting amid plants important to First Nations people. A number of poles were bought and shipped to Vancouver and Victoria for restoration.

Kwakiutl (Kwakwaka'wakw) totem pole carver Ellen Neel was employed in 1949 to repair some of the damaged and decayed poles; but after working on seven poles, she felt she had to return to her own work of carving for her retail store and on commission. Her uncle Mungo Martin, a master carver from Fort Rupert, agreed to take over the project. But patching up rotted wood proved too time consuming, tedious and unsatisfying, so the decision was made to better employ his skills in carving replicas of the old poles and in creating new ones.

Several poles and a house frame formed the first unit of Totem Park. In 1959 Haida artist Bill Reid and Doug Cranmer, an experienced Kwakiutl (Kwakwaka'wakw) carver, began an ambitious program of creating two houses and a group of Haida poles for the second unit of Totem Park. This major endeavour spanned two and a half years.

When the university's impressive new Museum of Anthropology opened in 1976, the plan called for a section of a Haida village to be situated at the edge of a pool, which would symbolize a beach front. The pool was never built (white pebbles indicate its proposed area), but the plank houses and some of the totem poles were moved there from Totem Park. Additional poles, representing other coastal cultures, have since been added to the attractive and appropriate setting of forest, sea and mountains.

5 LOCATION: *Vancouver—*
Museum of Anthropology,
University of British Columbia
CARVER: *Norman Tait*
CULTURAL STYLE: *Nisga'a*

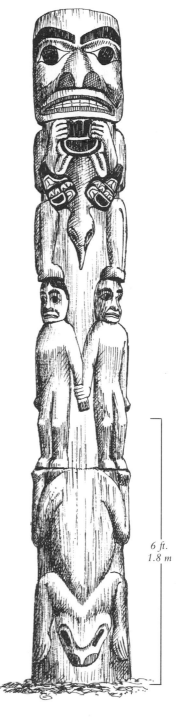

In 1977 the Museum of Anthropology held a one-man exhibition of the work of Norman Tait, a Nisga'a carver whose father and grandfather were carvers. The exhibit included woodcarvings, silk-screen prints, and silver and gold jewelry. During its run, he demonstrated woodcarving by working on a small totem pole in the exhibition gallery, and this pole now stands near the trail to the museum's outdoor display.

Backed by a setting of trees, the carving depicts the Tait family at the time. The carver himself is at the top holding Raven, a family crest; at the base, his wife, Jessie, is represented by her main crest, Frog. In between them are their two young children, Isaac and Valerie, holding hands. The girl has a traditional form of identification for a female: hair parted down the middle.

It is not unusual for this artist to include some cryptic detail in his work, and this pole carries a hidden message. Beneath Raven's upper beak, which is attached separately, he carved an inscription that will become visible only when the pole ages and rots, and the beak falls away.

Eight years after the pole was raised, Jessie Tait died, and Norman now considers it a memorial to her, pausing to pay his respects whenever he passes that way.

6 ft.
1.8 m

6 LOCATION: *Vancouver—Museum of Anthropology,
University of British Columbia*
CARVER: *Bill Reid with Doug Cranmer*
CULTURAL STYLE: *Haida*

In 1957 Bill Reid was part of an expedition that went to Ninstints on remote Anthony Island (or Skungwaii), off the southern coast of the Queen Charlotte Islands, to salvage totem poles that were endangered by continuing decay.

One particularly fine house frontal pole of 12.8 m (42 feet) had broken off at the ears of the bottom crest figure and was lying face-down in the moist earth. "We turned it over," Bill Reid said, "expecting to find total decay, but to our delight the carving was intact except for some rot and a long crack." The fallen part, which was cut into two sections for transportation, and the base figure, are on display inside the Museum of Anthropology.

Bill Reid made a near copy of this pole, scaled down by a third, for the pole fronting the Haida mortuary house. "Since no trace of paint remained on the original," he said, "I followed tradition in painting certain areas of the carving in red and black." This complex and beautifully proportioned pole, finished in 1959, was the first of several that he would carve in the years ahead.

Three Watchmen are seated above Raven, who has arms and hands to signify his ability to transform into a human. A small face occupies Raven's up-turned tail, while his claws emerge through the ears of Grizzly Bear, below. Filling the space on Grizzly Bear's chest is a small Raven, with a wing on each side of its beak. Beneath is Frog, wide eyed, with a small Mosquito between its eyes. Below Frog, a Bear cub crouches, its hind legs protruding through the ears of another Grizzly Bear, at the base of the pole. A Frog protrudes from Grizzly Bear's mouth, and there is a Wolf cub between his front and hind legs.

The structural remains of the large six-beam house that the original of this pole once fronted can still be seen at Ninstints.

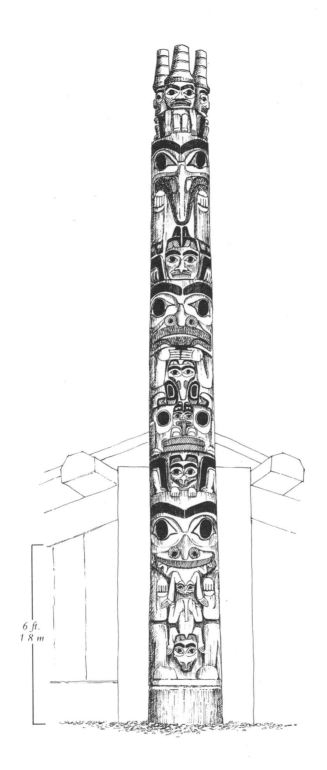

6 ft.
1 8 m

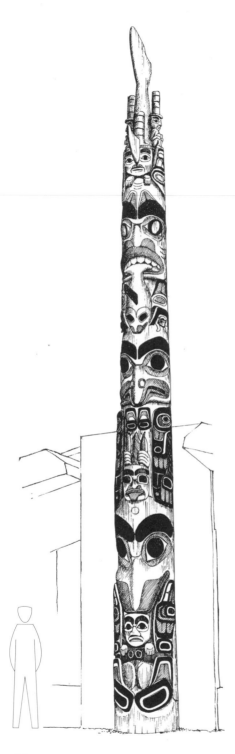

7 LOCATION: *Vancouver—Museum of Anthropology, University of British Columbia*
CARVER: *Bill Reid with Doug Cranmer*
CULTURAL STYLE: *Haida*

The focus of the museum's outdoor display is a large six-beam plank house, complete with house frontal pole—a replica of Haida dwellings of the late nineteenth century. When the sliding door at the side is open, visitors may go inside.

Fronting the dwelling, which is made entirely of red cedar, is a tall, complex pole, its design inspired by a pole that once fronted a house at the south end of Skidegate on the Queen Charlotte Islands. The asymmetrical tail flukes of Dogfish rise above three Watchmen, the central one of which is holding onto the domed head of Dogfish, whose dorsal fin forms the Watchman's nose. In its characteristic downturned mouth, Dogfish has a small Whale.

The next figure shows Frog protruding through the ears of Eagle, which is grasping Sculpin to its chest, holding in its claws the long spines that characterize sculpins.

At the base is Killer Whale, with a blowhole on its forehead; there is a man crouched above the upturned tail flukes, a combination that tells of the Nanasimget story.

8 LOCATION: *Vancouver— Museum of Anthropology, University of British Columbia*
CARVER: *Bill Reid with Doug Cranmer*
CULTURAL STYLE: *Haida*

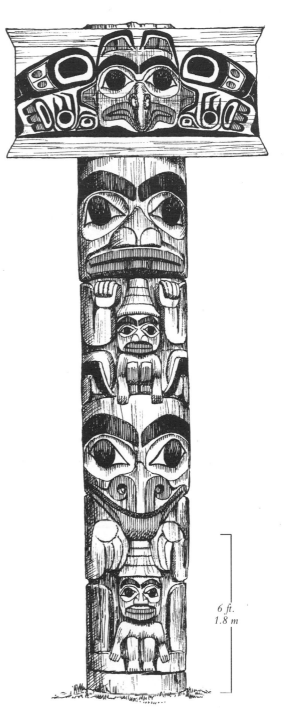

Impressed by the bold and powerful crest figures on poles collected from Skedans and Tanu on the Queen Charlotte Islands, Bill Reid carved a mortuary pole incorporating two of these figures to represent the Bear Mother story.

The upper figure is Bear Mother, the lower is Bear Chief; each parent holds a twin cub against its chest.

The frontal board at the top is Bill Reid's own creation and represents Eagle. In a classic split-design, the wings are placed at the top, with the legs and claws below, and the tail in the lower outer corners. However, with the knowledge now gained over years of association with Haida culture, he points out that Eagle was inappropriate, because this crest does not belong with the Bear Mother story.

As this mortuary pole was not intended to be functional, it has no cavity. The pole was on display at the Spokane World's Fair of 1974.

6 ft.
1.8 m

57

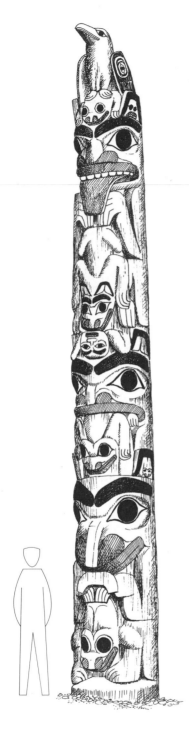

9 LOCATION: *Vancouver—Museum of Anthropology, University of British Columbia*
CARVER: *Jim Hart*
CULTURAL STYLE: *Haida*

Another example of classic Haida design is seen in the replica of a pole that once stood up against a house in Masset on the Queen Charlotte Islands, a village that bristled with some fifty poles during the late nineteenth century. Sometime before 1878 the house was abandoned, and in 1901 Dr. Charles F. Newcombe bought the pole for the provincial museum in Victoria, B.C. It stood in Beacon Hill Park for many years until a windstorm sent it crashing, breaking the pole beyond repair. The pieces were given to the Museum of Anthropology, and some of them are now displayed on the walls of the foyer.

The museum commissioned Jim Hart of Massett to replicate the pole, with Bill Reid acting as consultant. "I wanted to experience all aspects of carving the first pole for which I'd be responsible," Jim Hart said, "so I began by involving myself in choosing the cedar log." When some rot subsequently showed up, he adzed it out and carefully fitted in a section of good wood. For ten months he worked long and often lonely hours carving the pole.

At the top of the pole is Raven, then Frog, Sea Bear with its cub, an upside-down human, and Bear holding Frog in its mouth; small frogs peek through the ears of Grizzly Bear at the base, holding Sculpin.

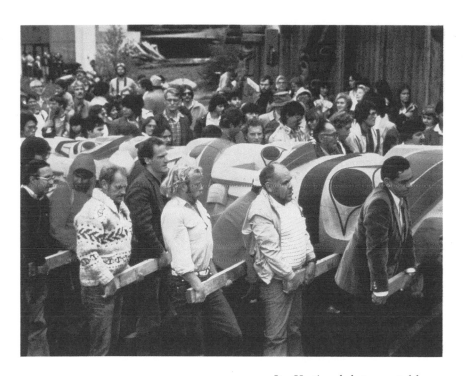

Jim Hart's pole being carried from the carving shed to the museum grounds, where it was raised, 1982. BILL MCLENNAN, MUSEUM OF ANTHROPOLOGY, UNIVERSITY OF BRITISH COLUMBIA

10 LOCATION: *Vancouver—Museum of Anthropology,*
University of British Columbia
CARVER: *Bill Reid with Doug Cranmer*
CULTURAL STYLE: *Haida*

A large double mortuary pole in an early photograph of Skidegate on the
Queen Charlotte Islands—once the home of Bill Reid's mother—provided
the carver with inspiration and reference for this one.

The wide frontal board depicts Dogfish in a split-design that combines
both two and three dimensions, one easily flowing into the other. The body
of Dogfish carries the characteristic sharp spine and dorsal fin at the top, the

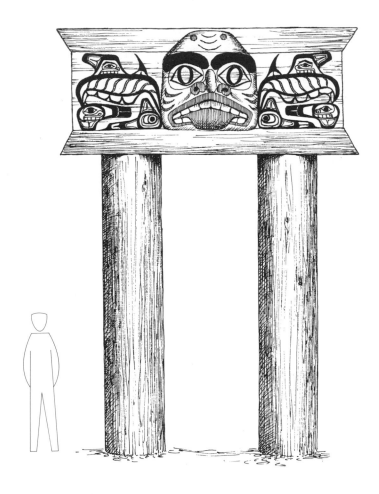

pectoral fins on either side of the mouth, and the asymmetrical tail in each lower corner.

Originally, this double mortuary pole had the required boxlike structure for the remains of the deceased. In 1974 it was dismantled and shipped to the Spokane World's Fair for display. On its return, however, the planks to form the box were missing, so it was reassembled without this feature.

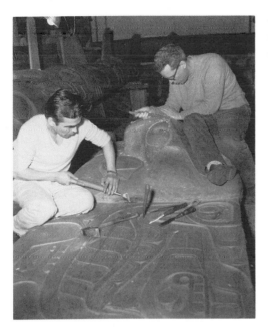

Doug Cranmer (left) and Bill Reid carving the frontal board of the double mortuary pole, around 1960. MUSEUM OF ANTHROPOLOGY, UNIVERSITY OF BRITISH COLUMBIA

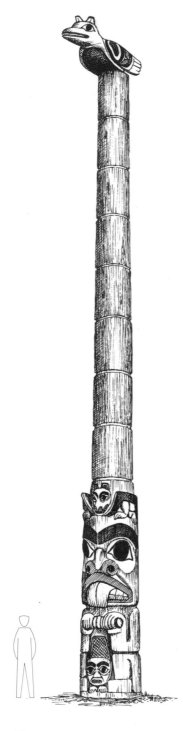

11 LOCATION: *Vancouver—*
Museum of Anthropology,
University of British Columbia
CARVER: *Bill Reid with Doug Cranmer*
CULTURAL STYLE: *Haida*

The last pole to complete the Museum of Anthropology's Haida village project was this memorial pole. There is a horizontal Raven atop eight skils, and at the base is a monumental Beaver with a Bear cub between its ears. The cub, in a split-design, interlocks with Beaver by having a front and hind leg in each of Beaver's large ears.

Unable to obtain a log of sufficient girth and length for the massive pole he had in mind, Bill Reid carved Beaver as a separate piece, hollowing out the centre and back. It forms a sheath around the base of the pole.

Beaver is textured all over by adzing, the only figure on which Bill Reid used this technique. The holes in the ringed section were created courtesy of pileated woodpeckers from the nearby woods.

12 LOCATION: *Vancouver— Museum of Anthropology, University of British Columbia*
CARVER: *Mungo Martin*
CULTURAL STYLE: *Kwakiutl (Kwakwaka'wakw)*

In addition to repairing some old poles for the Museum of Anthropology, master carver Mungo Martin created two new ones, completing both in 1951. They now stand on the grassy knoll directly behind the museum and are reflected in the glass walls of the Great Hall.

The pole on the west side was the subject of a short 16-mm film produced by the university. Entitled *Making a Totem Pole*, the film followed the process from raw log to finished pole and showed the carver's mastery of using the adze in a wide variety of techniques.

This pole carries crests that Mungo Martin, as a chief of Fort Rupert, was entitled to depict. At the top is the Cannibal Bird, or Huxwhukw, followed by Ancestral Chief holding Frog against him, then Bear holding a salmon; next, Killer Whale is depicted with its head downward. At the base is Beaver, chewing a stick, with the customary face on its tail joint.

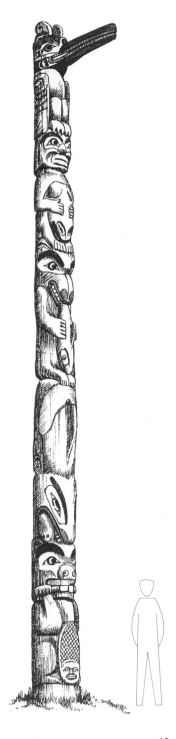

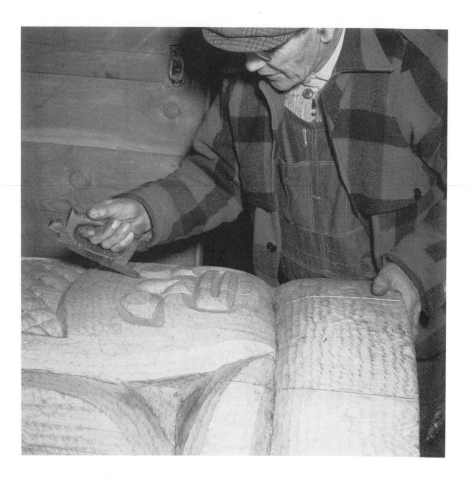

*Mungo Martin using a "D" adze to
sculpt a small face on the joint of
Beaver's tail on the pole shown on
the previous page.* MUSEUM OF
ANTHROPOLOGY, UNIVERSITY OF BRITISH
COLUMBIA

13 LOCATION: *Vancouver—*
Museum of Anthropology,
University of British Columbia
CARVER: *Mungo Martin*
CULTURAL STYLE: *Kwakiutl*
(Kwakwaka'wakw)

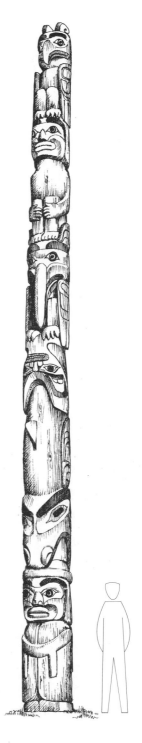

The other pole that Mungo Martin completed in 1951 for the Museum of Anthropology was to commemorate Chief Kalilix, the head of the Martin family line, who had obtained the privilege of being served first at potlatch feasts.

Although somewhere in his early sixties—his birth was not recorded—Mungo Martin worked diligently on the museum's totem pole project, without assistants. He would sing gently to himself or sometimes out loud, usually a song associated with the figure he was carving.

The crest figures on this pole show Thunderbird at the top, with its wings by its sides rather than outspread. Next is Ancestral Chief, followed by Raven perched over Whale; notice the upside-down face in Whale's inverted tail fluke, the protruding dorsal fin, and the head facing downward.

At the base stands another chief, possibly Chief Kalilix himself, with a blanket around his shoulders; the ceremonial head and neck rings he wears symbolize his rank.

Although much of the original paint has weathered away over the decades, this remains a fine pole, towering against a backdrop of coastal mountains.

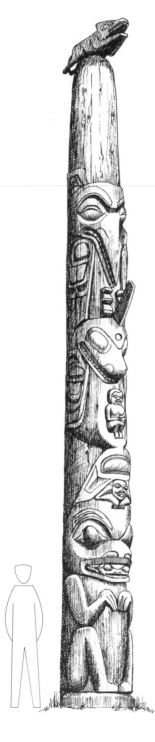

14 LOCATION: *Vancouver—Museum of Anthropology, University of British Columbia*
CARVER: *Walter Harris and Richard Harris, with Doreen Jensen, Rodney Harris, Vernon Stephens*
CULTURAL STYLE: *Gitksan*

The pole at the north end of the museum's outdoor exhibit had its beginning as a series of half-hour made-for-TV films on traditional skills in various cultures. Sunrise Films of Toronto commissioned Walter Harris, a well-known 'Ksan carving instructor, to create a totem pole with his sixteen-year-old son, Richard. (Traditionally, a carver would train his nephew.) To meet the deadline, the carver's sister, Doreen Jensen, herself an accomplished carver, his older son, Rodney, and others also worked on the pole. The Royal Bank of Canada, which funded the work, donated the completed pole to the Museum of Anthropology.

For the pole raising on 24 August 1980, a large contingent of Gitksan people from the Hazelton and Kispiox area of northern British Columbia flew in to create a lavish ceremony, rich in tradition. The pole was raised in three stages, marked by songs, speeches and dancing with masks. Hundreds of spectators helped to haul on the ropes, raising the pole to its upright position against a cloudless sky.

A pebble ceremony followed the Wolf dance. Those invited to the pole raising were asked to bring a pebble to throw into the excavated hole in which the pole was set. This gesture was symbolic of filling the hole with large rocks, as was done in early times, to buttress the base of the towering

monument. All those attending then feasted on a salmon dinner served from the nearby Haida house.

The film crew flew in and documented the final phase of their project—the pole raising—but that night thieves broke into their truck and stole not only the equipment but the reels of film. With improvisation, the film was completed, but it lacked complete coverage of the ceremonial event.

The top of this unpainted pole carries the crest of Running Wolf, followed by Mosquito. Below is Killer Whale, with a dorsal fin and a blowhole on its forehead, and a pectoral fin on each side. Killer Whale is abducting a woman, crouched on its chest, whose pursuing husband is looking out from between the sea mammal's tail flukes: the Nanasimget story. At the base is Frog, with a small frog in its mouth.

The elaborately carved folding doors at the entrance to the Museum of Anthropology are also the work of 'Ksan carvers, who worked under the guidance of Walter Harris. The rich array of figures illustrates a legend that tells of the origin of the first Gitksan people on the Skeena River.

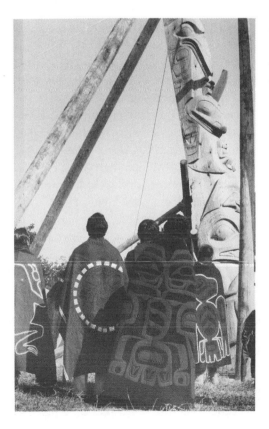

Participants in ceremonial attire at the raising of the 'Ksan pole at the Museum of Anthropology, 1980.
HILARY STEWART

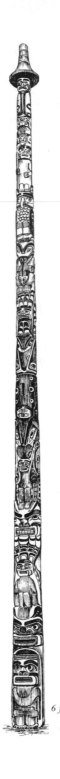

6 ft./1.8 m

15 LOCATION: *Vancouver—Maritime Museum, north foot of Cypress St.*
CARVER: *Mungo Martin with Henry Hunt, David Martin*
CULTURAL STYLE: *Kwakiutl (Kwakwaka'wakw)*

To mark the occasion of British Columbia's centenary in 1958, the province presented H.M. Queen Elizabeth with a superb totem pole towering nearly 100 feet (30.5 m) into the air, one foot for each year since the mainland colony of British Columbia was established. After the First Cut Ceremony, when Lt.-Gov. Frank M. Ross made the first cut into the log, it took the carvers almost seven months to complete the pole. It now stands majestically in Windsor Great Park, in England. The pole near the Maritime Museum is an exact duplicate of the one given to the queen.

The log for the original pole was an exceptionally fine 600-year-old red cedar from the Queen Charlotte Islands. The chief carver was Mungo Martin; his carving assistants were his son David Martin and his stepgrandson-in-law Henry Hunt, who later became a renowned carver himself.

Each of the ten figures is the crest of one of the many Kwakiutl (Kwakwaka'wakw) clans, and each represents the mythical ancestor of that clan. Although it is difficult to see the top figures because of the height, the pole depicts the following: at the top, a chief wearing a high-crowned hat and robe, followed by Beaver, Old Man, Thunderbird and Sea Otter holding a seal. Next is Raven (tail uppermost), his downward head between the tail flukes of Whale—

notice the face for the blowhole. Below, a woman is flanked by the body of Sisiutl, on whose central head she crouches. Next is Halibut (tail uppermost), having a human within its body; at the base is Cedar Man, wearing head and neck rings.

The enormous log for the centennial pole being prepared for carving by Mungo Martin, Henry Hunt and Tony Hunt. GOVERNMENT OF BRITISH COLUMBIA

Backed by the panorama of rugged mountains, the glass-towered city and the ships plying the waters of English Bay, this cedar monument stands as a reminder of the province's early inhabitants.

The entrance to the Vancouver Museum is marked by two welcome poles: on the left a man, on the right a woman. These dramatic figures were originally commissioned to flank the entrance to the British Columbia Pavilion at Expo 86 in Vancouver.

Joe David, a renowned artist and carver, has a studio on Echachis, a small island not far from his ancestral village of Tla-o-qui-aht, west of Tofino on Vancouver Island. "To make the welcome poles, I salvaged clear-grain cedar logs from nearby beaches—loggers' litter," he said, referring with some resentment to the huge quantity of sizable tree trunks that end up on the province's beaches.

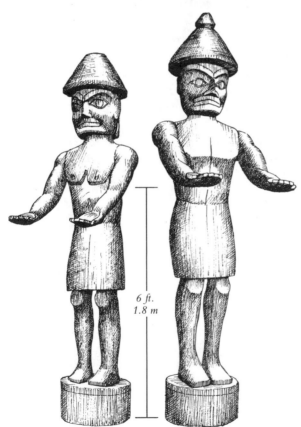

6 ft.
1.8 m

The welcome figures, carved in the tradition of the Tla-o-qui-aht, have arms that swivel at the shoulder. When positioned at the beach to welcome guests to a special event at the village, the arms of the welcome poles were raised; when not in use, the arms were lowered to facilitate storage.

The man (right) wears the traditional knobbed hat of a high-ranking person, perhaps a whaling chief, while the woman wears the domed hat common among her people. Both wear skirts that in reality would have been made of inner cedar bark, softly shredded and finely woven.

18 LOCATION: *Vancouver—*
VanDusen Gardens, 37th Ave. and Oak St.
CARVER: *Art Sterrit*
CULTURAL STYLE: *Gitksan*

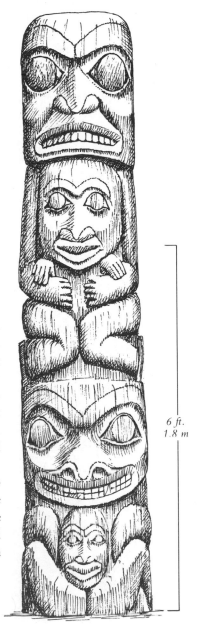

6 ft.
1.8 m

The two poles that flank the entrance to VanDusen Gardens were completed on site.

The first pole, raised on 11 June 1976, was a gift of the Leon and Thea Koerner Foundation to mark the opening of the gardens. Its carved figures tell the story of the Black Bear crest of the Killer Whale clan.

Long ago, a man went into the mountains to hunt mountain goats and was captured by Black Bear, who carried him back to his den. Instead of killing the hunter, Black Bear taught him many things, including how to catch salmon—at which men have excelled ever since.

Two years later the man was allowed to return home, but by then he resembled a black bear and the villagers greatly feared him. One kindly man, however, recognizing his plight, took him in, and rubbed medicine on the bear-man until he resumed his human form. As a human, the man took Black Bear for a crest, and from then on, whenever he was in trouble, he received help from his Bear friends.

At the top of the pole is the man who went to hunt mountain goats, with the kindly man who helped him. Beneath is the hunter in the form of Bear; the man's head between the paws represents the human side of the bear-man.

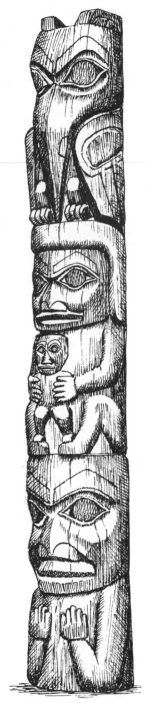

6 ft.
1.8 m

19 LOCATION: *Vancouver—
VanDusen Gardens, 37th Ave. and Oak St.*
CARVER: *Earl Muldoe with Brian Muldoe*
CULTURAL STYLE: *Gitksan*

The second pole at the entrance to Van-Dusen Gardens was a gift of Walter and Marianne Koerner, commissioned to celebrate Vancouver's 1986 centennial.

The ancient legend depicted here tells of a party of hunters and their wives who were pursued by strange beings from a village in the valley. Climbing a mountain, the hunters caused avalanches which killed all their pursuers except one. He was Baboudina, Chief of the Mosquitoes, who had a long proboscis of pure crystal. He in turned killed all the hunting party, except a woman who ran to a lake and climbed to the tip of an overhanging tree.

Seeing the woman's reflection in the still water, Baboudina repeatedly jumped in to kill her, but without success. When he finally gave up, he froze to death. The woman cut out his heart and swung it over her dead companions, who returned to life. Baboudina's body was burned on a large fire, and as his ashes rose, they became tiny mosquitoes—those pesky insects that are still with us today.

Looking down from the top of the pole is Baboudina, Chief of the Mosquitoes; beneath him is the mother holding her child, with her hunter husband below.

The raising of this pole, on 11 May 1986, included a performance by the 'Ksan Dancers, in traditional regalia and masks.

20 LOCATION: *Vancouver— Vancouver Community College, 100 West 49th Ave.*
CARVER: *Don Yeomans*
CULTURAL STYLE: *Haida*

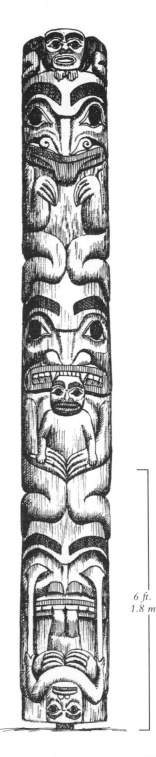

6 ft.
1.8 m

In the late 1970s, Don Yeomans, a nineteen-year-old student enrolled in Fine Arts at Langara College (now Vancouver Community College), was one of a large number of First Nations people continuing their education there.

The head of the Fine Arts department befriended the young man who loved to carve and spent a lot of time among the wood chips. When the college found itself with a limited amount of surplus funding, Don Yeomans was asked to carve a totem pole for the entrance to the college.

A cedar log was brought to the sculptors' open-air enclosure behind the college, where he spent six long months on the project. Late one night he stopped by to check on the pole. Instead of walking around it, he vaulted over the top, hitting the handle of a knife that tipped up and pierced his upper thigh. "I pulled out the knife and went to the college building to phone for an ambulance, but the cleaning lady refused to let me in," he said. "When I reached into my pants pocket for a dime, blood splashed out; then she saw I was serious and she quickly changed her mind and called an ambulance."

Although Don Yeomans had already established a reputation in his native art, this was only the second pole he had worked on. He has a strong sense of satire and very much a twentieth-century mind, and his

work—even today—often incorporates whimsy and inventive imagery. His explanation of the pole he created for the college, perhaps an expression of student difficulties, goes thus:

"Top figure: The Bear represents the cruel world or the bogey man; between its ears, a little man with an open mouth symbolizes the people who tell you to stay on the beaten path and forget your crazy dreams.

"Centre figure: Here we have another Bear, without ears, devouring a man with a flute in his hand. This says, 'It doesn't matter how good you are; if no one hears, you are as good as dead.' I do not believe this applies to specific talent such as art or music; the only real talent people have is to express what is really inside themselves.

"Bottom figure: In early times a figure carved upside-down was a way of degrading a specific individual. Here we have a man being degraded and eaten by a large man. I call this figure 'man with ulcers,' because both figures are the same person. The large image secretly weeps as he eats himself up inside over dreams not pursued."

Don Yeomans has become a successful artist, carver and jeweller in Vancouver.

21 LOCATION: *Vancouver—*
Plaza of Nations, 750 Pacific Blvd.
CARVER: *Earl Muldoe with assistants*
CULTURAL STYLE: *Gitksan*

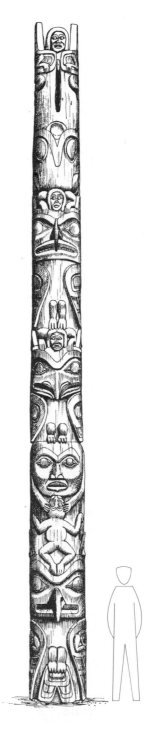

Clustered in an attractive setting, three totem poles look out over the Plaza of Nations—a legacy of the Expo 86 world's fair in the heart of the city.

Originally these poles, together with two smaller ones, were commissioned by Highfield Development to grace the entrance to Airport Executive Park in Richmond, B.C. Seventeen years later they were donated to the Vancouver Museum. The two small poles went to the Vancouver Trade and Convention Centre, and the three tall ones to the Plaza of Nations—all on long-term loan.

Two of the poles in the plaza are by Earl Muldoe, a veteran carver of 'Ksan. "I personally selected the logs I wanted to use," he said. "These are old-growth cedars, with scarcely a knot on their entire length. They came from the Kitimat Valley."

The Nanasimget story of Killer Whale abducting the man's wife is shown at the top of this pole: here the wife is riding Killer Whale's tail. Beneath the crouched figure of the husband is Hawk, with its claws on a small human who fills the space between the ears of Owl, below.

Next is a legendary being who has his head on his chest, not on his neck; hence, the arms are shown coming from the sides of the man's head. This is a crest of the carver. The being holds Frog, and at the base is Eagle.

75

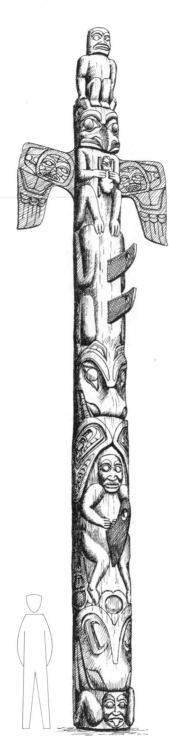

22 LOCATION: *Vancouver—Plaza of Nations, 750 Pacific Blvd.*
CARVER: *Walter Harris with assistants*
CULTURAL STYLE: *Gitksan*

One of the poles at the Plaza of Nations is by another veteran 'Ksan carver, Walter Harris. At the top of the pole, a human sits on the head of Eagle-Person, a crest said to have been taken by a family on its ancient migration from Hagwilget country to Gitanyow. In a lake they saw a large human being with an eaglelike head, wearing a headdress of grizzly bear claws that had water lily leaves around it: all these became crests.

The carving on the pole depicts this supernatural being with an eaglelike head, human arms holding Frog, wings carved with human heads, and legs that end in clawed feet. The outspread wings are an unusual feature for a Gitksan pole.

Beneath is Grizzly Bear of the Sea; the two dorsal fins signify its marine affiliation. Variations in Sea Bear crests for this area also have three fins, or one fin with a face carved on it.

The Gitksan have a story similar to the Haida's Nanasimget story, in which Killer Whale abducts a man's wife. The lower section of the pole portrays this: the wife is clinging to Killer Whale's dorsal fin; its pectoral fins are at the sides, and the tail fluke is turned over its back. The husband is at the base.

76

23 LOCATION: *Vancouver—Plaza of Nations, 750 Pacific Blvd.*
CARVER: *Earl Muldoe with assistants*
CULTURAL STYLE: *Gitksan*

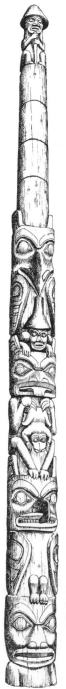

On the second pole by Earl Muldoe at the Plaza of Nations, a lone Watchman sits atop four rings, called "chief's rings" by the carver. "Each ring," he said, "had to be earned by the owner through some special undertaking or major commitment." Beneath the rings, Raven appears in his traditional duality—as bird and as human, with the latter crouched between the ears of Bear, who holds Frog before him. These are two separate crests carved in combination.

Bear's feet rest on the head of the supernatural Mountain Hawk. "He's always shown with both a recurved beak and a mouth with many teeth. It is a crest of my family," the carver said.

Also belonging to the Muldoe family is a very old crest known as Halfway Out, at the base of the pole. The origin of this goes back to the expedition of the warrior Naeqt against the Kitimat people. In the early 1920s, his great-grandson gave an account of it to anthropologist Marius Barbeau: "Naeqt started on the warpath against Kitimat. On his way down, he came upon a camp, wherein a man sat by himself. He took his knife and cut the man through the middle almost in two halves, so strong was he. The wounded man ran into the lake and stood in the water up to his ribs." The name and the crest Halfway Out were derived from this incident and brought back by the warrior.

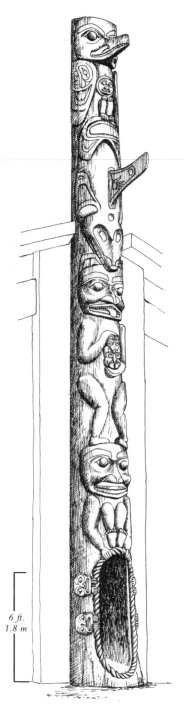

6 ft.
1.8 m

24 LOCATION: *Vancouver—*
Native Education Centre, 285 East 5th Ave.
CARVER: *Norman Tait with Robert Tait,*
Isaac Tait, Wayne Young,
Harry "Hammy" Martin
CULTURAL STYLE: *Nisga'a*

This unpainted portal pole adds richness to the façade of the Native Education Centre.

The carved figures tell the story of Man, who wandered the empty earth. Lonely, he went to the forest and asked the Spirit of the Forest, "Why am I alone? Isn't there anyone in the forest to help me?" The spirit said, "I will give you Black Bear. If you can live in harmony with him, I will send you more of my children." He did, and Man learned to live in peace with the forest people.

Paddling on the sea, Man asked the Spirit of the Sea, "Why am I alone on the water?" The spirit said, "I will send you Blackfish; if you learn to live with him, I will send you more of my children." He did, and Man learned to live with the people of the sea.

Noticing the emptiness of the sky one day, Man said to the Spirit of the Sky, "Send me one of your children, for I have twice shown that I can live with other than myself." The Spirit of the Sky sent him Raven, and Man again proved he could live in harmony with other creatures.

That humans can live together with the children of the forest, the water and the sky is evidenced by the many animals, fish and birds that still abound in these habitats. If we can learn to live in peace with such diverse creatures, we can surely live in peace with each other.

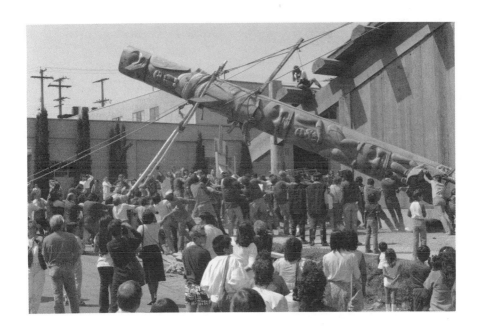

The Native Education Centre, based on the traditional northern plank house, contains some of the largest hand-hewn planks and beams in Canada. The landscaping includes plants traditionally used by native people. Each is labelled with its common English and scientific names, as well as its name in a Coast Salish dialect.

Norman Tait's pole being raised at the Native Education Centre.
HILARY STEWART

Norman Tait's carving assistants were all family: brother, son, nephew and cousin, and they are represented by the four faces around the entrance. Each man carved his own "signature piece"; though similar, all are different. Norman Tait's signature piece is the delightful little Wolf cub.

At the top of the pole is Raven, with moon on its chest, followed by Killer Whale (or Blackfish), Black Bear cradling a Wolf cub, and a crouching human holding the rope that encircles the doorway cut through the pole.

The pole is named Wil Sayt Bakwhlgat, meaning "the place where the people gather." On 28 June 1985, the finished pole was raised in a ceremony rich with regalia, speeches, dancing, drumming, singing, gift-giving and food for all. Vickie Jensen made a complete documentation, in writing and photographs, of the making of the pole and its carvers. It was published as a book in 1992, entitled *Where the People Gather: Carving a Totem Pole.*

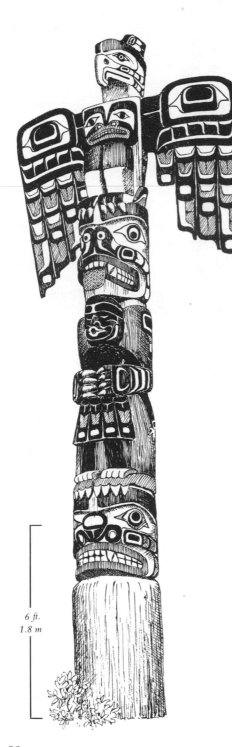

6 ft.
1.8 m

As work on this pole progressed, a lighthearted friendship sprang up between Richard Hunt, the chief carver, and Jane Wilson of the CBC's public relations department. Richard Hunt had originally intended to depict Bookwus, the Wild Man of the Woods. When he told Jane Wilson that he had decided instead to carve the female counterpart, Dzunukwa, the Wild Woman of the Woods, and that it would represent her, she thought he was joking again.

At the pole-raising ceremony in front of the CBC building, Richard Hunt turned to Jane Wilson and said, "There you go!" Interestingly, this representation of Dzunukwa (who is usually depicted without clothes) shows her wearing a skirt, perhaps as a courtesy to Jane Wilson.

The pole is topped by the mythical Kolus, a powerful giant supernatural bird. Beneath Kolus, Bear holds Dzunukwa to his chest, and below them is the head of Sisiutl, the supernatural double-headed sea serpent.

POLES AT BROCKTON POINT IN STANLEY PARK

VANCOUVER

In 1889, shortly before the great fire that all but wiped out the fledgling city of Vancouver, the Art, Historical and Scientific Association was born. An active organization, it put together the city's first museum, which included "Indian relics and handicrafts," and later decided to set up an "Indian village" in Stanley Park.

One suggestion for accomplishing this—reprehensible as it now seems—was that "some old deserted village should be purchased, transported to the site and re-erected." With that idea ruled out as impractical, the alternative was to buy the totem poles and build the houses.

Several poles were purchased and set up, but the village never materialized. To celebrate the city's golden jubilee in 1936, three more poles were added—a gift of the jubilee committee and the Department of Indian Affairs.

Over the years the totem pole collection in Stanley Park has changed considerably. New ones have been added, and deteriorating ones have been replaced or replicated.

Ignore the metal plaque with the obscure explanations of the various figures on

A few of the poles at Brockton Point in Stanley Park, Vancouver.
HILARY STEWART

the poles. But do take a look at the large boulder nearby, which is covered with petroglyphs—designs carved into the rock face (not pictographs as stated, which are paintings on rock).

In a dramatic grouping, backed by cedars and rugged mountains, floodlit at night, the crest figures and supernatural creatures of Stanley Park's totem poles contrast strongly with the modern glass-and-steel city that holds their gaze.

81

26/27 LOCATION: *Vancouver—Stanley Park*
CARVER: *Tony Hunt*
CULTURAL STYLE: *Kwakiutl (Kwakwaka'wakw)*

Two house poles, almost identical, are located in Stanley Park. Originally carved by Charlie James at the turn of the century, they were owned by Chief Tsa-wee-nok of Kingcome Inlet, their function being to support one of the crossbeams inside a large house. Another pair of house posts would have held a second beam, but it seems likely that the house was never built.

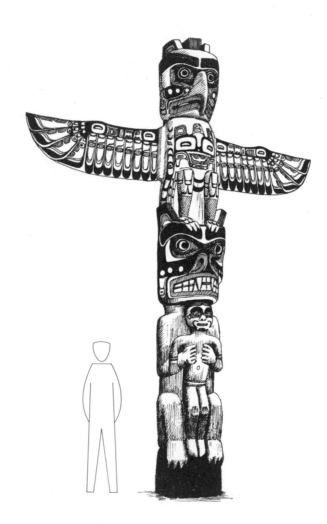

In 1914 the two posts were rented out to form part of a movie set built at Blunden Harbour for a full-length feature film about native people on the Northwest Coast. Entitled *In the Land of the Head-Hunters*, the movie was written and filmed by Edward S. Curtis, a photographer from Seattle, Washington, who spent a lifetime extensively documenting the native people of the Northwest Coast, largely through his camera, recreating the old ways and appearances.

The Art, Historical and Scientific Association of Vancouver, continuing its program of acquiring totem poles for Stanley Park, bought the pair of house posts in 1927. Many years later, when one of them became badly decayed, it

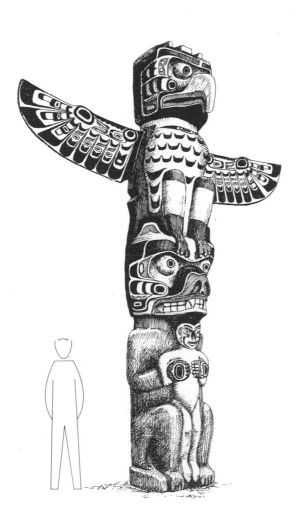

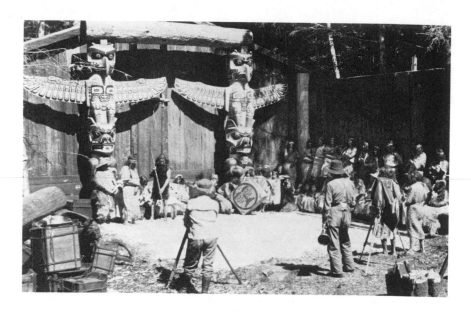

The original house posts formed part of the set for Edward S. Curtis's 1914 feature film. EDMUND SCHWINKE, UNIVERSITY OF WASHINGTON PRESS

was replicated in Fibreglas (right-hand pole) and the original was stored at the Vancouver Museum.

Many years of repainting had considerably changed the painted designs on the posts, so in 1988 when Tony Hunt carved a replica (left-hand pole) to replace the second post, he painted it with Charlie James's original designs, using an early photograph for reference.

Both house posts depict Thunderbird at the top, with Grizzly Bear holding a human at the base.

28 LOCATION: *Vancouver—Stanley Park*
CARVER: *Norman Tait with Robert Tait, Isaac Tait*
CULTURAL STYLE: *Nisga'a*

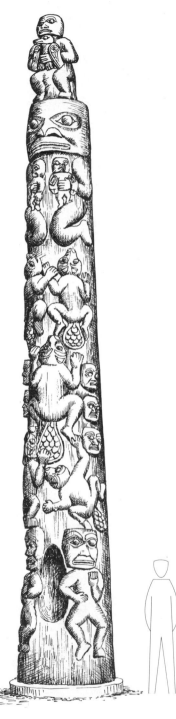

The legend of how the Tait family came to take Beaver for its crest is illustrated on this unusual pole.

Long ago, five brothers (the five faces on the pole) of the Eagle people went hunting beaver. The youngest saw two beavers and followed them to their lodge. Peering down through the lodge's smoke hole (the cavity in the pole), he was amazed to see them take off their skins and become men (the two figures beside the smoke hole).

"Our Beaver family is being slaughtered," they told their chief. "We must stop the killing." So they sang a sad song that caused the lake to freeze over; then they sang a happy song because they were now safe. Full of remorse, the Eagle people took Beaver for a crest and never again hunted them.

At the top, a man of the Eagle people (Tait's family) is holding Raven, who shares the sky with him. The large figure beneath has Frog in his right hand and Eagle in his left. They represent Norman Tait's son Isaac and his brother Robert, who worked on the pole.

This large pole was raised by hand on 30 October 1987. Part of the ceremony included Isaac Tait performing the Squirrel dance along the horizontal pole, and Norman Tait breathing life into the cedar log "to make it come alive."

85

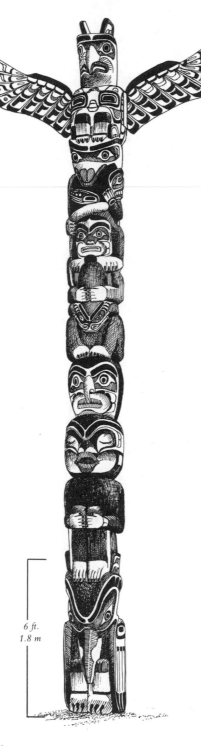

6 ft.
1.8 m

29 LOCATION: *Vancouver— Stanley Park*
CARVER: *Ellen Neel*
CULTURAL STYLE: *Kwakiutl (Kwakwaka'wakw)*

Traditionally, woodworking was, and with a few exceptions still is, the task of men. Ellen Neel was one of the exceptions.

In 1955 Woodward's department store commissioned her to carve five totem poles for a mall in Edmonton, Alberta. The poles took shape in a shed near her Totem Arts Studios, which she had opened in 1946 and where she sold her carvings in a thriving business. The studio was actually a World War II bunker at Ferguson Point in Stanley Park.

Thirty years later, three of the poles were returned to the coast, one as a gift to the University of British Columbia's Museum of Anthropology. The carver had died in 1966, but her son Robert renovated the pole, which is now in Stanley Park. The pole has truly come home.

The pole is topped by Eagle. Beneath, Sea Bear has his feet on the shoulders of a woman (holding a frog), who stands on the head of Bookwus, the Wild Man of the Woods. Below, Dzunukwa crouches between the ears of Raven.

30 LOCATION: *Vancouver—Stanley Park*
CARVER: *Art Thompson and Tim Paul*
CULTURAL STYLE: *Nuu-chah-nulth*

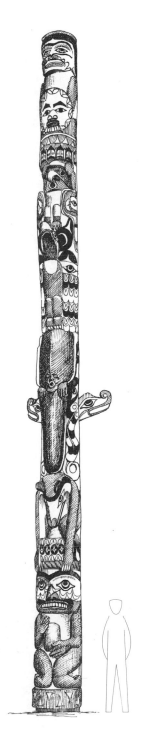

Carvers Art Thompson and Tim Paul said, "We wanted to carve a pole that would speak of our people's legends and traditions, yet be our own contemporary statement." The result is this unusual pole, added to the Stanley Park collection in 1988.

At the top is Sky Chief, holding Moon; below Sky Chief's skirt is Kingfisher, its clawed feet touching the symmetrical tail flukes of Humpback Whale. Riding on Humpback Whale's back is Thunderbird—feathered wings at each side—being dragged underwater by Whale. Often a whale's blowhole is depicted as a face, and here it is imaginatively shown with a pair of hands also.

Flanking each side of Humpback Whale's long snout is Lightning Snake, a mythical creature with a wolflike head, who assists Thunderbird in catching whales, on which it feeds. The Wolf below is carved in the style of Jimmy John, as a way of acknowledging this well-known Nuu-chah-nulth carver of the past.

The base depicts Man of Knowledge holding an object which Tim Paul called a *tupati*; it was used in certain marriage privileges such as games or tests of skill or courage.

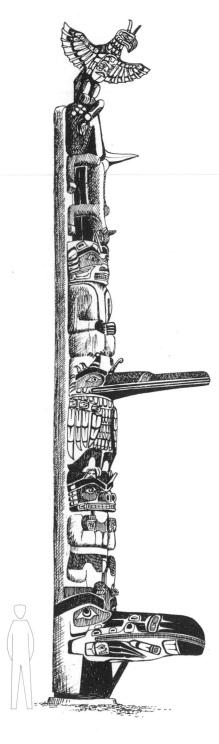

31 LOCATION: *Vancouver—Stanley Park*
CARVER: *Doug Cranmer*
CULTURAL STYLE: *Kwakiutl (Kwakwaka'wakw)*

One of the first of the elaborate poles to be raised in Alert Bay was a memorial to Chief Wa'kas. It also served as a house portal pole, with entry through Raven's open mouth at the base. The memorial's design, which represents the Wa'kas family history in a long and complex legend, was developed from the speaker's staff (or talking stick) belonging to the chief. The pole was created by a carver named Yuxwayu, who received 350 blankets (then valued at $515) in payment for his work.

The pole was raised prior to the mid-1890s, and a few years later an enormous beak was added to the open mouth of Raven. The upper beak was actually the prow of a canoe; the lower beak was carved to fit. Projecting an estimated 2.7 m (9 feet), the beak opened to create an impressive ceremonial entrance into the house, the lower half dropping down to form a ramp. The beak is shown here in its normal closed position. A door for daily use was installed to the left of the pole. By September 1900, outspread wings, a

tail and legs had been painted on the house front to complete the monumental Raven. The well-known British Columbia artist Emily Carr made a painting of this pole in 1903 when she visited Alert Bay.

In 1928 the Art, Historical and Scientific Association of Vancouver bought the pole for $700—raised by public subscription—and shipped it to Stanley Park. Some sixty years later, the deteriorating pole was sent to Ottawa for conservation. Over the years the old pole had been repainted several times, drastically altering the original design. Through consulting early photographs, the pole was restored as nearly as possible to its original appearance. It is now part of the Canadian Museum of Civilization's Northwest Coast exhibit, where it again fronts a Kwakiutl (Kwakwa̱ka'wakw) plank house.

In return, Stanley Park received a replica of the Wa'kas pole carved by Doug Cranmer, who also supervised the restoration of the old pole. On 31 May 1987 a large gathering assembled at the base of the new

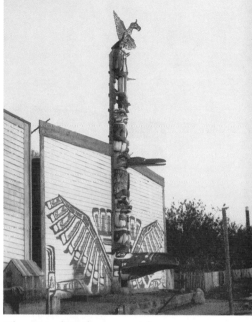

The original Wa'kas memorial pole in Alert Bay in the 1920s; notice the upside-down canoe prow used for Raven's upper beak.
VANCOUVER PUBLIC LIBRARY/4196

Wa'kas pole, bright with fresh paint, for the dedication ceremony. Among the special guests resplendent in their crested button blankets were many native people from Alert Bay, including a number of descendants and relatives of Chief Wa'kas. Speeches, dancing, singing and drumming were followed by a feast for everyone who had witnessed the event.

A dramatic Thunderbird holding Whale in its claws crowns the top of the pole; below is Wolf (head down), one of the ancestors of Chief Wa'kas. Beneath is Wise One, a man of myth, followed by the Cannibal Bird, Huxwhukw. Next is Bear—notice the faces carved on its paws. At the base is Raven.

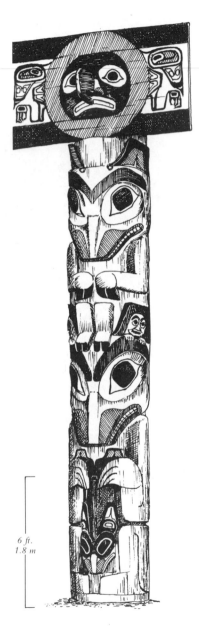

6 ft.
1.8 m

The only Haida pole among the ones in Stanley Park is this mortuary pole, which is a replica. The original pole was raised in Skidegate on the Queen Charlotte Islands, prior to 1878, to honour Chief Skedans. At the back were carved twenty-three short horizontal lines to record the number of blankets given away at the potlatch: each line represented twenty blankets.

In 1936 the city of Vancouver celebrated its golden jubilee, and in recognition of the city's native people, the pole was bought from Henry Moody, the then Chief Skedans, for $100.

As the old pole deteriorated over the years, it was patched with plaster and cement, and was badly repainted in nontraditional colours. In 1964 the Vancouver Parks Board commissioned Bill Reid to carve a replica. Since there were few native carvers around at that time, he took on a non-native woodworker as his assistant. They finished the pole in a month, with Reid receiving $1,500 and his assistant $1,000.

The frontal board at the top depicts Moon, with the face of Thunderbird, whose wings, legs and claws are painted on each side in a split-design. Beneath is Mountain Goat, identified by cloven hooves and two carved horns (now fallen off and not illustrated) on top of its head. At the base, Grizzly Bear holds what is probably Seal.

POLES IN THE "ROUTE OF THE TOTEMS" SERIES

BRITISH COLUMBIA

In 1966 British Columbia celebrated the centennial of the joining of the two colonies of Vancouver Island and the mainland to form the colony of British Columbia. One of the more imaginative ideas of the centennial committee was to involve the province's First Nations in a large-scale carving project entitled "Route of the Totems."

Eleven carvers (with assistants) were commissioned to create nineteen totem poles to be placed along tourist routes from Victoria to Prince Rupert. The poles were to be about 3.5 m (12 feet) in height, and 1 m (3½ feet) in diameter at the base. To bring unity to the variety of carving styles, the dominant figure on each pole was to be an upright Bear, with a secondary figure appropriate for the area for which it was carved.

To encourage high quality work, the provincial government held a contest, and anthropologist Wilson Duff of the provincial museum helped to judge the three best poles in the series.

A selection of the "Route of the Totems" poles follows, according to their geographic location.

NOTE: The Kwakiutl Arts and Crafts Organization was established in 1965 by James Sewid of Alert Bay to encourage Kwakiutl (Kwakwaka'wakw) artists and carvers in their work. The organization is credited with several "Route of the Totems" carvings, not all of which are included in this book.

33 LOCATION: *West Vancouver—Centennial Park in Horseshoe Bay, "Route of the Totems"*
CARVER: *Tony Hunt*
CULTURAL STYLE: *Haida*

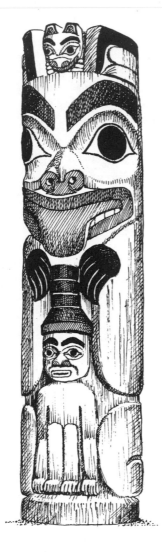

6 ft.
1.8 m

Situated between sheer mountains on one side and the community of Horseshoe Bay on the other is a major B.C. Ferry terminal, with a "Route of the Totems" pole in Centennial Park on the waterfront nearby.

Tony Hunt said that as a youngster in the mid-1950s, he had worked with master carver Mungo Martin in the replication of a Haida pole in Victoria—there being few Haida carvers in those early years. Tony Hunt, himself a Kwakiutl (Kwakwa̱k-a̱'wakw), said, "I chose to design the Horseshoe Bay pole in the Haida style, in part to confirm my ability to work in the northern style." He also drew from the heritage of his great-great-grandmother, a Tlingit, to incorporate the bold Grizzly Bear, a Bear cub crouched between its ears, with the cub's legs protruding through Grizzly's ears. At the base, he added a high-ranking person wearing a ringed hat.

Also in Horseshoe Bay, on the marina side of the bay, is the Boathouse Restaurant, with two beautiful panels carved by Norman Tait in 1981, beside the main doors. The figures represent the four main crests of his people, the Nisga'a: these are Raven, Wolf, Eagle and Killer Whale.

34 LOCATION: *Sechelt—community hall, Sechelt Indian Reserve*
CARVER: *Jamie Jeffries with Dwayne Martin, Howard Paul, Martin Baptiste*
CULTURAL STYLE: *Personal with Kwakiutl (Kwakwaka'wakw) overtones*

The Sechelt Band of the Coast Salish people has an interesting assemblage of totem poles fronting its modern community hall. Although the Coast Salish were not traditionally totem pole carvers, the Sechelt people used this medium to express and document twenty years of frustration and struggle trying to gain self-government. Eventually the Sechelt Band became the first in Canada to achieve municipal status, with the band council making its own decisions and policies.

To celebrate and document this important milestone, two poles were carved—one in recognition of the federal government's decision, the other in recognition of the provincial government's co-operation. Illustrated here is the latter pole, which was unveiled on 24 June 1988. The inscription at the base of the pole reads: "In celebration of practicality, good will and reasonableness, showing what can be achieved when governments work together."

Eagle looks down from the top of this pole and has a Wild Man of the Woods mask at his feet; below is Bear, clasping a salmon. The lower half of the pole depicts Whale, head down, with a Sun design on its turned-back tail flukes and a face carved on its dorsal fin.

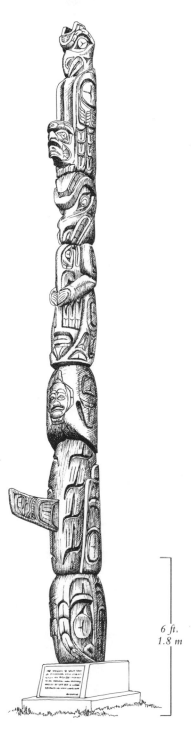

6 ft.
1.8 m

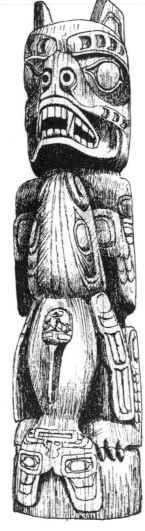

6 ft.
1.8 m

35 LOCATION: *Swartz Bay—
Swartz Bay Ferry Terminal,
"Route of the Totems"*
CARVER: *Henry Hunt*
CULTURAL STYLE: *Kwakiutl
(Kwakwaka'wakw)*

The ferry from Tsawwassen on the main-
land to Victoria on Vancouver Island ar-
rives at the Swartz Bay Ferry Terminal,
which also serves the Gulf Islands. In front
of the terminal's coffee shop is a fine, un-
painted carving of Grizzly Bear and Whale.

This is one of three poles in the "Route
of the Totems" series created by Mungo
Martin's stepgrandson-in-law, Henry Hunt.
At Mungo Martin's death in 1962, Henry
Hunt was appointed chief carver at the
Royal British Columbia Museum in Victo-
ria, where he remained for fourteen years.
His skill in carving monumental and cere-
monial pieces was, at the time, without
equal, and his output prodigious.

First prize in the "Route of the Totems"
contest was awarded to this pole. The carv-
er's son, Tony Hunt, believes this is the
finest piece his father carved; he calls it
"state of the art Kwakiutl [Kwak-
waka'wakw] carving."

On this powerful pole is Grizzly Bear of
the Sea; on its chest rests Killer Whale's
head, pectoral fins at each side; Killer
Whale's blowhole is represented as an up-
side-down head, while the dorsal fin ap-
pears immediately below, flat against its
body. Notice how the designs carved into
the sea mammal's tail flukes form a face,
also upside-down.

36 LOCATION: *Sidney—*
Washington State Ferries Terminal,
Ocean Ave., "Route of the Totems"
CARVER: *Tony Hunt*
CULTURAL STYLE: *Kwakiutl*
(Kwakwa̱ka̱'wakw)

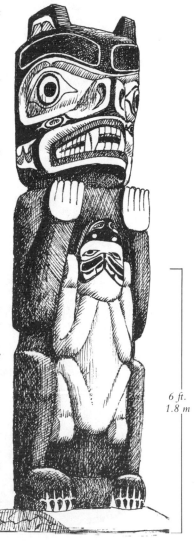

Passengers arriving in Sidney on Vancouver Island off the ferry from Washington State are greeted by another of the "Route of the Totems" poles, this one atop a sloping flower bed bearing the words: WELCOME TO SIDNEY, B.C.

Prior to starting this commission, Tony Hunt had been at the Royal British Columbia Museum, working on a replica Gitksan pole that had a large Frog on it. For the Sidney pole, he felt he wanted to do "one powerful Bear," and influenced by his recent work, decided to add a large Frog for the required second figure.

Because it was still early in his carving career, he made a model of the pole before tackling the 3.7-m (12-foot) log. Afterwards, he gave the model to Laurie Wallace, then deputy provincial secretary, who was responsible for the "Route of the Totems" program. This led to a request for the carver to make more model totem poles, to be given to visiting dignitaries of note. "I used to call them my VIP poles," Tony Hunt said.

Some time after the pole was illustrated, the carver restored the pole to its original appearance, using his original colours (red, black, green and brown) and leaving a lot of natural wood showing, to remedy an incorrect repaint job done by someone else.

6 ft.
1.8 m

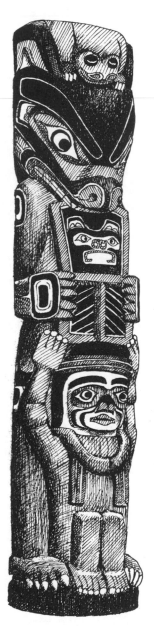

6 ft.
1.8 m

37 LOCATION: *Victoria—Inner Harbour, Government St. and Belleville St., "Route of the Totems"*
CARVER: *Henry Hunt*
CULTURAL STYLE: *Kwakiutl (Kwakwa̱ka̱'wakw)*

Another pole in the "Route of the Totems" series stands in the heart of Victoria, British Columbia's capital city, on Vancouver Island.

This much-photographed pole has a powerful Bear, capped by Frog between its ears; Bear is also holding a copper in its mouth and paws. At the base is a Hamatsa dancer wearing the ceremonial red cedar bark head and neck rings.

Henry Hunt, the best and the fastest of the carvers at the time, was commissioned to create three poles in the series. The other two, at the Bear Cove and Swartz Bay ferry terminals, are also in this book. These carvings perpetuate the memory of a great chief and a fine artist and carver.

Of Henry Hunt's six sons, four have continued in their father's tradition, becoming distinguished artists and carvers in their own right. Indeed, the Hunt family tree includes a large number of men and women from three generations who practise traditional artistic skills in one form or another.

38 LOCATION: *Victoria—*
Royal British Columbia Museum, courtyard
CARVER: *Richard Hunt*
CULTURAL STYLE: *Kwakiutl*
(Kwakwaka'wakw)

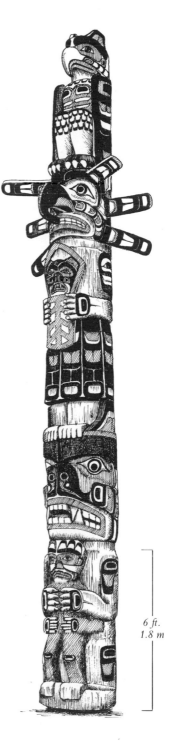

The courtyard in front of the Royal British Columbia Museum has a fine example of the carver's art. The pole, commissioned by the museum and raised in 1979, is by Richard Hunt, son of the renowned carver Henry Hunt.

As with all the poles he carves, he uses only crests and prerogatives that belong to the Hunt family—and there are many. At the top, with eaglelike ears, stands the supernatural bird Kolus; his great claws are clasping the head of a chief wearing a Sun mask. The mask has long decorative rays emanating from the face. The chief, holding a copper in his hands and wearing a cedar bark dance skirt, stands on the head of Bear, between its ears.

The man being held in front of Bear is George Taylor (nicknamed "Slash"), a long-time friend of the carver. When "Slash" was a youngster in Alert Bay, he and another boy played a reckless game with a sharp axe. Taking turns, each laid a finger on a chopping block while the other brought down the axe as close to it as he dared. Predictably, the blade veered off course and George Taylor lost half the index finger of his left hand. Richard Hunt's likeness of his good friend is complete with moustache and chopped finger.

6 ft.
1.8 m

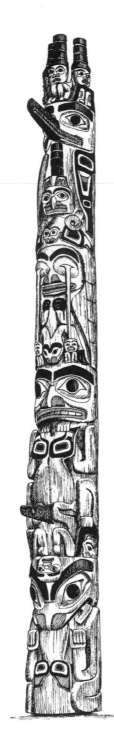

39 LOCATION: *Victoria—*
Royal British Columbia Museum,
main entrance
CARVER: *Henry Hunt and Tony Hunt*
CULTURAL STYLE: *Haida*

Dr. Charles F. Newcombe photographed it in 1901, Emily Carr did a painting of it in 1928, the Royal British Columbia Museum collected it in 1954, and Henry Hunt and Tony Hunt carved a replica of it in 1966.

This house frontal pole, one of the great masterworks from Tanu, the Haida village in the Queen Charlotte Islands renowned for the design and quality of its poles, once stood before a large plank house named House That Makes a Noise, owned by Gwiskunas.

The pole carries three Watchmen at the top, two of them with their legs and hands protruding through the ears of Eagle, below, a crest of the house owner's wife. Between Eagle's wings is the head of Hawk (or possibly Horned Owl), and between Eagle's curled talons is a hair seal.

Several different interpretations and names have been recorded for the next figure, which is a crest: Weeping Woman, Volcano Woman, Sea Anemone, and Salt Water or Sea Chief. There is a good indication that the latter name is the correct one for this figure. The story associated with it (recorded by Charles F. Newcombe) is about Sea Chief, who lived close to a small island near the north end of Bank's Island, across the strait from Tanu. Each night his eyes fell out and hung suspended from a ligature; his lids closed over the sockets. So that he could see to eat, his friends put his

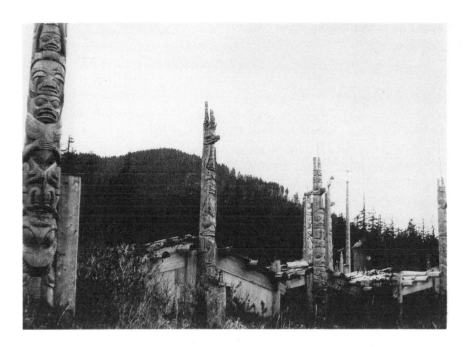

eyes back in place, held them there and propped open his lids. Sea Chief's food consisted mainly of hair seals, but as he had no teeth he swallowed them whole, later spitting out the bones and other undigestible parts, expelling them with great force. His eyeballs are depicted as small, crouching humans.

The original house frontal pole (second from left) standing against a large six-beam house, 1901.

On Sea Chief's chest is Frog, facing downward. Beneath is a human grasping the tail of Killer Whale, whose dorsal fin is between the knees of another human, shown upside-down, riding on Killer Whale's back. This trio tells of the Nanasimget story.

The downward head of Killer Whale becomes the head of Sea Bear, at the base of the pole. He is swallowing a sea mammal head first, with the flippers protruding from the sides of his mouth. Small animals peek through Sea Bear's ears as a filler.

POLES IN THUNDERBIRD PARK

VICTORIA

In 1940, on the southwest corner of Douglas and Belleville streets in Victoria, city lots C, D and E were vacant, and a display of totem poles and canoes from the provincial museum's collection was set up on the empty corner. The public liked what they saw, and a letter to the director said, "Your totem pole exhibit is a very good idea, and in an appropriate spot." Thus did the seed of Thunderbird Park begin to germinate.

Twelve years later, as wind and weather were causing deterioration to the carvings, they were taken indoors. The museum's curator of anthropology, Wilson Duff, was instrumental in setting up a major totem pole restoration program which employed Mungo Martin.

For two years previously, Martin had been carving for the University of British Columbia's restoration program, replicating decaying poles. Now a large carving shed was built so that the public could watch the new poles taking shape under the master carver's adze. This idea so fascinated visitors that it became a permanent feature; new poles continue to be carved on site.

Mungo Martin also built a traditional Kwakiutl (Kwakwaka'wakw) house, complete with carved house posts inside. On 16 December 1953 the house was opened with three days of ceremony, which included the performance over two days of more than fifty dances, all belonging to Mungo Martin's family lineage.

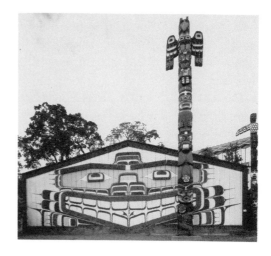

Mungo Martin's Kwakiutl (Kwakwaka'wakw) house in Thunderbird Park, Victoria, 1986.
B.C. ARCHIVES AND RECORDS SERVICE/PN16827

40 LOCATION: *Victoria— Thunderbird Park*
CARVER: *Mungo Martin*
CULTURAL STYLE: *Kwakiutl (Kwakwaka'wakw)*

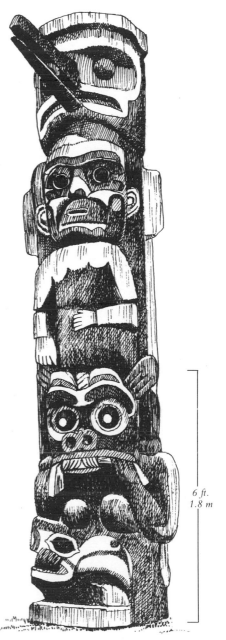

This carving is a replica of a house post, raised around 1870, which supported the central beam of a house at Koskimo, Quatsino Sound, on the coast of Vancouver Island. The original post was collected in 1913 and for many years stood in the grounds of Government House in Victoria, the official residence of the lieutenant-governor of British Columbia.

At the top of the house post is the head of Huxwhukw. Originally, the mythic Cannibal Bird had outspread wings, as did the replica, which were attached to the back of the post.

Below Huxwhukw is a humanlike being named Komokwa, or Copper Maker. As ruler or guardian of the Undersea, he lived in a marvellous house beneath the water which contained great wealth and had live sea lions for house posts guarding the entrance. Those seeking wealth who approached the house might be escorted in by a Whale. After a lengthy stay that seemed to last but a few hours, the visitor returned home in a canoe loaded with treasures.

At the base of this house post, Grizzly Bear has a copper in his mouth— eating or breaking it—and his right hand is in the mouth of a small Whale, profiled to his right at the base.

6 ft.
1.8 m

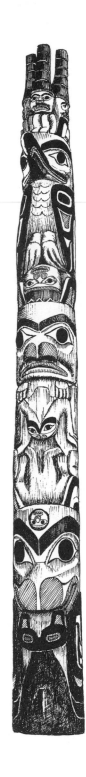

6 ft.
1.8 m

The village of Tanu on the Queen Charlotte Islands was once renowned for its superbly designed and carved house frontal, memorial and mortuary poles. One of these, collected in 1911, has been replicated in precise detail and stands outdoors with the clean lines and freshness of paint that the original once had.

The exact interpretation of this house frontal pole has been lost, but the figures can still be recognized. Three Watchmen at the top stand guard over the house—two with their lower limbs protruding through the ears of Eagle below them. Eagle's personified tail fits neatly between the ears of a humanlike figure who may well be Dzelaqons holding a frog.

Dzelaqons married a prince of the Grizzly Bear people and had children. The oral history telling of her place in Haida lore is long and involved, giving rise to other names for her: Frog Woman, Mountain Woman, Copper Woman and Volcano Woman.

The large creature at the base is Whale, with pectoral fins at each side; its hind end, with dorsal fin and tail flukes, is turned up onto its body. Whale's blowhole is defined by the head of an upside-down human figure. This figure may pertain to the Nanasimget story, or may be ridiculing a person or family in debt to the pole's owner.

42 LOCATION: *Victoria—Thunderbird Park*
CARVER: *Gerry Marks and Richard Hunt,*
with Tim Paul
CULTURAL STYLE: *Haida*

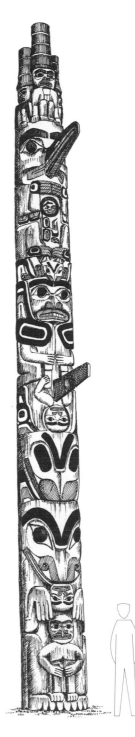

When fire gutted the Thunderbird Park carving shed in 1980, it took with it a nearby Haida totem pole carved fifty-five years earlier. The shed was rebuilt in a style based on that of a northern plank house, with a replica frontal pole.

The original pole was carved sometime after 1878, in Cumshewa on the Queen Charlotte Islands. In 1901 it was purchased by the Field Museum of Natural History in Chicago. During the 1930s the Salvation Army bought the pole for a children's camp in Illinois, which in turn sold it to a collector in the 1960s. In 1982 the Canadian Museum of Civilization purchased the pole and brought it back to Canada.

On 9 June 1984 the new pole, replicated in the carving shed, was raised with ceremony; among those invited was Charlie Wesley, the hereditary chief of Cumshewa.

At the top of the pole sit three Watchmen; below is Cormorant, looking somewhat human with arms and fingers, but with feathers at his elbows. Beneath Cormorant, in a complex interlocking design, is Whale, with a woman clinging to his tail flukes that lie on either side of her face. Whale's dorsal fin protrudes above its blowhole, carved as the head of a small upside-down human—likely the story of Nanasimget. At the base stands Grizzly Bear with humanlike twin cubs.

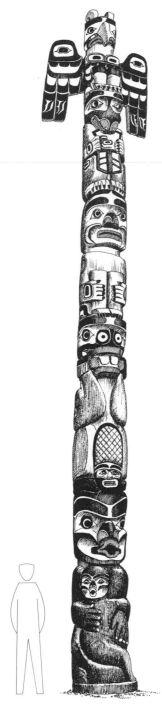

43 LOCATION: *Victoria—Thunderbird Park*
CARVER: *Mungo Martin with assistants*
CULTURAL STYLE: *Kwakiutl*
(Kwakwaka'wakw)

The heraldic pole customarily displayed the crests of the owner of the house, but this pole, carved by Mungo Martin, carries the crests of four of the many clans (groups of related families) that form the Kwakiutl (Kwakwaka'wakw) nation.

Perched on top is Thunderbird, the crest of a clan at Knight Inlet whose original ancestor was the Thunderbird who transformed into a man. Below is Grizzly Bear (holding a copper), who was the ancestor of a Kwakiutl (Kwakwaka'wakw) clan, and below him is Grizzly Bear in human form. Next is Beaver, ancestor of a group at Blunden Harbour, and at the base is the giantess Dzunukwa, a crest of a clan of the Nimpkish people. According to clan tradition, a man who chased Dzunukwa for stealing dried fish eventually married her, and their son, half man and half Dzunkwa, was the founder of the clan. He is at the base of the pole being held by his mother and looking back over his shoulder.

The house behind the pole is an authentic though scaled-down version of a Kwakiutl (Kwakwaka'wakw) house built at Fort Rupert in about 1853 by Chief Naka'penkim, whose position and name Mungo Martin inherited; thus, he took special pride in building the house. Inside are four house posts, two at the back and two at the front, carved with the crests of three clans to which Naka'penkim was related by heredity or marriage. The painting on the

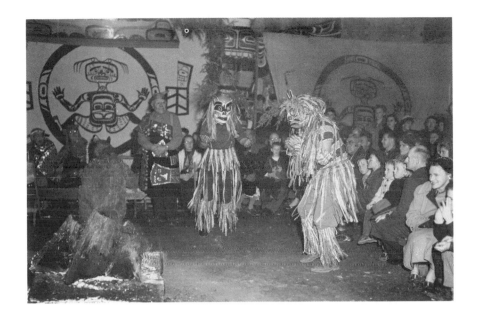

house front represents a supernatural sea monster in the form of Bullhead (or Sculpin), and is taken from the house front design of a chief who was distantly related to Mungo Martin.

Masked dancers representing Raccoon and Mouse at the opening celebrations of Mungo Martin's Kwakiutl (Kwakwaka'wakw) house, 1953. ROYAL BRITISH COLUMBIA MUSEUM/7038

The house in Thunderbird Park was opened in mid-December 1953 with a three-day potlatch, to which the general public was invited on the third day. Notice of the occasion stated that it "will mark the first time this ancient Indian ceremony has been staged in the open in British Columbia since the Canadian government banned the practice in 1880." (It was actually banned in 1884.) In fact, Mungo Martin gave the first legal potlatch in almost seventy years.

The elaborate affair was attended by native people from all over the coast. It brought back many of the ancient and complex ceremonies of the potlatch, one of which saw Mungo Martin, as the owner of the house, give gifts to some thirty high-ranking people and tokens to around two hundred guests of lesser standing.

44 LOCATION: *Victoria—Thunderbird Park*
CARVER: *Mungo Martin, David Martin, Henry Hunt, Tony Hunt*
CULTURAL STYLE: *Gitksan*

According to an elder of long ago, a chief named Tu'pesu could not afford the large expense of raising the original of this pole. Thus the pole was jointly erected by him and his friend Chief Wawralaw in 1855 (or 1885) at Gitsegukla on the Skeena River. This replica was carved in 1954.

Great Being from the Lake, wearing the Brave's Helmet, tops the pole. Running through the headgear is a stick on which two Real Kingfishers are perched. All of these are family crests.

Below the uncarved length of pole is Hanging Frog, a crest probably derived from a legend about Neegyamks, a chief's daughter who disappeared one night. She was missing for two years, until one day two Frogs appeared in the chief's doorway and led people to a nearby lake. With the help of neighbours, the lake was drained, whereupon a huge number of small Frogs took flight. The legend continues at length, telling of the death of Neegyamks and of her father killing a large Frog and taking it for a crest.

At the base of the pole is the figure of Reflections in the Water. This crest is derived from a legend that tells how a woman, crossing a lake on a raft, saw the faces of children in the water. Her family also saw the same faces, and they composed a dirge to commemorate the adoption of the reflections (or shadows) as a crest.

45 LOCATION: *Victoria—Thunderbird Park*
CARVER: *Mungo Martin, Henry Hunt,*
Tony Hunt
CULTURAL STYLE: *Gitksan*

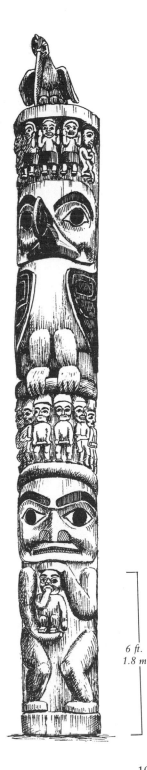

An especially fine pole, this is a replica of a memorial pole that belonged to the chief of the Wolf clan of the village of Gitanyow.

In 1958 the village chiefs allowed several old poles to be removed to museums for preservation, on condition that they be replaced with carved replicas. The original of this pole now stands in the Great Hall of the Museum of Anthropology in Vancouver. In 1960 a second replica of one of these poles was carved for Thunderbird Park.

At the top is Giant Woodpecker, a crest that originated with the story of an ancestress who kept a woodpecker as a pet. She fed it constantly until it grew into a huge monster, eating up everything made of wood. Finally it was killed, and thus the family took Giant Woodpecker for a crest.

Below Giant Woodpecker is Mountain Eagle (the Gitksan equivalent of Thunderbird), who had a craving for human flesh. He kidnapped and mated with a young woman, whose offspring, part bird and part human, he devoured. Eleven people are depicted in two rows, one above and one below Mountain Eagle; notice their varying expressions, arm positions and headgear.

At the base of the pole is the ancestress Will-a-daugh holding her child who sucks its fingers. The nose of the original was probably long and sharp edged (as on other such figures).

6 ft.
1.8 m

107

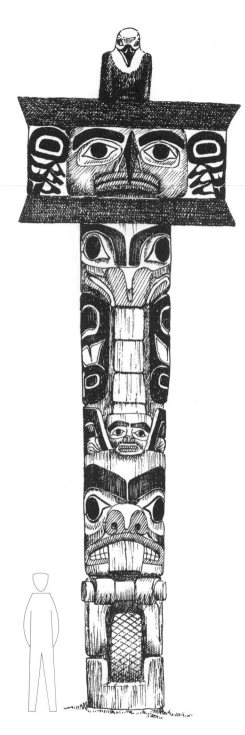

46 LOCATION: *Victoria— Thunderbird Park*
CARVER: *Mungo Martin with Henry Hunt and David Martin*
CULTURAL STYLE: *Haida*

This bold and dramatic mortuary pole is a fine example of Haida art. The original, which once stood at Tanu on the Queen Charlotte Islands, was erected for a high-ranking woman who was shot while travelling through the San Juan Islands in Washington State. Her body was cremated; the remains were taken back to Tanu and placed in the cavity behind the frontal board.

By 1911 Tanu had been abandoned some years, and Dr. Charles F. Newcombe obtained the mortuary pole for the provincial museum, which makes it almost the only such pole that has been preserved. It stood outside the museum until it became evident that continued weathering and rot would eventually cause its destruction.

At that time, the 1950s, there were few Haida carvers experienced in creating poles, so the task of duplicating it fell to Mungo Martin, a Kwakiutl (Kwakw<u>a</u>k<u>a</u>'wakw). Working from the original, he carved a replica of the old Haida pole in 1955.

Perched atop the pole is Eagle—the original had a copper

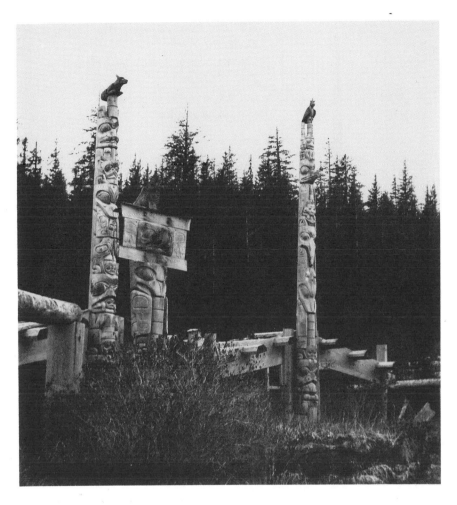

(not present in the replica) leaning against its chest. The frontal board represents the mythical Mountain Hawk, with its recurved beak and wings at each side.

The original mortuary pole in the deserted, overgrown village of Tanu, 1901. CHARLES NEWCOMBE, ROYAL BRITISH COLUMBIA MUSEUM/PN100

Below is Whale, represented only by its head and tail flukes, the latter wrapping part way around the pole on each side. A small figure (possibly the deceased) with three skils crouches between the ears of Beaver at the base.

f

e

d

c

b

a

6 ft./1.8 m

47 LOCATION: *Victoria—Beacon Hill Park, Dallas Rd.*
CARVER: *Mungo Martin with Henry Hunt, David Martin*
CULTURAL STYLE: *Kwakiutl (Kwakwaka'wakw)*

This pole of 38.9 m (127 feet, 7 inches), raised on 2 July 1956, was the tallest totem pole in the world—until Alert Bay laid claim to the title. Carved by the renowned Mungo Martin, the pole depicts an ancient legend that tells of the origin of the clan to which he belonged.

Geeksen was one of the "First Men" of the Kwakiutl (Kwakwaka'wakw)—human beings who were created in various ways in diverse places and who founded the different clans. He lived alone near the mouth of the Nahwitti River at the north end of Vancouver Island.

One morning before dawn, he awoke to strange sounds: first the cry of Huxwhukw the Cannibal Bird, then the squeal of Whale, next Sea Lion's bellow and Eagle's screech. Peering outside, Geeksen saw a strange sight. Rising out of the beach, growing ever taller, was a pole with live animals and birds on it, one above the other, each adding its voice to the din. At the base, a man wearing a red cedar bark neck ring spoke to Geeksen: "Observe carefully all the figures on the pole. These will be your crests, to be displayed by you and your descendants." Then the pole disappeared.

Mungo Martin's tall pole was the first time all his clan's crests had been brought together in one carving. Then, with space

a b c

d e f

on the log left over, he added two First Men from other stories at the top.

The pole's height makes it difficult to distinguish and identify each crest, but starting at the bottom makes this easier. At the base is Geeksen himself, wearing a ceremonial blanket and cedar bark head ring. Progressing upwards are Huxwhukw, Killer Whale, Sea Lion, Eagle, Sea Otter (clutching a fish), Whale with an upside-down human, Beaver, Man, Seal, Wolf and finally three men on top of each other, the top two wearing blankets.

This pole was painted for the third time in August 1989. Working from a massive scaffold, it took two artists several weeks to complete the task.

An undated plaque on the metal base reads: "This tablet in memory of the British Columbia Indians who gave their lives in the World Wars 1914–1918 1939–1945 was erected by the B.C. Indian Arts and Welfare Society."

THE "CITY OF TOTEM POLES"

DUNCAN

Duncan, a small city 64 km (40 miles) north of Victoria on Vancouver Island, completed a revitalization project in 1983. Concrete pavers, hanging flower baskets and colourful banners spruced up the town considerably, but they were not enough to prevent tourists from driving through without stopping—until Mayor Douglas Baker hit on an imaginative idea: make Duncan the "City of Totem Poles."

The project began with two Cowichan carvers from the region, Tom and Douglas LaFortune; then a third, Francis Horne, joined them. Twelve large cedar logs were donated by a logging company, and the poles began to take shape in a warehouse type of building, visible from the highway.

Enthusiasm mounted, particularly when a Maori carver from Duncan's sister city of Kaikohe in New Zealand came to Duncan to carve a Maori pole. Tupari Te Whata returned to New Zealand with a Northwest Coast totem pole, while his Maori pole remained in Duncan.

By 1986 a series of carved and painted poles, sponsored by local business and industry, lined both sides of the highway through the city, and more poles stood elsewhere. A plaque on an Eagle and Beaver pole reads: "Dedicated to the Mayor and council for his initiative and creation of 'the City of Totem Poles.'"

Duncan surely deserves its title, as with each succeeding year more poles are raised throughout the town. The following is a small selection of those poles. It should be noted, however, that several other poles around town do not hold to the traditional art styles of the cultures that they represent.

48/49 LOCATION: *Duncan—on the Island Highway*
CARVER: *Doug LaFortune/Francis Horne*
CULTURAL STYLE: *Northwest Coast*

Two of the many poles on pedestals that line both sides of the main highway that heads up Vancouver Island through Duncan are shown here.

Although the carvers of these two are Coast Salish people, they chose to work in a generalized Northwest Coast style, combining design characteristics and using the traditional red and black colours for feature emphasis. Created separately by different carvers, the poles were raised in 1986.

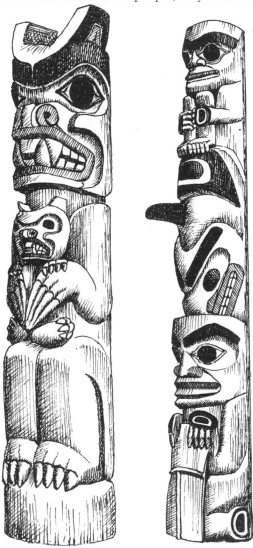

LEFT: This pole by Doug LaFortune is a strong Bear clutching its cub. This sturdy pole, 4.4 m (13 feet, 4 inches) in height, could serve as a house post, with the beam resting in the space between Bear's ears. Large nostrils and big teeth with canines characterize Bear, as do the clawed feet.

RIGHT: A human sits crouched on top of the turned-back tail flukes of Whale, who has a dorsal fin protruding above its head. Another human, kneeling at the base, holds a copper. This pole, 5 m (14 feet, 8 inches) tall, was carved by Francis Horne.

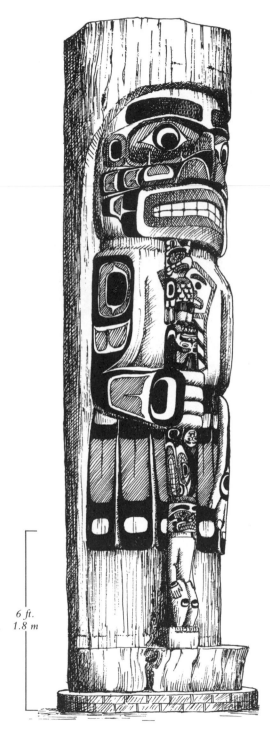

6 ft.
1.8 m

50 LOCATION: *Duncan—*
Provincial Building,
Station St. and Jubilee St
CARVER: *Richard Hunt*
CULTURAL STYLE: *Kwakiutl*
(Kwakwa̲ka̲'wakw)

Around the time that Genghis Khan was roaming Asia, a cedar seedling sprouted in the fertile soil on the west coast of what we now call Vancouver Island. It grew tall and straight for some 775 years, until Wayne Beecroft, a log merchandising superintendent, came across it near Port Renfrew. For three months he had been on the lookout for a particularly large cedar that the MacMillan Bloedel Company would donate to Duncan's "City of Totem Poles" project.

The diameter of the log, cut well above the flaring base of the tree, measured nearly 2 m (over 6 feet) at the butt. It contained enough wood to roof three two-bedroom houses with cedar shakes.

Richard Hunt was approached about creating a totem pole from the giant cedar. "I was really excited at the chance to work on something so huge," he said, "and

I thought about how I could use the log to its fullest width. I decided to carve Cedar Man, the spirit of the cedar tree personified. For inspiration, I used the Cedar Man figure on Mungo Martin's memorial pole in Alert Bay, that my father carved."

The log was delivered to the front of the Provincial Building. For shelter, a huge tent was set up over the enormous tree trunk, and sets of three-tiered bleachers gave the carver access to the sides and top of the log. Many Duncan residents visited regularly, using the bleachers to sit comfortably and watch the pole take shape. To carve such an enormous figure necessitated extra-large tools, and Richard Hunt used double-bit axes, shipwright's adzes and chisels with blades of 9 cm (3½ inches) for much of the work.

Just prior to working on this carving, Richard had made a mask with eyes measuring 2.5 cm (1 inch) across. By comparison, the eyes he carved on Cedar Man were over 40.6 cm (16 inches) across; the head alone measured 1.8 m (6 feet) high, and the talking stick a staggering 4.3 m (14 feet).

Raising the pole by the traditional manner was out of the question because of its size, and a crane had to be brought in to handle the task. With the pole already raised in place, the ceremonial dedication ceremonies took place on 17 November 1988, and members of the Hunt family, in full regalia, performed traditional dances.

"Seen from a distance," Richard Hunt said, "Cedar Man appears to stare down the street at you. He is transforming, walking out of the log." He wears a cedar bark skirt, has a copper painted on his chest and carries a talking stick with Kolus at the top. The mythical bird is followed by Whale, whose turned-back tail flukes are above Cedar Man's large hand, with its head below. At the base of the talking stick is a chief wearing a cedar bark head ring.

This pole's diameter holds the world's record—with little likelihood of its ever being broken.

51/52 LOCATION: *Duncan—Cowichan Valley Museum, Canada Ave. and Station St.*
CARVER: *Francis Horne/Richard Hunt*
CULTURAL STYLE: *Kwakiutl (Kwakwaka'wakw)*

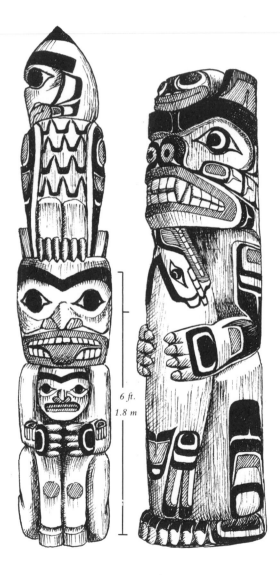

6 ft.
1.8 m

Duncan's heritage railway station now houses the Cowichan Valley Museum. Two of the four poles on the south side of the old station are illustrated here.

LEFT: The pole by Francis Horne is topped by an interesting depiction of Owl. The carving shows Owl with its head swivelled to one side—a movement typical of owls—and with a decoratively feathered breast. Beneath is Bear holding a human.

RIGHT: The other pole is by Richard Hunt. His massive Bear figure holds Seal, whose fore flippers are hidden beneath Bear's great paws and whose tail is turned up from the base. Crouched between Bear's ears is a small creature reminiscent of a frog, though it is without front or hind legs. "It would have been a frog," the carver said, "but the lack of funding for additional carving time resulted in a pollywog."

53 LOCATION: *Nanaimo—north end of Pearson Bridge, "Route of the Totems"*
CARVER: *Jimmy John with Norman John*
CULTURAL STYLE: *Nuu-chah-nulth*

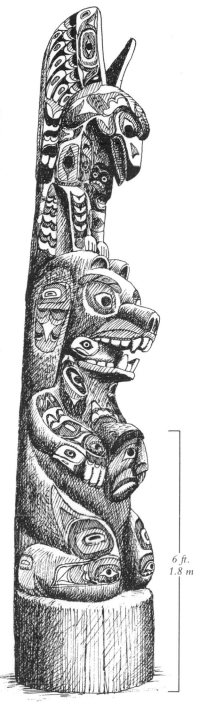

6 ft.
1.8 m

Jimmy John of the village of Yuquot (Friendly Cove), on Vancouver Island, was quite elderly when he carved this lively pole with his son Norman John in 1966. Born before births were recorded, Jimmy John was thought to be about 114 years old when he died in 1987.

Carving since the age of eighteen, Jimmy John created masks, headdresses, feast bowls and other items, including a fine totem pole that still stands at Yuquot. Nuu-chah-nulth carver Tim Paul described him as a "real powerhouse."

This pole typifies the elderly carver's flamboyant style. Ellen White, an elder of the Nanaimo Band, provided Jimmy John with the story for this pole: Long ago her people found themselves short of food, not realizing that there were fish in the river. One day Eagle swooped over the water and picked up a salmon in its strong claws, and thus it was that the people came to depend on the salmon in the river, smoking and drying it for winter. Like Eagle, Bear harvested salmon from the streams, and chiefs reminded the men to show the strength of Bear in order to supply winter food for all the village, including the old and the feeble.

Eagle, topping the pole, looks down at Bear, holding a salmon in its mouth and paws. The head on Bear's chest represents the guardian, or master, of the ceremonial dance house.

117

54 LOCATION: *Departure Bay—Nanaimo Ferry Terminal, "Route of the Totems"*
CARVER: *Kwakiutl Arts and Crafts Organization*
CULTURAL STYLE: *Kwakiutl (Kwakwaka'wakw)*

Beside the entrance to the coffee shop at this busy ferry terminal stands a colourful and dramatic totem pole. This is another in the "Route of the Totems" series of poles and a fine example of the imaginative flair that native carvers can bring to their three-dimensional art.

With outspread and uplifted wings, the great Thunderbird appears ready to take flight as it glares down at passers-by. Below is Bear eating a salmon held in its paws.

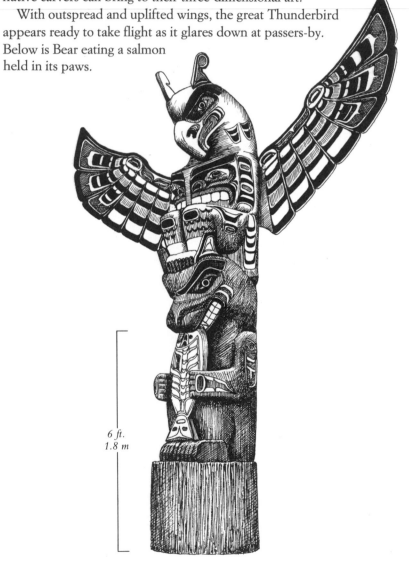

6 ft.
1.8 m

55 *LOCATION: Qualicum Beach—on the Island Highway, "Route of the Totems"*
CARVER: *Simon Charlie*
CULTURAL STYLE: *Coast Salish*

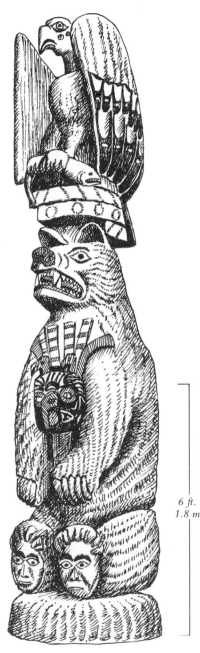

This unusual pole combines the three-dimensional realism of the Coast Salish tradition with the carver's personal style. After the cedar log for the pole was delivered to his house, Simon Charlie checked on local history to find an appropriate subject to go with the required upright Bear, but without success. "I sat on the log for three days wondering what to carve," he said, "then I thought about the name Qualicum—it means dog salmon in our language."

One morning Simon Charlie found blood on one end of the log. This ill omen troubled him deeply. "I decided to fight that," he said. "I used my mind to fight it." He succeeded. When the pole was finished, it won a special prize for originality.

He chose a golden eagle for the top figure and depicted it with a dog salmon in its claws. As a carver of the traditional (and only) Coast Salish mask, the Swaixwhe, Simon Charlie portrayed this on Bear's chest. Believing that moving body parts of large creatures have a spirit, he added faces to the soles of Bear's feet. "Life always has a happy side as well as a sad side, you know. So I made one face happy and the other one sad," he said.

The sculpture is finished with an adzed texture, a trademark of this carver's work.

6 ft.
1.8 m

119

56 LOCATION: *Courtenay—Tourist Infocentre, "Route of the Totems"*
CARVER: *Kwakiutl Arts and Crafts Organization*
CULTURAL STYLE: *Kwakiutl (Kwakwa̱ka̱'wakw)*

This fine pole, which is on the Island Highway at the south entrance to Courtenay, won second prize in the "Route of the Totems" series contest.

The imposing and elaborately painted bird at the top is the supernatural Kolus. On his chest is incorporated the mystic Hwhy-Hwhy mask of the nearby Comox people. The origins of this mask lie in an encounter by their ancestors who, while travelling through a swampy area, saw two strange figures moving through the rising mists. Believing them to be the figures of a spirit man and woman, the travellers returned home, where carvers depicted the likeness of the spirit people.

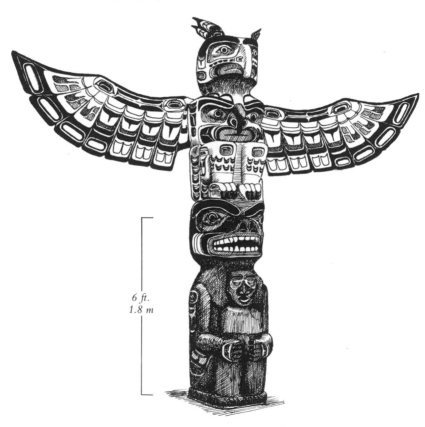

6 ft.
1.8 m

Beneath is Grizzly Bear, holding Dzunukwa, whose baby was discovered by a young man in its cradle in the forest. He teased the baby by pinching it, causing it to cry loudly. Dzunukwa heard the cry and called out, "Whoever you are that may be teasing my baby, let him alone and I will give you a spear."

Pleased at such good fortune, the young man pinched the baby three more times and was offered the Water of Life, a magic wand and a supernatural canoe if he would leave the baby alone. Satisfied, the man stopped teasing the child, returned home with his gifts and, because of his encounter with Dzunukwa, became rich and powerful. Originally a small carved canoe rested on Dzunukwa's hands, but it was removed for repair and has not been replaced.

An old story tells of two brothers who felled a cedar and carved a dugout canoe. The younger brother insisted on launching the craft even though it was not finished and the paddles were not yet made. He had, however, painted a double-headed sea serpent on the sides of the canoe. Putting his older brother in the bow, facing forward, the younger brother sang a special power song and slapped his hands alongside the stern, where he sat, causing the canoe to propel itself through the water with great speed.

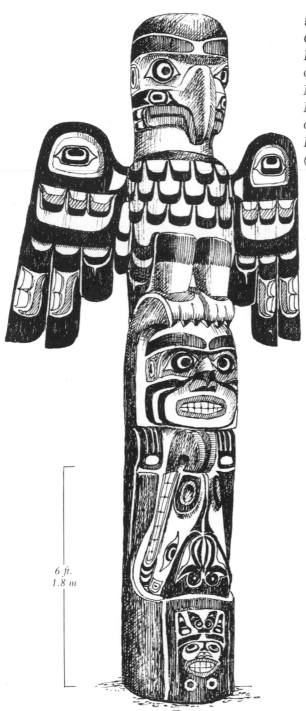

57 LOCATION:
*Courtenay—
Lewis Park*
CARVER: *Mungo
Martin with David
Martin, Henry Hunt*
CULTURAL STYLE:
*Kwakiutl
(Kwakw<u>a</u>k<u>a</u>'wakw)*

6 ft.
1.8 m

An interesting background comes with the pair of poles at the entrance to Lewis Park. In 1927 the Courtenay Board of Trade acquired two poles said to have been carved by Johnny Tla-kwa-dzi, a carver from Salmon River. However, local historian George Pidcock said the poles belonged to Chief Joe Wallace, who carved them at Cape Mudge for the entrance to his house but reached old age and blindness before acquiring the necessary wealth to raise them.

Over the years, the poles became badly decayed. The Royal British Columbia Museum arranged for two new poles to be carved by Mungo Martin, with assistance from his son David and stepgrandson-in-law Henry Hunt, at a cost of $1,000. Rather than replicate the originals, Mungo created his own version of the same figures.

In 1957 the newly carved and freshly painted poles were raised in a traditional ceremony attended by many high-ranking native people, resplendent in ceremonial regalia. Ancient songs and dances were performed in front of a dance screen, giving Chief Andy Frank of Comox, who organized the event, the opportunity to wear a special mask—the Hwhy-Hwhy—for only the second time in his life. He had received it in 1927, on the occasion of his marriage, in a native ceremony.

Although the poles were raised by crane, there was initially a demonstration of the old method of pole raising. As a wealth token, Chief Andy Frank placed a silver dollar under the base of each pole; he also gave quantities of silver dollars to those who had assisted in the whole event, and he gave gas money to those who had travelled to attend. In addition, many visiting native people and representatives of pioneer families were his guests at a large banquet at a restaurant in Courtenay.

The two poles differ slightly; the one illustrated is on the left of the park entrance. Chief Andy Frank's wife, Margaret, talked about the pole in her native language, translated for me by her daughter Mary Everson. (Margaret Frank played the part of Naida, the young heroine in Edward S. Curtis's feature film *In the Land of the Head-Hunters* in 1914.) At the top is Thunderbird, wings outspread; beneath is Sisiutl, whose two heads and their tongues appear as a single head with a split tongue. At the base is the upper portion of a copper with a Whale design.

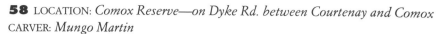

58 LOCATION: *Comox Reserve—on Dyke Rd. between Courtenay and Comox*
CARVER: *Mungo Martin*
CULTURAL STYLE:
Kwakiutl
(Kwakw̱ak̲a'wakw)

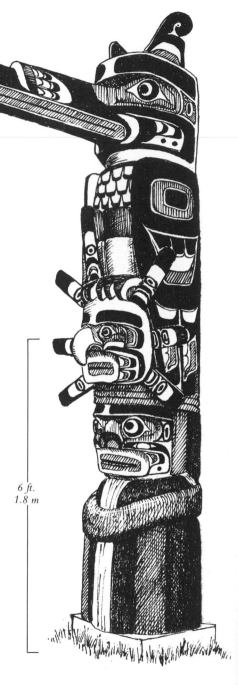

6 ft.
1.8 m

Easily noticed from the road is the Comox Reserve's Ceremonial Big House, its front painted with Thunderbird grasping a huge Whale in its claws. Standing before it, to the left, is a memorial pole by master carver Mungo Martin. Both the house and this pole have a touching history.

The Big House was originally constructed in 1958, only the second on the coast to be built since early times—the other being at Thunderbird Park in Victoria. Mary Everson of the reserve said that in those days there was a lack of pride in being Indian, and to conceal their reserve from the general populace, the band located the Big House in Centennial Park, just outside nearby Courtenay.

Mungo Martin's son David had carved three of the house posts inside. A year later, on board a salmon seiner that was crossing from Comox to Steveston, he was swept overboard in heavy seas. Despite an intensive search, his body was never found. The death of his only son was devastating to Mungo Martin, and one year later, following tradition, he raised a memorial pole in his son's honour. Then eighty-two years old, he carved the pole entirely alone. It was raised in a sad and solemn ceremony beside the Big House in Centennial Park, on 26 May 1960.

In 1974, with a renewed sense of pride and identity spreading among native people everywhere, and to fulfil a wish by the late Chief Andy Frank, the Comox Band moved both the house and the pole to take their rightful place on the reserve. It is there that the pole now stands in memory of David Martin, who would have inherited all his father's crests, rights and privileges.

At the top is the Cannibal Bird, Huxwhukw, with the Sun crest below; the high-ranking man at the base—notice the head and neck rings—represents the chiefly lineage to which David Martin belonged. A marble tablet in front of the pole reads simply: "DAVID MARTIN July 1 1917–Sept 4 1959 KWAKIUTL TRIBE."

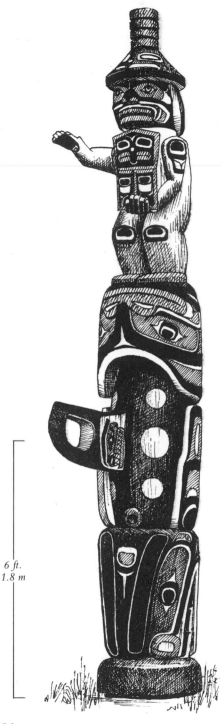

6 ft.
1.8 m

Between Courtenay and Comox lies the Comox Reserve, where Mary Clifton was born in a traditional plank house in 1900. She recalled that in front of the house stood an old pole, the carved figure of a man; one of his hands shaded his eyes, looking out over the shore, while the other hand reached out in a welcoming gesture.

As a small child, Mary Clifton accompanied her mother and others from the village to a fish cannery at Quathiaski Cove on Quadra Island, where they were seasonally employed each summer. "In those days," she said, "we went by canoe"—a journey of some 64 km (40 miles). "One year, when we got home, that welcome pole had been stolen," she said, adding wistfully, "but in those days there was nothing you could do about it."

When a memorial pole was planned in honour of her brother, Chief Andy Frank, Mary Clifton, nearly ninety years old, suggested that the pole should have on it the welcoming figure from the old Frank home.

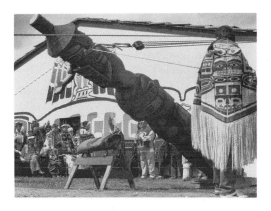

Calvin Hunt (right) at the raising of his pole in Comox, 1989.

HILARY STEWART

As a child, Calvin Hunt had known Andy Frank and recalled, "He always had a smile on his face. I felt honoured to be asked to create the memorial for this great man." He topped the pole with the old figure—one hand in the welcome gesture, the other holding a copper to symbolize Andy Frank's chiefly position. Beneath, he carved Whale, the main crest of this high-ranking and much-loved man who died in 1972.

An ancient legend tells of two brothers who, knowing that a flood was coming, each made a canoe. The waters rose, and when all the land was covered, Whale surfaced near them; they tied their canoes to it until the waters receded, and they eventually became the founders of the Comox and the Puntledge people. The Whale, it is said, can still be seen on the mountain.

The memorial pole was raised in front of the reserve's Ceremonial Big House (originally built by Chief Andy Frank and recently renovated by Calvin Hunt) on 20 May 1989. A large crowd, including many people from distant places, gathered for the ceremony and the attendant potlatch. Two dramatic Thunderbird house posts, with a painted screen between, formed a backdrop for the many drummers beating on the long log drum, carved and painted in the form of Whale by Calvin Hunt. Smoke from the central fire rose up through the smoke hole all afternoon and evening as a series of dancers, ceremonially robed or wearing elaborately carved masks, performed their special dances. The eight-hour event, with speeches and tributes (mainly in the Kwakwala language) to Chief Andy Frank, a sumptuous feast for over five hundred people and the giving of money to everyone present, affirmed the status of this past chief of the Comox Band.

This major event, held on the reserve and right beside the highway, made a proud statement and was in bold contrast to the earlier time when both the house and the memorial pole were tucked away in a city park.

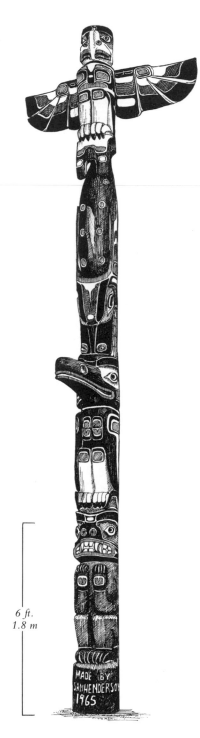

6 ft.
1.8 m

60 LOCATION: *Campbell River—Coast Discovery Inn*
CARVER: *Sam Henderson*
CULTURAL STYLE: *Kwakiutl (Kwakwaka'wakw)*

The expansion of tourism in Campbell River—dubbed "The Salmon Capital of the World"—brought a new hotel overlooking the salmon-rich waters of Discovery Passage. The owners of the inn, built in 1965, commissioned Campbell River carver Sam Henderson to create a totem pole to enhance the new building's exterior.

Sam Henderson remembered the fine pole that had once stood on his reserve and that had belonged to his wife's father's family, the Kwasistala (sometimes spelled Quocksister) family. In 1910 they had been persuaded by a New York collector to sell the pole to a museum there, and so he decided to make a new version of the old pole. When he had married his wife, May—in both traditional native and non-native ceremonies—the couple acquired each other's crests. This gave him the right to carve his wife's family pole, which was raised and dedicated on 9 June 1965. Eighteen years later, a year after Sam Henderson's death, his son, Mark, also an artist and carver, gave his father's work a new coat of paint.

Although the original pole was topped by Thunderbird, Sam Henderson chose to make his top figure Eagle. Below are Whale, Raven and Bear.

61 LOCATION: *Campbell River—Coast Discovery Inn*
CARVER: *Sam Henderson*
CULTURAL STYLE: *Kwakiutl (Kwakwaka'wakw)*

Also commissioned by the Coast Discovery Inn, this pole is another by the renowned local carver Sam Henderson. Born in 1905, he clung to and nurtured Kwakiutl (Kwakwaka'wakw) traditions throughout his life, passing them on to his family and, later, other younger generations.

Sam Henderson was deeply knowledgeable about the roles and rights that dictated the potlatch. Fluent in his native tongue, he was also a dancer, composer, singer and speaker until his death in 1982.

Thunderbird tops this totem pole, followed by Killer Whale and a human at the base. The pole was raised in 1965.

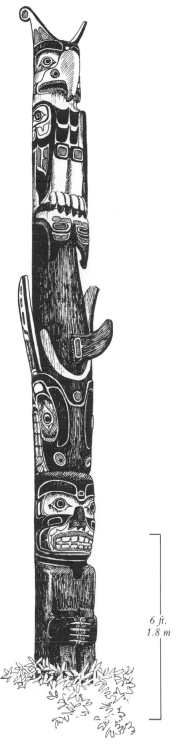

6 ft.
1.8 m

129

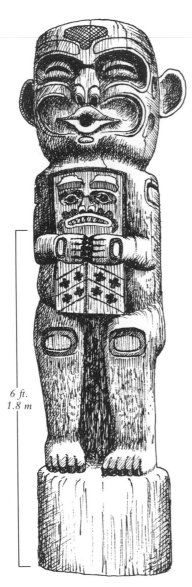

6 ft.
1.8 m

62 LOCATION: *Campbell River—Tyee Plaza Shopping Mall*
CARVER: *Sam Henderson*
CULTURAL STYLE: *Kwakiutl (Kwakwa̱ka'wakw)*

For several years in the early 1970s, the Tyee Plaza Merchants Association had been staging an annual marketing device and tourist attraction that they called "Pow-Wow Days." Sales clerks dressed up in fake Plains Indian costumes, and Rose McKay, curator of the town's museum, loaned items from the museum collection for display in store windows.

Elizabeth Kwasistala, a Kwakiutl (Kwakwa̱ka'wakw) woman of the nearby Campbell River Reserve, objected to the eastern Canadian Indian word *pow-wow*. She suggested instead "Bakwum Days," the word *bakwum* in her language meaning "native people," as opposed to *mamathla*, or "white people."

To give local native authenticity to the event, Rose McKay suggested that a memorial pole be raised in honour of her good friend Chief Peter Smith of Turnour Island. The Tyee Plaza Merchants Association liked the idea and commissioned Sam Henderson to carve the pole. The right to use Dzunu̱kwa had been passed to the chief's family in a potlatch, so, for the memorial, Henderson carved Dzunu̱kwa holding a copper in her hands.

On 23 May 1975 the traditional pole-raising ceremony, with drumming, dancing and speech making, brought the true flavour and dignity of Northwest Coast native culture to the plaza, dispelling the earlier stereotyped image.

130

63 LOCATION: *Campbell River—Campbell River Museum,*
"Route of the Totems"
CARVER: *Sam Henderson*
CULTURAL STYLE: *Kwakiutl (Kwakwaka'wakw)*

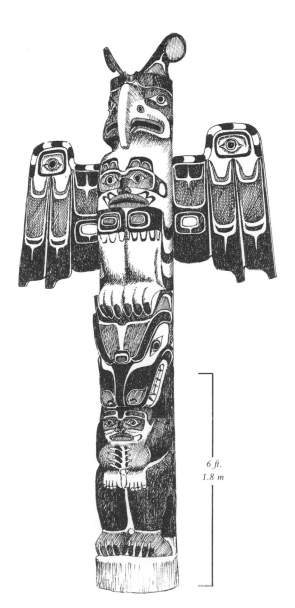

6 ft.
1.8 m

Another pole in the "Route of the Totems" series is this fine work by the prolific carver Sam Henderson, who lived on the nearby Campbell River Reserve.

He created a big, bold Thunderbird, typically Kwakiutl (Kwakwaka'wakw) in style, with decorative outspread wings. Thunderbird's strong claws grip the head of a large Grizzly Bear, who holds a human figure.

In 1966, two of Henderson's sons, Bill and Mark, both well-known carvers, repainted the pole. They replaced the Thunderbird's distinguishing head curlicues, which had long ago fallen off, and enhanced the wings with a few additional embellishments. The pole is painted all over.

131

64/65 LOCATION: *Campbell River—Foreshore Park*
CARVER: *Bob Neel with Eugene Alfred Sr., Dora Sewid Cook/Sam Henderson with Bill Henderson and Ernie Henderson*
CULTURAL STYLE: *Kwakiutl (Kwakwaka'wakw)*

Standing at the water's edge, looking across Discovery Passage to Quadra Island, Heritage Pavilion in Foreshore Park takes the form of the framework of a traditional plank house. One pair of carved house posts at each end supports crossbeams, which in turn carry the main roof beams. An early village

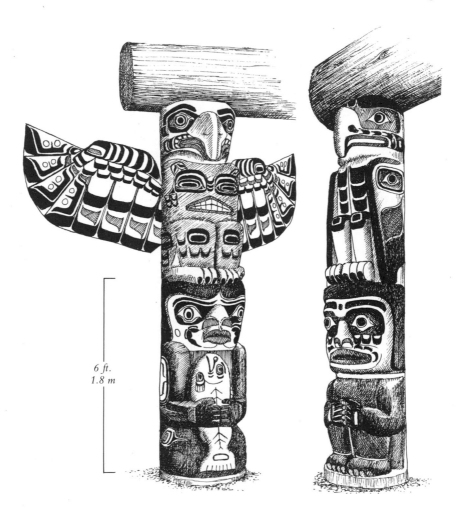

6 ft.
1.8 m

would have had a long row, sometimes two, of similarly constructed houses facing the water.

The pair of house posts at the eastern end, towards the sea, were created by Bob Neel, son of the famed carver Ellen Neel (1916–1966), with the assistance of Eugene Alfred Sr. and Dora Sewid Cook. One of them is shown here (left-hand pole). Beneath each Eagle with outstretched wings is a human holding a salmon.

The two house posts at the opposite end, and both the crosspieces with carvings of Sisiutl, were the work of the renowned Campbell River carver Sam Henderson (1905–1982) and his sons Bill and Ernie. One of these house posts is shown here (right-hand pole). The figures represent crests that belong to their family, handed down through many generations and acquired through the potlatch system.

Notice the two massive roof beams, decoratively adzed, each an 18.3-m (60-foot) clear cedar log from the Nimpkish Valley, one of the oldest stands of timber on northern Vancouver Island. Also notice the dugout canoe hanging under the roof peak—a gift from the native people of Church House, a village at the entrance to Bute Inlet.

The beginning of the 1973 Campbell River Annual Salmon Festival saw the dedication of Heritage Pavilion, with an elaborate ceremony that involved members of native bands from Campbell River, Cape Mudge and Alert Bay. The festival committee produced a 35-minute sound and colour film showing the construction of the pavilion, with Dora Sewid Cook, one of the carvers, narrating some of the history of her people.

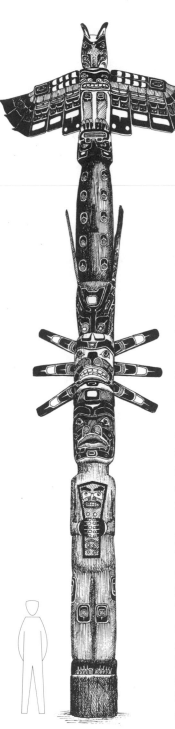

66 LOCATION: *Campbell River—Thunderbird Hall, 1400 We-Wai-Kum Rd., Campbell River Reserve* CARVER: *Bill Henderson with Sam Henderson Jr., Patrick Hunt* CULTURAL STYLE: *Kwakiutl (Kwakwaka'wakw)*

Fronting the We-Wai-Kum Band's large, modern community hall stands a tall pole—a memorial to Bill Roberts, a renowned chief of the band for many years. Both the height and location of this memorial pole carry significance.

A successful fisherman in his day, Bill Roberts always had his trolling poles "exactly 42 feet (12.8 m) long." "When I carved the miniature pole for the Roberts family's approval, before tackling the large version," Bill Henderson said, "I made it 42 inches (107 cm), and the actual pole was 42 feet (12.8 m)."

Bill Roberts was a strong and determined individual who served in World War II and who involved himself in political issues. The chief's memorial, raised in June 1986, graces the front of the community hall which he was instrumental in acquiring for his band.

The figures on the pole illustrate a legend belonging to the Roberts family. It concerns Whale stuck in rocks at Gowlland Harbour (on Quadra Island, across from the village), a big man with a copper and Kolus, who lifted Whale out. The mythical Kolus, with elaborately painted wings, graces the top of this memorial pole. Below is Grey Whale, with long pectoral fins and turned-back tail having a face, followed by Sun, a crest of the Roberts family. At the base is the big man with the copper.

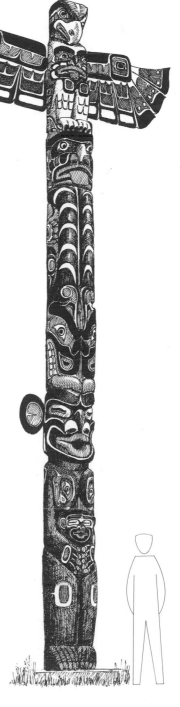

67 LOCATION: *Campbell River—We-Wai-Kum Band cemetery, Campbell River Reserve*
CARVER: *Ernie Henderson with Bill Henderson*
CULTURAL STYLE: *Kwakiutl (Kwakwaka'wakw)*

Standing out against the sky and distant islands, and surrounded by gravestones, are two memorial poles in the cemetery of the We-Wai-Kum Band. The one on the left is a memorial to the renowned carver and greatly esteemed chief of high rank, Sam Henderson, who was also a protector of ancient Kwakiutl (Kwakwaka'wakw) traditions.

Sam Henderson died in 1982 at the age of 77 years. Seventeen months later a memorial pole carved by two of his sons, Ernie and Bill, was raised with difficulty against a wind blowing in from the sea. The following day, when the pole was unveiled in a solemn ceremony, before a very large crowd, the wind abated.

At the pole's top, wings outstretched, is Eagle, the carver's main crest inherited from his mother. Beneath Eagle is the central head of Sisiutl, its scaly, snakelike body folded in half down the pole, terminating in two heads whose tongues meet in the centre. The supernatural Sisiutl had the power to help as well as to harm. If a canoe at sea was unable to proceed because of wind, Sisiutl would surface and fold itself in half to form a self-propelled canoe from which the paddlers towed their own canoe behind.

At the base of the pole stands Dzunukwa holding her child. To the right of the memorial pole is a headstone inscribed to Sam Henderson.

135

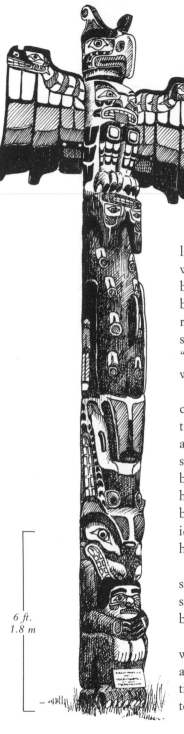

6 ft.
1.8 m

68 LOCATION: *Campbell River—We-Wai-Kum Band cemetery, Campbell River Reserve*
CARVER: *Sam Henderson*
CULTURAL STYLE: *Kwakiutl (Kwakwaka'wakw)*

The memorial pole standing next to Sam Henderson's is that of his beloved wife, May, the eldest daughter of the high-ranking Capt. John Quocksister (Kwasistala) of Campbell River. A strong and influential woman, she was highly revered for her role both in the community at large and within the band. To the right of her pole, a headstone reads simply: "Mother, May Louise Henderson. Mar. 17/1917–Sept. 17/ 1978." The word "mother" carries significance for a woman who bore seven sons and eight daughters.

The memorial displays May Henderson's crests. At the top is Thunderbird, with an interesting design device: Sisiutl, stretched across the top edge of Thunderbird's outspread wings, has its central head on the bird's chest. Beneath is a large Grey Whale, head down, with its tail flukes curved over its back; the short dorsal and long pectoral fins identify the sea mammal. At the base is Bear holding a child.

There are only a few instances where a person has both a memorial pole and a headstone, but Sam and May Henderson each have both.

Traditionally, totem poles always faced the water, the route of travel for anyone arriving at the village. But these poles, in a different time and context, face not the sea but the contemporary route of travel—the roadway.

69 LOCATION: *Cape Mudge, Quadra Island—Kwagiulth Museum and Cultural Centre*
CARVER: *Dora Sewid Cook with Eugene Alfred Sr., Jeff Wallace*
CULTURAL STYLE: *Kwakiutl (Kwakw<u>aka</u>'wakw)*

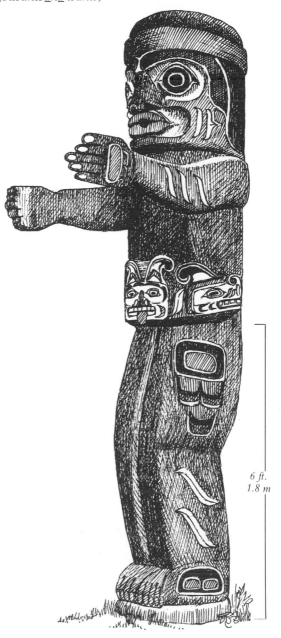

6 ft.
1.8 m

This pole is a recarving of one of three welcome figures that were given by Chief Wa'kas of Alert Bay to Major Dick of Cape Mudge as part of a dowry. They stood inside his big house at Cape Mudge until his death, when they were moved to his gravehouse on the foreshore. Many years of outdoor exposure caused their deterioration before the Campbell River Museum collected and preserved two of the poles, the third being too rotted to save.

In 1972 the Cape Mudge Band brought together several petroglyph boulders endangered by erosion and created Petroglyph Park (across the road from the museum). Dora Sewid Cook and assistants carved three new figures that stood to welcome people to the park, but in 1979, with the opening of the Kwagiulth Museum and Cultural Centre in the village, the

poles were moved to welcome visitors there. The Campbell River Museum returned the two original figures, which are now housed in the Kwagiulth Museum.

In giving the original welcome figures to Major Dick, Chief Wa'kas also gave the legend that went with them:

Paddling upriver, a man and his servant reached a village occupied only by an old blind woman and her granddaughter. When the man ordered his servant to fetch water from the river, the old woman warned him of a huge river monster, which had swallowed all the villagers who had gone near the water. The man took off his belt, made in the form of a Sisiutl, and put it around his servant for protection, but to no avail, for the river monster swallowed him. The man called to the Sisiutl, "Break apart! Break apart!" The monster jumped ashore and his stomach broke apart, releasing the servant, human bones and others still half-alive. The man splashed the Water of Life on them, and they revived; he also splashed it on the blind woman's eyes, and her sight returned.

The Sisiutl around the waist of this welcome figure commemorates the achievements of the supernatural creature and recalls the story that goes with the carving.

70 LOCATION: *Cape Mudge, Quadra Island—*
Kwagiulth Museum and Cultural Centre
CARVER: *Sam Henderson with Bill Henderson,*
Ernie Henderson
CULTURAL STYLE: *Kwakiutl (Kwakwaka'wakw)*

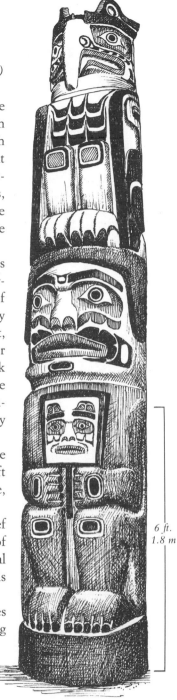

The Kwagiulth Museum and Cultural Centre at Cape Mudge, built in 1979, has a collection of potlatch ceremonial regalia, most of which had been appropriated by federal government agents during the famous Dan Cranmer potlatch of 1921. After years of negotiations, many of these valuable family heirlooms were finally returned to their owners and are housed in the museum.

Standing boldly beside the front entrance is a totem pole that was carved by Sam Henderson of Campbell River with help from two of his two sons, Bill and Ernie. It was originally commissioned by the provincial government, loaned to Expo 70 in Osaka, Japan, and later presented to the Kwagiulth Museum to mark its opening. The formal ceremonies for the museum's opening on 12 November 1980 included the dedication of the pole, followed by the customary potlatch and feast for all.

Thunderbird, with wings folded, tops the pole. This crest was a *kaysoo*; that is, a gift brought to the carver from his wife's lineage, through his marriage to her.

The figure at the base represents the chief or "First Man" of the Nakwakto people of Blunden Harbour, Sam Henderson's original home. The chief holds a painted copper in his hands.

The squarish ovoids painted on the knees of seated figures are generally an identifying mark of Henderson's work.

6 ft.
1.8 m

139

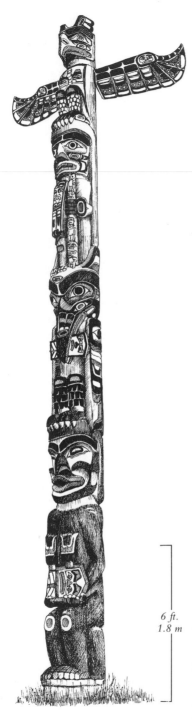

6 ft.
1.8 m

71 LOCATION: *Alert Bay—*
Alert Bay cemetery
CARVER: *Henry Hunt and Tony Hunt*
CULTURAL STYLE: *Kwakiutl*
(Kwakwaka'wakw)

On a grey day in September 1970, more than a thousand people gathered to pay homage to a man renowned along the coast as a great Kwakiutl (Kwakwaka'wakw) chief and for his role in preserving and passing on his people's artistic skills and knowledge, as well as traditional beliefs.

Mungo Martin had died on 16 August 1962, at the age of seventy-eight. His body lay in state in the traditional plank house he had built in Thunderbird Park, Victoria; his coffin was carved with his crests at both ends, and a replica of his copper was carved on top. To fulfil his wish to be buried among his people, the casket was taken to Alert Bay on board the naval vessel HMCS *Ottawa*. The coffin was covered with flowers and guarded by four sentries with fixed bayonets during the voyage north. As the boat left Victoria harbour, every flag dipped in respect.

The elaborately carved totem pole, raised by hand-hauled ropes in the Alert Bay cemetery, stands near the grave of the widely acclaimed chief. It was the first pole raised in the village in forty years. At the ceremony, many high-ranking chiefs, richly dressed in ceremonial regalia and all speaking their native tongue, testified to the worth and stature of this great man. The traditional pageantry was followed by lavish feasting and further ceremonies in the dance house. Carved house posts and a painted screen created a backdrop to the

140

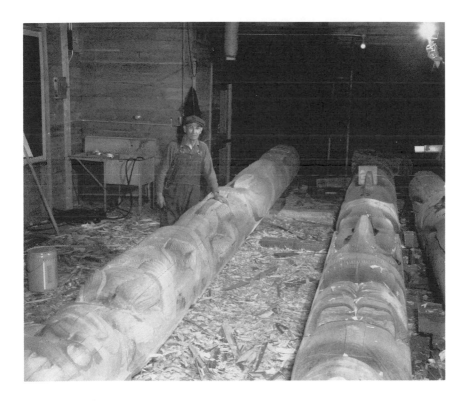

drummers and dancers, as a fire blazed in the centre of the earth floor.

Master carver Mungo Martin with two unfinished poles at the carving shed on the University of British Columbia campus, 1951. MUSEUM OF ANTHROPOLOGY, UNIVERSITY OF BRITISH COLUMBIA

The figure at the top of the memorial pole is Kolus, who founded the lineage from which Mungo Martin's father was descended; he has a copper painted on his chest. Below is Cedar Man emerging from the log, holding a copper and a carved talking stick. The third figure is Raven, holding a copper in his beak, wings at his side. Raven, a Hunt crest, was carved in memory of Mungo Martin's son David, who had married into the Hunt family. At the base holding a copper is Dzunukwa, a crest of Mungo's wife, Abaya'a. The depiction of four coppers on one pole attests to the high rank and prestige of this remarkable man.

An additional memorial to Mungo Martin is a wooden plaque, designed by Bill Reid and carved by Tony Konings, at the Royal British Columbia Museum. It depicts Mungo Martin in chiefly attire holding his talking stick and copper, as well as in working clothes carving a totem pole.

141

72 LOCATION: *Alert Bay—
Nimpkish Band cemetery*
CARVER: *Willie Seaweed with
Joe Seaweed*
CULTURAL STYLE: *Kwakiutl
(Kwakwa̱ka'wakw)*

A much-photographed pole is
this memorial to Billie Moon.
The pole, carved at the village
of Ba'a's (Blunden Harbour)
in 1931, is by Willie Seaweed,
a man renowned for his pro-
lific output of exceptionally
fine Hamatsa masks. His son
Joe assisted him.

Blunden Harbour, in its
northern isolation, maintained
its old customs for longer
than other villages on the
coast, and Willie Seaweed,
born in 1873, continued his
people's tradition of well-
crafted carving. This is one of
his finest creations. He died
in 1967.

The finished pole was
towed by fishboat from Blun-
den Harbour to Alert Bay,
some 58 km (36 miles) to the
south. Since that time, it has
been repainted at least twice,
resulting in changes to the
many design details.

The memorial is topped by
Thunderbird, its claws grasp-
ing the head of the giant
Dzunu̱kwa, with her charac-
teristic sleepy eyes, pursed
lips and pendulous breasts.

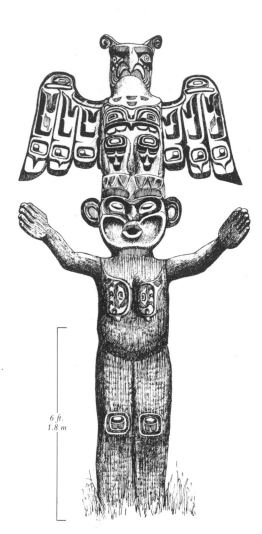

6 ft.
1.8 m

142

73 LOCATION: *Alert Bay—*
Nimpkish Band cemetery
CARVER: *Tony Hunt with Calvin Hunt,*
John Livingston, Peter Knox
CULTURAL STYLE: *Kwakiutl*
(Kwakw̲ak̲a'wakw)

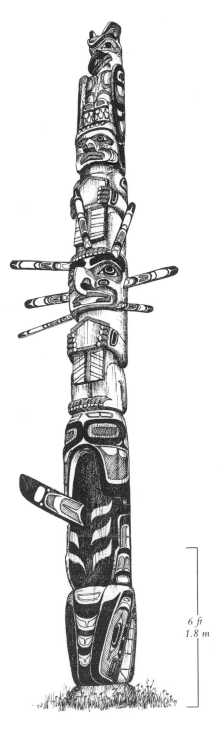

Jonathan Hunt was born in Fort Rupert, in a traditional plank house. He was the grandfather of Tony Hunt, and he was getting on in years when he attended the ceremonies in Alert Bay for the raising of Mungo Martin's memorial pole, which Tony and his father, Henry, had carved.

Mungo Martin and Jonathan Hunt had been close friends for many years, and during the eulogy that Jonathan Hunt gave at the ceremony, he said, looking Tony Hunt in the eye: "When I die, I want a pole just like my best friend's."

A few years later, Jonathan Hunt died. His grandson fulfilled the elder's wish by carving a memorial pole equal to that of Mungo Martin's. Six days of ceremonies and potlatching accompanied the pole-raising event, which included the transference of hereditary rights and privileges to Hunt family members. "It was at this time," Tony Hunt recalled, "that I began asserting my role as a chief."

The memorial pole has Kolus perched at the top, followed by Cedar Man holding a copper; beneath is Sun in human form, also holding a copper; at the base is Killer Whale, head downward, with its tail turned back onto its body.

6 ft
1.8 m

143

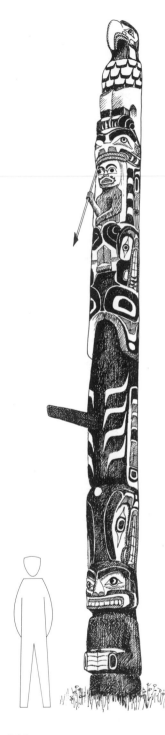

74 LOCATION: *Alert Bay—Nimpkish Band cemetery*
CARVER: *Doug Cranmer with Richard Hunt, Bruce Alfred, Donna Ambers, Fah Ambers, Richard Sumner*
CULTURAL STYLE: *Kwakiutl (Kwakwaka'wakw)*

The name Dan Cranmer is legendary on the Northwest Coast, particularly among the Kwakiutl (Kwakwaka'wakw). In 1921, when potlatching was still banned, Dan Cranmer gave a potlatch so opulent (the gifts included twenty-four canoes, five gas boats and three pool tables) that the law-makers pounced hard. Thirty-four people were charged; some went to jail, and others surrendered their ceremonial masks and other objects in lieu of a sentence. After a long battle with the federal government, the native people of Alert Bay and Cape Mudge eventually succeeded in having many of these items returned.

A fine memorial pole for Dan Cranmer was raised in 1978. It was created by his son Doug Cranmer, a renowned carver, working with several assistants. Traditional ceremonies in the large dance house and a lavish potlatch accompanied the solemn event of Dan Cranmer's memorial.

The figure at the top is Thunderbird (wings now fallen off), standing on the centre head of Sisiutl, with a man holding a spear between the body of the two-headed serpent. Below is Killer Whale, its head downward. At the base is Giant Halibut, a mythical being who, at the mouth of the Nimpkish River, shed his tail, fins and skin, transformed into a human, and became the founder of the Nimpkish people.

75 LOCATION: *Port Hardy—Bear Cove Ferry Terminal, "Route of the Totems"*
CARVER: *Henry Hunt*
CULTURAL STYLE: *Kwakiutl (Kwakwaka'wakw)*

Travellers making the day-long ferry voyage from Port Hardy through the scenically spectacular Inside Passage to Prince Rupert will see a "Route of the Totems" pole close to the pay booths at the entrance to the terminal at Bear Cove.

The pole originally stood at the ferry terminal at Kelsey Bay, some distance south of its present location, which was as far north as the road then went. With the extension of the highway to Port Hardy, the ferry terminal was relocated to Bear Cove in 1979 to shorten the long voyage, and the totem pole went with it.

Carved by Henry Hunt, the pole portrays Grizzly Bear holding a salmon. It is painted all over in red, black and white, colours that by chance happen to harmonize with the grey and reddish tones in the rocky bluff backing it.

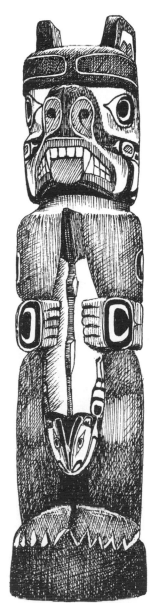

6 ft.
1.8 m

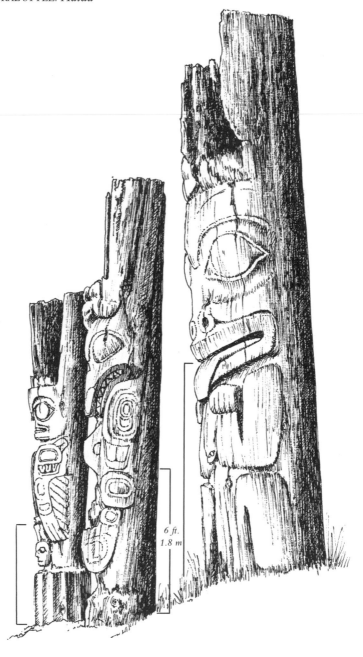

6 ft.
1.8 m

146

Off the west coast of the southern tip of Haida Gwaii (the Queen Charlotte Islands) lies Anthony Island (or more correctly, Skungwaii), and on it is the old village site of Ninstints. Some sixteen poles and house remains line the crescent beach, giving a haunting glimpse of a former grandeur. Its power remains yet.

In 1981, about a hundred years after Ninstints was abandoned, UNESCO declared it "A World Heritage Site, of importance to the history of Mankind." Many of the largest and best preserved poles had been removed in 1957 for preservation; now, nearly all those remaining are mortuary poles, their frontal boards fallen away. One, however, still has the planks covering the top and the rocks which hold them down.

Illustrated are three of these poles. From left to right, their main crests are: Eagle (the beak, attached separately, has fallen away), Whale (with its dorsal fin in the centre, upturned tail at the base) and Grizzly Bear.

Ninstints is protected by law because of its world heritage status, as well as by onsite Haida custodians called Watchmen.

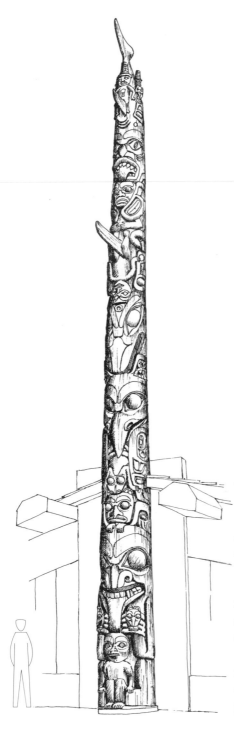

79 LOCATION: *Skidegate—
Skidegate Band Office*
CARVER: *Bill Reid with
Gary Edenshaw and others*
CULTURAL STYLE: *Haida*

When the Skidegate Band Council
needed larger premises, they con-
sidered purchasing a double-wide
trailer. What they eventually got
was an attractive cedar building de-
signed by Rudy Kovacs on the lines
of the traditional six-beam plank
houses that had once lined the
beach in profusion.

Bill Reid, talking one day with
Chief Councillor Percy Williams,
deplored the lack of poles in the vil-
lage. There remained only a single,
weather-worn, decaying pole out of
the dozens that once had stood be-
fore the old houses. And thus an
idea was born: Reid would design
and carve a new pole to front the
administration building. Because
Haida art had been the focus of his
long and successful career, and be-
cause his mother had come from
Skidegate, he would donate the
pole as a tangible expression of his
gratitude.

Bill Reid spent the summers of
1976 and 1977 at Second Beach
near Skidegate, working under a
small plastic-covered framework as
shelter against the elements. The
18.3-m (60-foot) log protruded
from both ends of the shelter; as
each section of carving was com-
pleted, the lightweight shelter was

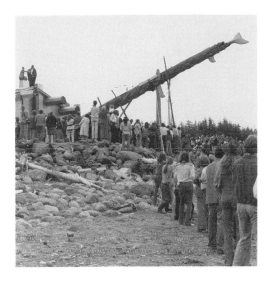

Raising Bill Reid's pole at Skidegate. Crutches help to support the pole's weight.
HILARY STEWART

moved along to the next uncarved area. Haida carver Gary Edenshaw (now better known as Guu-jaau) made a significant contribution to the work, and well-known artist/carvers such as Robert Davidson, Gerry Marks and Joe David volunteered their carving skills.

Scores of visitors, many from around the world, stopped by to watch as the flying wood chips piled up around the log. Those attending the party at the project's completion went home with autographed chips of red cedar.

On 10 June 1978 the pole was raised with much pomp and ceremony against a background of rich regalia worn by high-ranking native people from all along the coast. Fifteen hundred native and non-native people attended the potlatch that evening, at a sit-down feast comprised mainly of a wide assortment of local seafoods. Gifts were distributed to everyone.

The unpainted pole, now weathered to a silver grey, represents the animal kingdom with a fish, a bird, a sea mammal and a land animal. At the top, four Watchmen are grouped around the asymmetrical tail of Shark, which has a large downturned mouth and pointed teeth. Below are the three principals of the Nanasimget story—the husband clasping the tail flukes of Killer Whale, and the wife (upside-down) on its back. Raven, beneath, has Frog in his beak; the human head and hands signify the human side of Raven and form his upturned tail. Grizzly Bear at the base tells of the Bear Mother story.

In 1988 a fierce wind sent the single, old, decayed pole crashing to the ground, but Skidegate is not without a cedar monument.

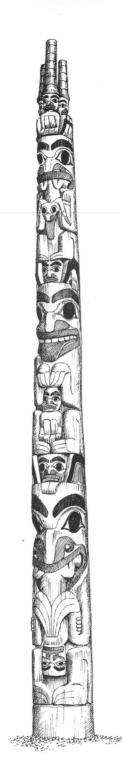

80 LOCATION: *Old Massett—*
St. John's Church
CARVER: *Robert Davidson with Reg Davidson*
CULTURAL STYLE: *Haida*

In 1965 a Haida youngster left his native village of Old Massett, on the Queen Charlotte Islands, to attend secondary school in Vancouver. While visiting a museum there, he came to realize the greatness of his artistic heritage. He saw bowls, ladles, boxes, masks and paddles—all carved from wood—as well as miniature totem poles of argillite, a soft black stone found on the islands—and was deeply impressed. The youngster, Robert Davidson, is now an artist, carver and jeweller of international repute.

At nineteen years old he studied a short while with Bill Reid, and together they carved a 1.8-m (6-foot) totem pole—the master carving one side, the young artist the other. Robert Davidson also attended the Vancouver School of Art.

On a subsequent visit to Old Massett, the young carver felt a deep compassion for the elders, people out of touch with their once rich and flourishing artistic culture. He "felt driven" to carve a totem pole for them. For inspiration, he turned to old photos of his village and chose a simple-looking pole. Consulting with his eighty-nine-year-old grandfather, the young carver showed him a photo of the pole. "I can't see it," the elder said. "Do me a drawing so I can see it."

"So I made a drawing," Robert Davidson said, "and I had to create my own interpretations for figures that weren't clear in the old photo."

Claude Davidson, Robert's father, felled a tree for the pole, but it was not big enough for the carver. He felled another, and Robert Davidson, only twenty-two years old, set about the formidable task of carving a 16.8-m (40-foot) traditional Haida pole. When it was finally raised, by hand, in the late summer of 1969, with a large crowd to witness and attend a lavish potlatch, it was the first totem pole to be raised in the Queen Charlotte Islands in close to half a century.

Three high-hatted Watchmen crouch at the top of this pole, which is composed mainly of three Bear crests, integrated with several small humans and Frog. At the pole raising, the carver interpreted the figures as representing the Bear Mother story. Research carried out in later years describes the figures at the base of the old pole (indistinct in the photo) as Wolf eating Whale.

The raising of this pole marked a turning point in pride on the islands, sparking a rebuilding of Haida culture and nationhood that continues still.

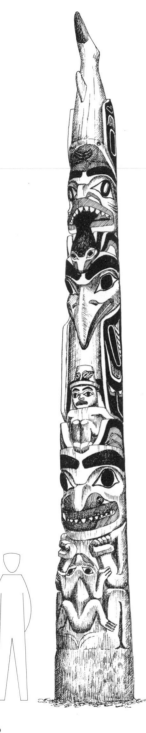

81 LOCATION: *Old Massett*
CARVER: *Reg Davidson with Richard Baker*
CULTURAL STYLE: *Haida*

At the north end of Old Massett stands the first pole on the Queen Charlotte Islands—in perhaps a century—to be raised for a house and its chief. The name of the house is K'a·adsnee, Shark House. Claude Davidson acquired the name from an uncle.

This was the first pole Reg Davidson, Claude's son, carved on his own, and he found it a tremendous amount of work: "Towards the end we were working from daybreak to sundown, twelve hours at a stretch." Glen Rabena helped near the end.

The totem pole was raised in front of Claude Davidson's house during a potlatch on 21 and 22 November 1986. The first day saw a solemn ceremony in memory of Claude's brother, Alfred, and Alfred's wife, Rose. The pole was raised the following day. That evening, Claude Davidson was made the hereditary chief of Dadens, a historic and long-abandoned village on Langara Island.

At the top of the pole is Shark, with Whale in its teeth. Next is Raven, and at his feet a woman who represents Sarah Davidson, Claude's wife. She wears a labret to signify high rank, and on her spruce root hat is painted Eagle (left) with a round eye, and Raven (right) with an ovoid-shaped eye.

At the base of the pole stands Grizzly Bear, the main crest of Claude Davidson, and Frog, a crest given to his wife, Sarah, a non-native.

152

82 LOCATION: *Prince Rupert—*
Museum of Northern British Columbia,
McBride St. and 1st Ave.
CARVER: *Dempsey Bob with Glen Wood*
CULTURAL STYLE: *Nisga'a*

Beside the Museum of Northern British Columbia is a pole that is the third reincarnation of a pole that belonged to an Eagle family at Gitlakdamix, on the Nass River. The original was destroyed by fire, and a replica (carved in the early 1890s from a photograph) was taken to the Royal British Columbia Museum, where it now stands by the ground-floor escalator.

The second replica was carved in the early 1960s by William Jeffrey, but it eventually blew down in a tremendous windstorm, breaking into several pieces.

In 1978 well-known carvers Dempsey Bob and Glen Wood were commissioned to replicate the pole once again. The pole, finished with a minimum amount of paint (as was traditional), shows some of the figures associated with the migration of the Eagle people to the Nass River.

Two Eagles perch side by side atop the pole above what the carver said is a Gitksan Human crest. "The head once had tufts of hair hanging from its forehead," Dempsey Bob explained, "but years of wind and weather have worn them to stubby bristles, which you can see." Beneath are two rows of three human figures, followed by Split-Person (notice the head), and then White Marten. Below are two brothers and their uncle who feature in the family history, and at the base is Eagle-Person representing the Eagle family that owned the pole.

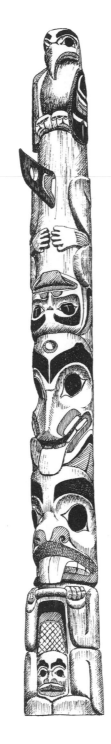

6 ft.
1.8 m

83 LOCATION: *Prince Rupert—Museum of Northern British Columbia, McBride St. and 1st Ave.*
CARVER: *Alvin Adkins with Dale Campbell, Terry Campbell*
CULTURAL STYLE: *Haida*

Just east of the Museum of Northern British Columbia, on Market Place, stands a simple wooden shed that would hardly be noticed—if it were not for the fine pole fronting the gabled building. The structure is a carving shed, a workshop facility for northern native carvers who pay an annual fee to make use of it. During the summer the doors often are open, affording a chance for visitors to watch artists working on a small argillite sculpture, making silver jewelry, carving a mask, a bowl or perhaps even a totem pole.

Haida artist Alvin Adkins designed the carving shed's frontal pole, while the brother and sister team of Tahltan/Tlingit carvers, Dale and Terry Campbell, assisted in the carving. Sponsored by the nearby museum, the pole also provided an opportunity for less experienced carvers to learn as they worked on the cedar log with adze and chisel.

Eagle tops this pole, which has the classic Haida Beaver at its base. Between is the often depicted Nanasimget story of the man whose wife was abducted by Killer Whale. She is shown upside-down, clinging to Killer Whale's body, with the dorsal fin protruding above her hands. The centre of the pole carries Killer Whale's head, with the blowhole shown as a circle on its forehead. The pole was raised with due ceremony in 1981.

154

84 LOCATION: *Prince Rupert—Moose Tot Park, 6th Ave. and McBride St.*
CARVER: *Freda Diesing with Josiah Tait*
CULTURAL STYLE: *Haida*

An excellent replica of an old, classic Haida pole towers above the children who frequent the playground where it stands.

The original was a house pole on the southernmost dwelling in a long row of houses at Tanu, a large, once thriving village on the Queen Charlotte Islands. In 1939, when the abandoned village was heavily overgrown with vegetation, the pole was cut down and taken to Prince Rupert for display. Seventeen more years of weathering took their toll, and in 1965 the pole was taken to Victoria to be housed inside the Royal British Columbia Museum.

Freda Diesing, a Haida carver, was commissioned to carve a replica. She had studied at the Gitanmaax School of Northwest Coast Indian Art in 'Ksan, and became one of the few women to carve totem poles. She worked on the pole with Nisga'a carver Josiah Tait (father of carver Norman Tait), and together they finished the pole in 1974.

As is typical of many Haida poles, this one is topped by three Watchmen. Below is Eagle holding a staff and with a human face on its upturned tail. Beneath is probably Owl (possibly Hawk), with a short downturned beak, holding an object in its humanlike hands. Next is an abbreviated Whale, depicted only by its round snouted head and upturned tail flukes, followed by Grizzly Bear and Frog.

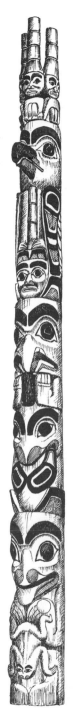

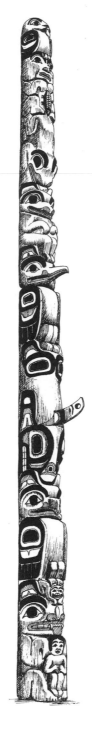

6 ft.
1.8 m

85 LOCATION: *Kitsumkalum—4 km (2½ miles) west of Terrace on Highway 16*
CARVER: *Freda Diesing with a team of assistants*
CULTURAL STYLE: *Gitksan*

On the north side of the highway, close to a native gift shop, stand two tall totem poles—the first to be raised in the village in more than 150 years. Both were carved by a team mainly of women: Freda Diesing, Dorothy Horner, Myrtle Laidlaw and Sandra Westley, with the help of two young men, Norman Horner (Dorothy's son) and Norman Guno.

The Kitsumkalum Band commissioned the first pole, illustrated here, which incorporates the crests of all the families in the village. The pole is topped by Robin (the band's name means "people of the robin"), below which is a man holding a fish. He represents We-gyet (Big Man), the supernatural human/Raven of Gitksan, Tsimshian and Nisga'a lore who brought salmon to all the rivers. Next, in descending order, are Frog, Wolf, Raven, Killer Whale and Eagle. At the base, three figures represent the Bear Mother story: Bear, with a cub between its ears, holds his human wife in front of him. Each carver completed a crest figure, with Freda Diesing supervising.

In a unique ceremony on 1 August 1987, both poles were raised at a major celebration called Su-sit-'aatk, which means "a new beginning." The event, which also included the installation of a high-ranking chief, expressed the intention of the villagers to revitalize their culture.

86 LOCATION: *Kitsumkalum—4 km (2½ miles) west of Terrace on Highway 16*
CARVER: *Freda Diesing with a team of assistants*
CULTURAL STYLE: *Gitksan*

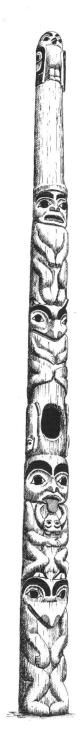

6 ft.
1.8 m

The second Kitsumkalum pole is largely a replica of an old pole that once stood in the village but which was swept away during a major flood more than a hundred years ago. This replacement pole was carved from an early photograph by the same team that created the first Kitsumkalum pole, plus a fifth woman, Lorraine McCarthy. "The formal style," Freda Diesing said, "is that of the Upper Skeena River area a century ago, depicting humans and animals rather than birds, and with very little paint."

The entire carving represents the Bear Mother story, as did the original, but with the addition of the Kitsumkalum Robin perched on top of a tall hat worn by one of the brothers who searched for the abducted woman. Beneath is Bear, and in the centre of the pole is a cavity that represents the cave in which the Bear family lived in hiding. The animals flanking the cavity are the dogs of the hunters searching for them. Below is the Bear Mother holding one of her cubs, with her Bear husband at the base.

Dorothy Horner recounted the hard work involved in adzing and carving, day after day, for weeks and months on end. Then she added, "It felt good, it made you feel calm. I miss it now—I'd like to do another."

157

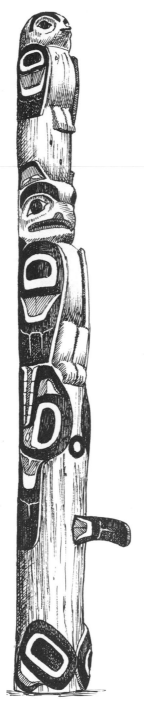

6 ft.
1.8 m

As a longtime resident of Terrace, carver
and artist Freda Diesing felt that it would
help to foster good relations between the
citizens of Terrace and the people of Kit-
sumkalum if the native people donated a
totem pole to the city to commemorate its
diamond jubilee.

Three carvers from the team that made
the Kitsumkalum poles carved their own
crests from Freda Diesing's design. Vernon
Horner worked on his Robin crest at the
top, which also represented the band; his
mother, Dorothy Horner, carved Eagle in
the centre, and Norman Guno carved
Whale at the base. Whale's head, with its
large teeth and circular blowhole, is upper-
most, with a flipper at each side, a protrud-
ing dorsal fin and symmetrical tail flukes at
the base.

On 29 July 1987, the mayor, Royal
Canadian Mounted Police, civic dignitaries
and townspeople joined with the people of
Kitsumkalum to witness the ceremony in
which Chief Clifford Bolton officially pre-
sented the pole to the city of Terrace. In a
speech, he explained that the crests repre-
sented progress and future development,
as well as being the crests of "the carvers
and the people of Kitsumkalum—which
people shall be forever present."

POLES AT 'KSAN

NEAR HAZELTON

On the banks of the Upper Skeena River, near Hazelton in north central British Columbia, amid spectacular scenery, stands the village of 'Ksan. Its single row of traditional plank houses with painted fronts and a cluster of totem poles stand where native villages have stood for thousands of years.

The reconstructed Gitksan village of 'Ksan, on the Skeena River near Hazelton, 1977. HILARY STEWART

'Ksan had its beginnings in the 1960s as an attempt to solve the social and economic problems of Hazelton (population then 432) and to promote understanding and respect for native people and their traditions. It began with a single building to house and display the ceremonial artifacts and regalia of many chiefs, who had access to them when needed. Quality native crafts were also available for visitors to purchase. Over the years, the success of this small museum, called the Treasure House, eventually led to the idea of building an entire village as it would have been a hundred years ago.

Through the co-operation of local, provincial and federal governments, the necessary funding was raised, and 'Ksan was officially opened on 12 August 1970 with great ceremony and jubilation.

'Ksan is a reconstructed Gitksan village, with traditional-style buildings that house a museum, an exhibit hall, the only existing school for Northwest Coast native art, a gift shop that sells local native work and a feast house where visitors can witness traditional dances and ceremonies. A large campsite beside the river caters to visitors from around the world. There is no entry fee to the village.

The name 'Ksan means "river of mists," though anglicization has changed the river's name to Skeena. The prefix *git* means "people of"; thus, the Gitksan of the Hazelton area are "the people of the river of mists." The revival of their arts includes a large, well-costumed dance group, the 'Ksan Dancers, which has performed internationally.

Because of its place in this cultural renewal, 'Ksan is regarded as "the Breath of our Grandfathers." Inspired by the past, born in the present and bequeathed to the future, the arts of 'Ksan continue to enjoy success and popularity. Understanding and respect for their traditions have indeed become a reality.

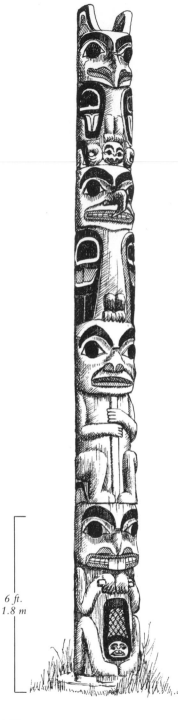

6 ft.
1.8 m

88 LOCATION: *'Ksan—at the entrance*
CARVER: *'Ksan carvers*
CULTURAL STYLE: *Gitksan*

Although an archway to mark an entrance is not a traditional concept in Northwest Coast native culture, nevertheless the twin poles joined by carved and painted planks form an inviting entrance to the renowned village of 'Ksan.

Each pole carries figures of people and creatures found in Gitksan histories and traditions.

At the top is Eagle, and beneath him crouches a small Frog, whose hind legs appear in the ears of the figure below. Many Frog crests are derived from long and complex legendary tales pertaining to frogs.

The creature below Frog is Hawk, a supernatural bird having a sharply recurved beak as well as a mouth with teeth. The next figure is that of a chief holding a staff, and below him is Beaver with large incisor teeth, holding a chewing stick, and with the customary cross-hatched tail having a face at the joint. The poles are painted red and black.

The two cedar planks that form the arch are similar to those once used in house construction. Boards of great width and length were split from cedar logs to build the walls and roof of a house, as well as the interior platforms.

To pass through the arched entrance and to walk into the village of 'Ksan is to take a journey back in time.

89 LOCATION: *'Ksan*
CARVER: *Duane Pasco and 'Ksan carvers*
CULTURAL STYLE: *Gitksan*

The opening of the village of 'Ksan on 12 August 1970 called for great ceremony, and a special totem pole was raised to commemorate the jubilant event. This pole, called the Meeting Place, carries crests of the three local clans.

Standing stiffly to attention on the top of the pole, and looking somewhat out of place, is a white man—a British Columbia government representative, complete with top hat and bow tie. At his feet are leaves of the dogwood tree, its flower being the official floral emblem of the province.

Beneath the white man is Eagle, representing a small clan of the area, and below is a crouched Wolf, with a long snout and upright ears, representing the Wolf clan. At the base is a crest of the dominant Fireweed clan—Mosquito transforming into a human, with wings giving way to arms and the human legs already in place. A small Frog is visible on Mosquito's forehead—a part of the story that goes with the crest.

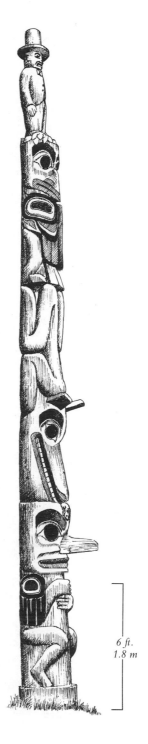

6 ft.
1.8 m

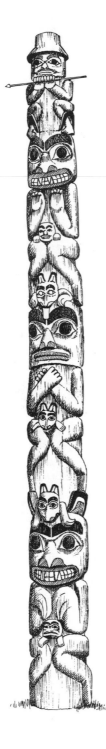

90 LOCATION: *'Ksan*
CARVER: *Duane Pasco with 'Ksan carvers*
CULTURAL STYLE: *Gitksan*

Because 'Ksan is a reconstructed village, the poles created for it are also reconstructions; family crests and story figures shown are somewhat hybrid versions of the real thing.

This pole, for instance, loosely portrays the Bear Mother story. At the top is one of the brothers. Below is Bear, with the woman he abducted shown peeking out over his thighs. The next two figures portray the Bear Mother and her Bear husband, but the design includes three cubs instead of the traditional two. A small Frog fills the space below Bear's paws.

This was the first pole raised in the 'Ksan project. Sheltered by a lean-to shed, the carvers began working on it in October 1969 and continued on into the cold winter of the north. By the time the pole was ready for painting, the plunging temperature and cold winds turned the paint into a jellylike paste, making continuous painting impossible. To overcome the problem, the carvers worked in relays.

Duane Pasco said, "One man would heat his can of paint indoors, then run out and apply the paint for as long as it stayed liquid; then another man would replace him with a warmed can of paint and continue the work." Eventually, in spite of freezing cold fingers, even in gloves, the job was finished.

91 LOCATION: *Hazelton—at the foot of Government St.*
CARVER: *Not known*
CULTURAL STYLE: *Gitksan*

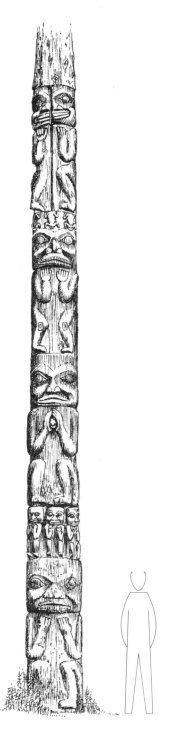

Carved around 1889, this tall pole now stands on the banks of the Skeena River, relocated from Gitanmaax village.

The upper third of the pole, adzed into a square shaft, may once have been topped by a crest figure. The uppermost figure is Corpse Split in Two, and beneath is Nose Like Coho, two crests whose origin and significance have been lost to antiquity. The delicately carved frogs on the forehead of Nose Like Coho represent the Flying Frogs crest.

Below is Man of the Wilds (or Bush Man) gently holding a small frog in his cupped hands in the same way that a shaman holds a patient's soul.

Next is a row of three children; they depict a dramatic spirit device enacted at the winter ceremonials, in which children of the household represented the salmon running upstream. The figure at the base is either a crest figure called Halfway Out (of the door) or Man of the Wilds again.

This pole is especially noteworthy for its interesting details, which can easily be missed: look for the two different facial expressions on the two halves of Corpse Split in Two, as well as the fact that one palm is turned in and the other out. Also, look for the small oval faces (sideways on) carved on Nose Like Coho's knees and elbows—the one on the right is the best preserved.

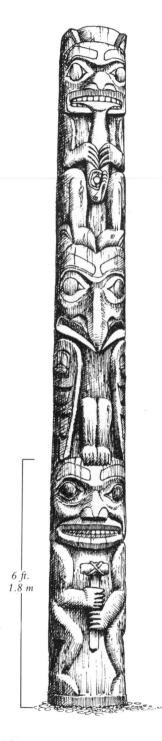

6 ft.
1.8 m

At the entrance to the old village of Kispiox, which is well known for its totem poles, is an attractive band office and cultural centre building.

A red-and-black painted split-design of Raven stealing the sun fills the triangle formed by the building's roof gable, while Eagle and Raven decorate the double front doors. In addition, two fine unpainted poles flank the entrance and proclaim the identity of the band.

Part of the ceremony to officially open the new building in October 1978 was the carrying and raising of these two poles. Drumming and singing by elders in ceremonial regalia culminated in a speech, in his native tongue, by eighty-five-year-old Moses Morrison. As he cut the ribbon, he called out in English, "We are all united!"

The pole on the left has Bear with a salmon at the top. In the centre is Raven, and at the base is the figure of the legendary Ya-l, the founder of the Kispiox people, holding a weapon. In ancient times there was but one village, Temlaham, where lived a wicked man named Ya-l. He would kill at the slightest provocation, then flee to a hiding place, but he always returned with many beaver skins. One day a boy taunted the snow, causing a local winter, and the people left the village. A group led by Ya-l moved to his hide-out, which he had named Kispiox, meaning "place of hiding."

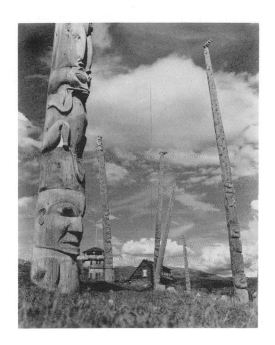

Leaning totem poles at Kispiox, before the 1920s reconstruction project; some of them are still standing. ROYAL BRITISH COLUMBIA MUSEUM/7960

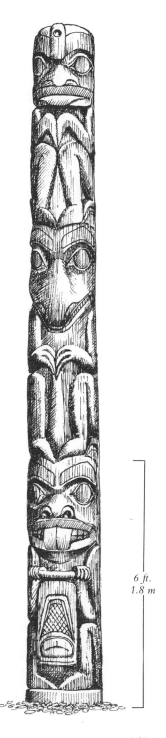

6 ft.
1.8 m

The pole on the right depicts Frog at the top. Below is long-snouted Wolf holding his long tail, followed by a classic Beaver with its cross hatched, upturned tail, round nostrils and two large incisor teeth.

The well-known artist and carver Chief Walter Harris, who lives in Kispiox, worked on the poles alone.

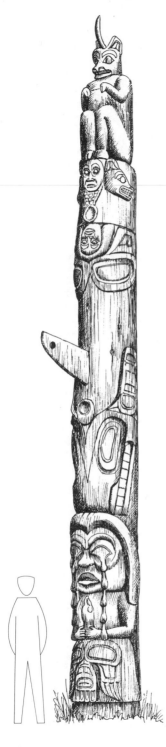

94 LOCATION: *Kispiox*
CARVER: *Walter Harris, Earl Muldoe, Vic Mowatt*
CULTURAL STYLE: *Gitksan*

Raised in 1973 with all due ceremony, this fine pole carries ancient and interesting stories.

At the top is a family crest—One-Horned Mountain Goat. In the ancient past, the villagers of Temlaham no longer regarded animals with respect and recklessly slaughtered herds of mountain goats. They took one young goat home as a trophy, but a youth of the village took it for a pet, rescuing it from abuse.

In revenge for the slaughter, the surviving goats, in human form, invited the offenders to a feast at their mountain lodge. Unaccustomed to such craggy terrain, the villagers fell to their deaths in the night—all except the youth who had been kind to the young goat. Thus, his family adopted as a crest the goat with a single horn on its head.

Below are Wolf heads flanking a supernatural being wearing a necklace of abalone shell, with a pendant representing the sun. The central figure is White Whale, head downward.

At the base, Weeping Woman tells of a time when there was starvation in the land. Two sisters saw a grouse, which they captured and ate; but it had come too late to save their brother. The carved figure shows a grieving sister holding a grouse to her; its body, tail and wings create a design on her skirt.

95 LOCATION: *Kispiox*
CARVER: *Walter Harris*
CULTURAL STYLE: *Gitksan*

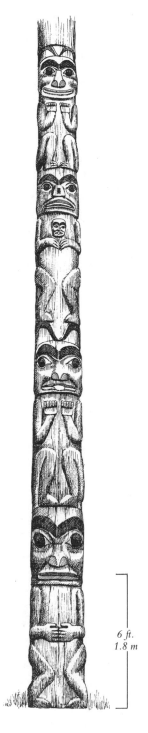

The original of this pole was carved sometime in the first decade of the twentieth century. Tradition required that the carving of a pole be done by a person of another clan. Because the carver of this pole was within the same clan, a man of a different clan was appointed in charge of the work as the nominal carver, to "stand over" the work.

Chief Walter Harris, an experienced and skilled carver of Kispiox, repeated history when he precisely replicated the old pole. He appointed his uncle Jeffrey Harris, who was from a different clan, to "stand over" the work, or "to take credit for carving the pole," as he put it.

The top figure, an ancient crest called Leading In, is a being with a humanlike face and a very large mouth. Beneath is another crest figure called Glass Nose (also Ice Nose or Sharp Nose), whose long, carved nose has now fallen away; notice the slot in the pole into which it once fit. The small head on the crest may represent Grizzly Bear Woman. Leading In is represented twice more on the lower half of the pole.

This cedar document was raised in 1972, a major event that brought high-ranking chiefs and guests from far and wide to witness and celebrate with traditional ceremonies and feasting.

6 ft.
1.8 m

167

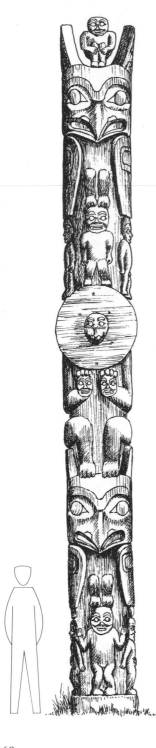

Erected in 1845 as a memorial to a chief named Gitludahl, the White Owl pole was at one time among the oldest in Kispiox. Some forty years later, a pole named Grizzly Bear of the Sun was raised for another chief of the same name. Both poles are now gone.

The pole that stands today in Kispiox was carved in 1976 and combines the crests from both these old poles.

At the top is White Owl, with a small figure carved in each ear, another standing on its forehead and a row of three humans below. Beneath is Grizzly Bear of the Sun. The origin of this crest goes back to when Kispiox was first established. While at a fish camp at Salmon Creek, a young girl, secluded in a small hut as part of her puberty rites, saw a bear coming down the creek with a "sun collar" around its neck. Her parents killed the animal and gave her the emblem to use as a crest for her offspring.

Below Grizzly Bear of the Sun is a repeat of White Owl, then three human figures, two of which have headgear representing tendrils of the Fern crest. Notice that the pole was carved (as was the original) on an inverted log, so that the wide base of the tree is uppermost.

97 LOCATION: *Kispiox*
CARVER: *Solomon Johnson*
CULTURAL STYLE: *Gitksan*

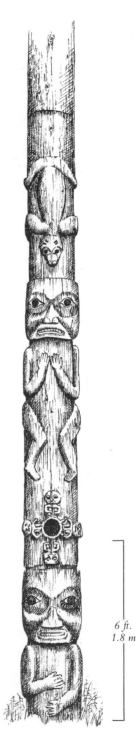

This very old pole, thought to have been erected in the 1860s, is part of the family history of Alice Wilson, who lives in Kispiox.

It was originally topped by a horizontal wolf, a family emblem known as Raiding Wolf, and of which the owner had a mask. Beneath the uncarved section, Raiding Wolf is depicted again, head down, but with its ears and tail (which were separate attachments) now fallen off; notice the slots into which the ears were affixed.

The next figure is a crest named Running Backwards, as is the bottom figure. The haunches and legs of the base figure are turned backwards (as can be seen in an early photo of the pole), but over time they have become buried—possibly as a result of restoring the leaning pole to an upright position in the 1920s.

Between these two figures is depicted a family crest named Hole Through, a miniature representation of a ceremonial house entrance. The regular door of a house sometimes had above it a ceremonial entrance in the form of a circular doorway, with several small humanlike beings carved around it, their feet facing the rim. Whenever a feast was given, the regular door was blocked, and ladders inside and out gave access to the house through the circular doorway.

Although badly weathered, the small, detailed figures on the pole are a fine example of the woodcarver's skill.

6 ft.
1.8 m

169

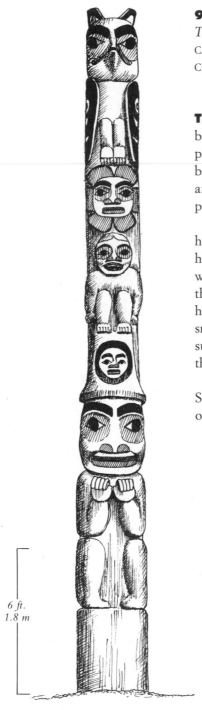

98 LOCATION: *Ketchikan, Alaska—*
Tongass Historical Society Museum
CARVER: *Dempsey Bob*
CULTURAL STYLE: *Tlingit*

The story of Raven stealing the sun and bringing daylight to the world is often depicted by that bird carrying a disc in his beak. Here, all the characters in the story are brought together to create an entire pole.

At the top of the pole is the culture hero, Raven, with a six-rayed sun beneath him. Below is the chief's daughter, who wears a labret to signify her high rank; at the base is the chief himself, wearing a tall hat to indicate his wealth and rank. The small face of the baby, encircled in black to suggest his ravenness, has been carved into the chief's hat.

This pole, named Raven Stealing the Sun, was raised on 21 May 1983, and honours the Tongass Tlingit people.

6 ft.
1.8 m

170

99 LOCATION: *Ketchikan, Alaska—Totem Heritage Centre*
CARVER: *Nathan Jackson*
CULTURAL STYLE: *Tlingit*

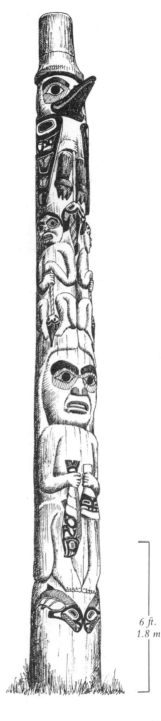

6 ft.
1.8 m

The Fog Woman pole, as it is called, was carved in 1981 and illustrates the ancient story of how the first salmon came to the rivers.

Raven and his two slaves, out fishing, caught only bullheads. They were paddling home because of fog when Fog Woman suddenly appeared in Raven's canoe—and he took her for his wife. Daily, Fog Woman dipped her hands into fresh water in a basket she had made; and daily, a large salmon appeared. Soon the drying racks and storehouse were filled with dried and smoked salmon, and Raven boasted of his success in providing so much food. This angered his wife, and the two quarrelled fiercely. Raven hit Fog Woman with a dried salmon; she ran down the beach and into the sea, and as he reached out to grab her, she turned into fog. All the salmon then left the racks and followed her, leaving Raven holding an inedible bullhead.

The pole shows Raven and his two slaves, all with bullheads on their lines. Below, Fog Woman holds a salmon in one hand and a representation of a copper (a symbol of wealth) in the other. At her feet are the first salmon she brought forth from her basket of fresh water.

Now Fog Woman's daughter, Creek Woman, lives at the head of every salmon stream and brings the salmon back up the rivers each year.

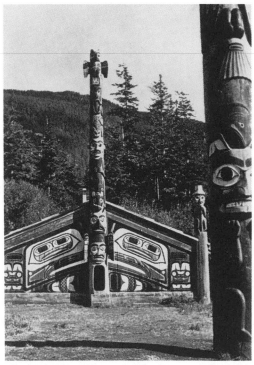

Totem poles and a traditional Tlingit house at Totem Bight State Park, north of Ketchikan, Alaska.

HILARY STEWART

Totem Bight State Park, 16 km (10 miles) north of Ketchikan, brings together a large collection of totem poles and a traditional plank house.

In the 1930s the United States Forest Service began a program to recreate a Tlingit village. The site chosen was Mud Bight in Tongass National Forest, which had once been a Tlingit campsite for many generations. Much of the work was done by the Civilian Conservation Corps, an organization set up by the U.S. government to provide employment during the 1930s Depression.

The ambitious project called for dwellings, smoke houses and gravehouses, together with totem and mortuary poles from the various Tlingit groups, as well as from the Haida. The poles would be replicas of old poles from deserted villages and new ones carved especially for the site.

Work began in 1938, with head carver Charles Brown supervising workers in the construction of a plank house with a portal pole, carved corner posts, a memorial pole in front and another out on the point.

Unfortunately, the entry of the United States into the Second World War prevented completion of the project. However, additional carved poles representative of the Tlingit and Haida have been added over the years, and the uninviting name of Mud Bight was changed to Totem Bight.

100 LOCATION: *Ketchikan, Alaska—*
Totem Bight State Park
CARVER: *John Wallace*
CULTURAL STYLE: *Haida*

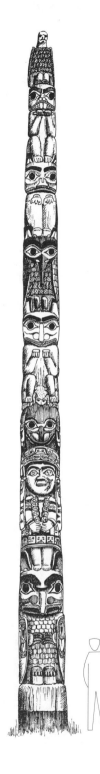

The Master Carpenter pole created in 1947 by Haida carver John Wallace of Hydaburg, Alaska, is one of the few remaining poles originally made for Totem Bight State Park.

The pole depicts several crests belonging to the Eagle and Raven clans of the Haida people. Beneath Eagle, who tops the pole, is Beaver holding his chewing stick, followed by Bullhead. Next is Raven, then Bear—notice the two very small coppers under his feet and Frog between. Next is Blackfish (or Killer Whale), represented by its head and pectoral fins only, followed by Master Carpenter, with Owl at the base.

Legend tells that Master Carver taught the Haida to carve. He appeared to them lavishly adorned and surrounded by light. During the night he carved and painted poles, house posts and the front of the house, and he also painted wondrous human and animal figures all over the partitions inside the house. He then came daily, instructing men in the skills of design, carving and painting, and in the spiritual training for successful work.

Master Carpenter is shown with richly ornamented garments, a tattooed face and carved fingernails (each with a different expression), which are depicted here as a necklace. Down each side is a fish club ornamented with Shark (or Dogfish) and Bear.

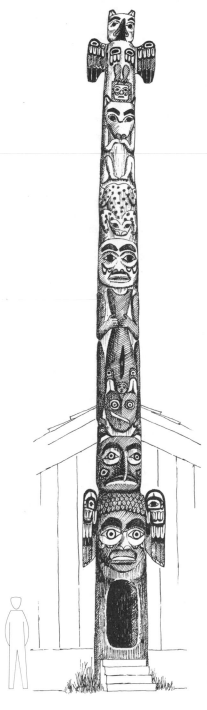

101 LOCATION: *Ketchikan, Alaska—Totem Bight State Park*
CARVER: *Charles Brown*
CULTURAL STYLE: *Tlingit*

Outside the park's large plank house is a portal pole called Wandering Raven, which illustrates several stories. Raven, the legendary light-bringer, is at the top of the pole, his feet on the box containing the sun. Beneath is Mink, a powerful spirit helper of a well-known shaman who could foresee events. Next is Frog, recalling a lengthy story of a young woman who met and married a man who, though he appeared human, was really Frog.

Below Frog is a man named Natsihlane, holding Whale. A long and involved story concludes with Natsihlane building a chain of four pools on the beach, the last leading into the sea. In the first pool he put a wooden whale he carved, which made a leap and sank. Carvings of whales in other woods failed to come fully alive until he made one of yellow cedar. When it swam through all four pools to the sea, Natsihlane told it to find and destroy the canoe of his brothers-in-law. This done, Whale was instructed to never again harm humans. And it never does.

Beneath Whale is Raven at the Head of the Nass, the chief who owned the sun, identified by his curved beak, feathered breast and wings; below him is his wife, who wears a large labret.

POLES IN KIKS'ADI
TOTEM PARK
WRANGELL, ALASKA

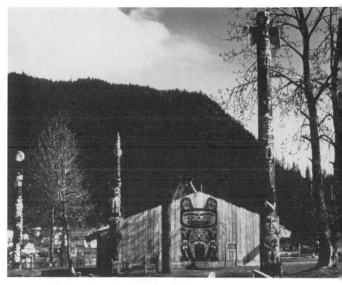

The growth of facilities for Wrangell's harbour eventually displaced many of the old totem poles along its shore. The toppling of one particularly fine pole by a windstorm in 1978 triggered a major restoration project.

In 1984, the Wrangell Cultural Heritage Committee, a native group, commissioned the replication of four early poles. The Sealaska Corporation purchased a waterfront site on Front Street, where one old pole still stood, and it became Kiks'adi Totem Park, dedicated with ceremony on 2 July 1987.

A view of Kiks'adi Totem Park in Wrangell, Alaska. ALASKA DIVISION OF TOURISM

The two carvers who undertook the task of replicating the decayed poles were Steve Brown, an experienced non-native carver from Seattle, Washington, with many years of Northwest Coast native studies behind him, and Wayne Price, a talented young Tlingit carver from Haines, Alaska. To ensure precision, they studied early photographs and worked with each original pole lying close to the new log, taking measurements and making templates.

Steve Brown said, "Wayne and I had such admiration and respect for those old works that we tried very hard and took great pains to make them as true as we possibly could. We tried to leave 'ourselves' out of the variables." The results carry the visitor back a hundred years or more.

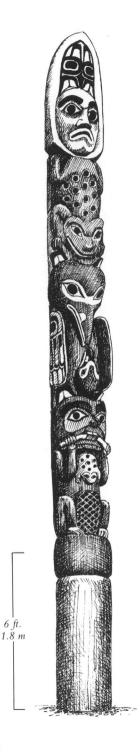

6 ft.
1.8 m

102 LOCATION: *Wrangell, Alaska—Kiks'adi Totem Park*
CARVER: *Steve Brown and Wayne Price*
CULTURAL STYLE: *Tlingit*

The original of this pole, carved about 1890 by William Ukas, was raised to honour a Kiks'adi chief named Kohlteen.

Carver Steve Brown said, "When it came time to carve the pole, some of the grandchildren of the original carver requested that we do the carving using only hand tools. William Ukas's son, Thomas, did not think chainsaws and other power tools appropriate to totem pole art. We were inclined to agree."

The two carvers worked through the winter of 1985–86, using only hand tools, and completed the work in five months.

Holding to tradition, the Kiks'adi pole was raised by hand at the dedication of the park on 2 June 1987.

The pole is topped by a personified mountain, Person of the Glacier, to which the Kiks'adi people retreated during the great flood. Below is Frog, a main crest, followed by Elder Raven "teaching" Younger Raven. At the base is Killisnoo, the Beaver, with a small frog.

The complex story of Killisnoo, who was a chief's pet, includes his transforming into a giant Beaver, tunnelling under the villagers' houses, making a spear and killing the chief, then finally slapping his tail so hard that the earth shook and all the houses collapsed into his underground excavations.

103 LOCATION: *Wrangell, Alaska—Kiks'adi Totem Park*
CARVER: *Steve Brown and Wayne Price*
CULTURAL STYLE: *Tlingit*

This is a replica of one of two poles of similar design. One of the poles was raised by Chief Shakes VII in memory of Kaukish, his sixty-eight-year-old nephew who died in 1897, leaving Shakes all his property. The other, on which the replica pole is based, is from Old Wrangell village, for which the carvers used a photograph taken in 1910.

The story behind the Old Wrangell pole is complex and includes an episode about a one-legged fisherman who looked like Eagle and who wore a coat on which were the heads of two Grizzly Bears. With his magical spear, he caught many fish, then paddled upriver to a Grizzly Bear cave. There, one of the Bear heads on his coat pulled off salmon from his string of fish and fed them to the Grizzly Bears. A man named Kayak coveted the supernatural spear. Wearing the skin of a monster, he killed the owner to acquire it, and he, too, caught a string of salmon. Kayak also went to the cave to feed the Grizzly Bears, but they realized he was an imposter. A fight ensued, and he killed the Bear family.

The replica pole shows the fisherman in Eagle form. The head below is unidentified, but may represent Kayak in the skin of the monster—note the small faces in its eyes, as well as the strings of salmon down the rest of the pole.

This pole is known as the Kayak pole or the One-Legged Fisherman pole.

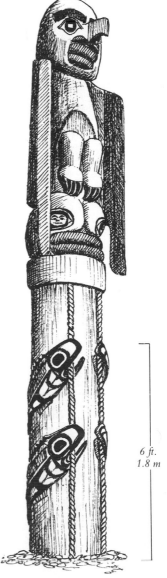

6 ft.
1.8 m

177

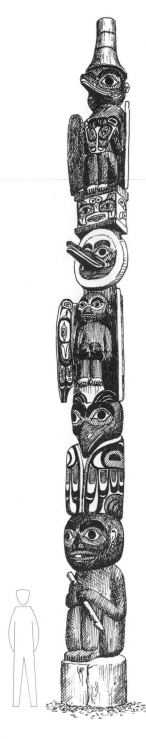

104 LOCATION: *Wrangell, Alaska—Kiks'adi Totem Park*
CARVER: *Steve Brown and Wayne Price*
CULTURAL STYLE: *Tlingit*

The original of this memorial pole was carved by William Ukas and raised in 1896. Dr. Thwing, a missionary in Wrangell at the time, wrote in the local newspaper, the *Alaskan*: "This winter there has been a very special feeling of suspense and expectancy in view of the great feast and intertribal dance for which Chief Shakes has been preparing for a year or two. To dignify a living son, and commemorate one dead, there has been a new totem pole carved." It stood for eighty-two years until a windstorm sent the rotted monument crashing.

The replica pole illustrated here depicts the much-told story of Raven bringing daylight to the world. At the top is Raven at the Head of the Nass, the original keeper of the sun, shown in both Raven and human form, sitting on the box that contains the sun. Below is another Raven with a sun halo around his head, and on his chest a female wearing a labret—perhaps the daughter of the chief who owned the sun. The third Raven, in another interpretation, is also described as the daughter to whom Raven was born.

The figure at the base, wearing a large labret, has also been given various identities: Tribal Astronomer who led the people during clan migrations, or Woman Who Holds Up the Earth (Raven's mother in an earlier reincarnation).

This cedar monument is called the Raven pole.

105 LOCATION: *Wrangell, Alaska—Shakes Island*
CARVER: *Civilian Conservation Corps/Steve Brown with Wayne Price, Will Burkhart*
CULTURAL STYLE: *Tlingit*

Two mortuary poles stand in front of a 1939 replica of Chief Shakes's traditional plank house, built by the Civilian Conservation Corps (CCC).

The original of the left-hand pole is called the Double Killer Whale Crest Hat pole. An elaborately carved ceremonial crest hat was the most prestigious object of a Tlingit clan. The hat crest on the top of this pole is comprised of two Killer Whale heads and dorsal fins, back to back, with three skils in the centre. The identity of the figure is unknown.

The original pole appears in an 1868 photo, but there is no crouched figure beneath the man wearing the crest hat. A photo from the 1880s shows the replicated pole with that figure. The identity of the small crouched figure has been lost.

Some sixty years later, the replica pole had decayed and was accurately copied by the CCC. The hat on the pole was in a poor state of preservation by 1984, and was replicated again, with the carvers working from photos of the previous poles. The rest of the pole was well preserved, having been protected from the rain by the hat.

This type of mortuary pole held the ashes of the deceased in a rectangular niche at the back, covered by a panel. The replica has two niches, but the ashes of Chief Shakes VI's parents were, of course, only in the original.

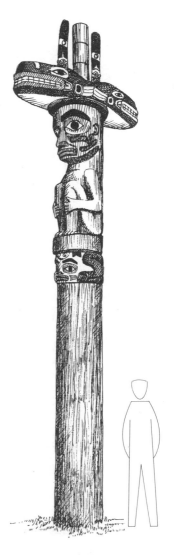

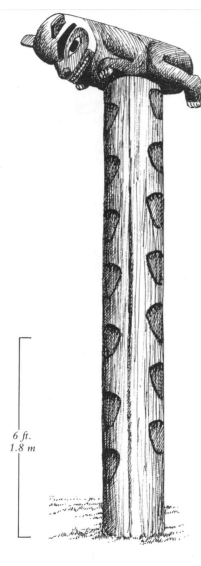

6 ft.
1.8 m

LOCATION: *Wrangell, Alaska—Shakes Island*
CARVER: *Civilian Conservation Corps/Steve Brown with Wayne Price, Will Burkhart*
CULTURAL STYLE: *Tlingit*

The second of the two mortuary poles in front of Chief Shakes's house is known as Bear Up the Mountain pole. The original appeared to be quite new when it was photographed in 1868, but it was sufficiently rotted by the late 1930s to warrant being recarved by the Civilian Conservation Corps. It, too, decayed over the years, and part of it, the Bear figure, was again replicated in 1984 by Brown, Price and Burkhart from the 1868 photo.

The crest originated a long time ago when there was a great flood in the land. As the people of the Nanya·ayi clan were climbing a mountain to escape the rising waters, Grizzly Bear and Mountain Goat went along with them.

Ultimately, the Nanya·ayi killed Grizzly Bear, took it for a crest, and preserved its hide intact. The hide became a valuable and renowned heirloom, which was displayed at potlatches and other important occasions, with gifts given away each time it was shown. Whenever the hide disintegrated with age, it was replaced.

The mortuary pole, which originally held the ashes of Chief Shakes's brother, depicts the great Grizzly Bear, with its footprints going up the mountain.

There are six other poles on the island, four copies and two originals, all made during the CCC project of 1938–1940.

107 LOCATION: *Juneau, Alaska—Centennial Hall, Egan Dr.*
CARVER: *Nathan Jackson with Steve Brown*
CULTURAL STYLE: *Tlingit*

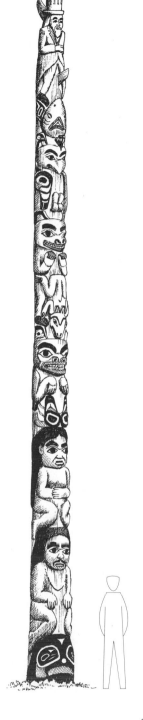

Two poles were carved to celebrate Juneau's centennial in 1980, and both stand outside Centennial Hall. This one is called the Wooshkeetaan pole, and it represents the history of the Wooshkeetaan people. George Jim, a respected clan leader from the small but traditional village of Angoon, near Juneau, determined which crests should be on the pole and gave an account of his people's history. The following is a much abbreviated version.

Long ago, a group of Tlingit people migrated along the Taku River, eventually arriving at its mouth. From there, they scattered throughout the southeast of what is now Alaska, with some going to the Wrangell area, some to Klawak and others to Glacier Bay. Eventually the village at Glacier Bay was destroyed by the advancing glacier, and the people from there moved again. Their descendants, the Wooshkeetaan, finally established villages in the Juneau area.

But the late nineteenth century brought other disruptions. With the discovery of gold in Juneau in the 1880s, many native people from surrounding areas were drawn to Juneau and Douglas (across the channel). In 1882 the U.S. Navy, through an unfortunate set of circumstances, bombarded the village of Angoon, looted the partially destroyed village and smashed canoes. Events such as these, which caused major

changes in the life of the people, eventually led to the abandonment of the old villages.

This totem pole carries crests and legends of the Wooshkeetaan people of the Eagle clan. Uncle Sam stands at the top, as a reminder that no apology or compensation has ever been made to the people of Angoon for the navy's actions. Uncle Sam straddles Shark (or Dogfish), whose dorsal fin is between his knees. Shark's head, flanked by his pectoral fins, has a high dome and gill slits. Just beneath Shark's head is Murrelet, a small diving seabird.

Below is Eagle, followed by Bear. On Bear's stomach is a crouching Wolf, head down, representing the legend of how Wolf claimed the Wooshkeetaan as part of his family. Beneath Wolf is Sea Bear—notice the small fins on his elbows and the upturned tail flukes instead of legs.

The next figure is Good Luck Woman who, because she was giving birth in a separate hut behind the village, escaped being killed during a massacre of all the villagers, and who was the source of the regeneration of the clan. She is depicted carrying her infant on her back, behind her left shoulder.

Below is Spirit Man, who represents the five powerful Spirit Men of the Wooshkeetaan village in Berner's Bay. The indistinct Halibut on his chest symbolizes his strength. At the base is Berner's Bay Mountain, the ancestral home of all the Wooshkeetaan.

108 LOCATION: *Juneau, Alaska—Centennial Hall, Egan Dr.*
CARVER: *Nathan Jackson with Steve Brown*
CULTURAL STYLE: *Tlingit*

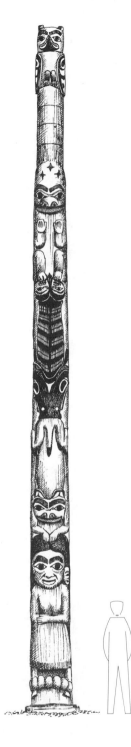

The other pole commissioned for Juneau's centennial is named the Auk Tribe pole. Like the Wooshkeetaan pole, it speaks of the history of its people, in this case the Raven clan of Dipper House. Bessie Vesaya, an elder of the Auk people, advised on what crest figures should be on the pole.

The pole is topped by Raven, who perches on four skils. Below is Monster Frog, crowned by seven stars that represent the celestial dipper for which the house is named. The human hands on Monster Frog represent his supernaturalness.

Below are two Auk crests. One is Dog Salmon, head downward, with dash lines representing the spawning colours of its skin. The other crest is Summer Weasel, identified by its black-tipped tail.

At the base stands Good Luck Woman with her child on her back. When she left the massacred village with her baby, the woman walked along the beach, eating seven mussels at a time and discarding the shells. It is said that finding seven mussel shells nested together brings good luck. At the bottom of the pole are carved the seven shells.

Working outdoors, the carvers laboured in a race against the oncoming winter. "We were spurred on," Steve Brown said, "by the sight of the snowline descending ever lower down the steep slopes of Mount Juneau." They made it in time.

183

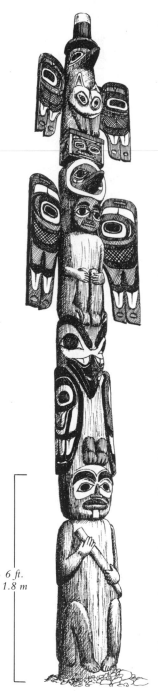

6 ft.
1.8 m

109 LOCATION: *Juneau Alaska—
Auk Tribe Building, Village St. and
Willoughby Ave.*
CARVER: *Edward Kunz, William Smith,
Tom Jimmy, Edward Kunz Jr.*
CULTURAL STYLE: *Tlingit*

Two poles stand in front of a panel painted
with Tlingit motifs on the Auk Tribe Build-
ing. Both poles were carved in 1972 to hon-
our the Raven and Eagle clans of nearby
Auk. This pole, depicting Raven's cosmic
creations and his supernatural powers, is
based on the original from Wrangell by
William Ukas.

At the top is Raven, standing on the
bent-wood box from which he released the
sun to give light to the world.

A major characteristic of Raven is his su-
pernatural ability to transform himself into
anything at all—quite often a human. The
next portrayal of Raven shows his duality in
being both bird and human at the same
time. The carving has the heads of both,
and wings as well as arms, while the clawed
bird legs share space with human legs and
feet.

Below is Raven again, complete in bird
form, having also put the moon and stars
into the sky.

The figure at the base wears a labret and
is an all-knowing old woman who can fore-
tell the future. In a Tlingit version of the
story of Raven stealing the sun, carver Ed-
ward Kunz recounted that it was she who
warned the chief who owned the boxes
containing the sun, moon and stars that
Raven was up to no good.

110 LOCATION: *Juneau, Alaska—Auk Tribe Building, Village St. and Willoughby Ave.*
CARVER: *Edward Kunz, William Smith, Tom Jimmy, Edward Kunz Jr.*
CULTURAL STYLE: *Tlingit*

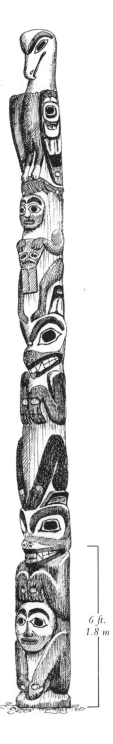

6 ft.
1.8 m

The second of two poles in front of the Auk Tribe Building was carved to honour the Eagle clan and displays their crests. Edward Kunz provided the identities and details of each crest. It took the carvers six weeks, working eight hours a day, to complete the pole.

Looking down from the top is proud Eagle, holding a coho salmon in its claws. This represents a man of the Eagle clan, holding to him his wife of the Coho people of the Raven clan.

Beneath Eagle is a slave holding a copper worth ten slaves, and below him is Wolf, sitting upright. At the base is Bear, also sitting up, paws to its chin. The carved face on its stomach, Edward Kunz said, is a way of showing Bear's feelings. Kunz also painted the design on the wall between the two poles.

Juneau has some eighteen totem poles, indoors and out. They are mainly replicas or fairly recent carvings, but one of the oldest and finest is from the late nineteenth century. Originally situated in the Haida village of Sukkwan, across the channel from Hydaburg, Alaska, it now stands indoors in the main lobby of the State Office Building.

LIST OF POLES BY LOCATION

Alert Bay, British Columbia
Poles 71 to 74

Bear Cove Ferry Terminal,
British Columbia
Pole 75

Campbell River, British Columbia
Poles 60 to 68

Cape Mudge, British Columbia
Poles 69 and 70

Comox Reserve, British Columbia
Poles 58 and 59

Courtenay, British Columbia
Poles 56 and 57

Departure Bay, Nanaimo Ferry Terminal,
British Columbia
Pole 54

Douglas border crossing, British Columbia
Pole 1

Duncan, British Columbia
Poles 48 to 52

Hazelton, British Columbia
Pole 91

Horseshoe Bay Ferry Terminal,
British Columbia
Pole 33

Juneau, Alaska
Poles 107 to 110

Ketchikan, Alaska
Poles 98 to 101

Kispiox, British Columbia
Poles 92 to 97

Kitsumkalum, British Columbia
Poles 85 and 86

'Ksan, British Columbia
Poles 88, 89 and 90

Nanaimo, British Columbia
Poles 53 and 54

Ninstints, British Columbia
Poles 76, 77 and 78

Old Massett, British Columbia
Poles 80 and 81

Port Hardy, British Columbia
Pole 75

Prince Rupert, British Columbia
Poles 82, 83 and 84

Qualicum Beach, British Columbia
Pole 55

Sechelt, British Columbia
Pole 34

Sidney, British Columbia
Pole 36

Skidegate, British Columbia
Pole 79

Swartz Bay Ferry Terminal, British Columbia
Pole 35

Terrace, British Columbia
Pole 87

Vancouver, British Columbia
Poles 2 to 33

Victoria, British Columbia
Poles 37 to 47

West Vancouver, British Columbia
Pole 33

Wrangell, Alaska
Poles 102 to 106

Bancroft-Hunt, Norman, and Werner Forman. *People of the Totem.* Toronto: Doubleday; New York: G. P. Putnam's Sons, 1979.

Barbeau, Marius. *Totem Poles.* 2 vols. Anthropological Series no. 30, Bulletin 119. Ottawa: National Museum of Canada, 1964.

Boas, Franz. *Kwakiutl Ethnography.* Ed. Helen Codere. Chicago: University of Chicago Press, 1966.

B.C. Indian Arts Society. *Mungo Martin, Man of Two Cultures.* Sidney, B.C.: Gray's Publishing, 1982.

Clutesi, George. *Potlatch.* Sidney, B.C.: Gray's Publishing, 1969.

Cole, Douglas. *Captured Heritage: The Scramble for Northwest Coast Artifacts.* Vancouver/Toronto: Douglas & McIntyre; Seattle: University of Washington Press, 1985.

Duff, Wilson, ed. *Histories, Territories and Laws of the Kitwancool.* Anthropology in B.C. Memoir no. 4. Victoria: British Columbia Provincial Museum, 1959.

Foster, Scott. *Totem Talk: A Guide to Juneau Totem Poles.* Juneau: Gastineau Channel Centennial Association, 1985.

Garfield, Viola E., and Linn A. Forrest. *The Wolf and the Raven: Totem Poles of Southeastern Alaska.* Seattle: University of Washington Press, 1961.

Halpin, Marjorie M. *Totem Poles: An Illustrated Guide.* Museum Note no. 3. Vancouver: University of British Columbia Press in association with University of British Columbia Museum of Anthropology, 1981.

Hasset, Dawn, and F. W. M. Drew. *Totem Poles of Prince Rupert.* Prince Rupert, B.C.: Museum of Northern British Columbia, 1982.

Hawthorn, Audrey. *Kwakiutl Art.* Vancouver/Toronto: Douglas & McIntyre; Seattle: University of Washington Press, 1967.

Holm, Bill. *Smoky Top: The Art and Times of Willie Seaweed.* Seattle: University of Washington Press; Vancouver/Toronto: Douglas & McIntyre, 1983.

Jonaitis, Aldona. *From the Land of the Totem Poles: The Northwest Coast Indian Art Collection at the American Museum of Natural History.* New York: American Museum of Natural History; Seattle: University of Washington Press; Vancouver/Toronto: Douglas & McIntyre, 1988.

Keithahn, Edward L. *Monuments in Cedar—The Authentic Story of the Totem Poles.* Seattle: Superior Publishing, 1963.

MacDonald, George F. *Haida Monumental Art: Villages of the Queen Charlotte Islands.* Vancouver: University of British Columbia Press, 1983.

McDonald, James. "Su'sit'aatk: The Raising of Two Crest Poles." *Rotunda.* Vol. 21, no. 2 (Fall 1988).

Malin, Edward. *Totem Poles of the Pacific Northwest Coast.* Portland, Oregon:
 Timber Press, 1986.

Miller, Polly, and Leon Gordon Miller. *The Last Heritage of Alaska: The Adventures
 and Art of the Alaskan Coastal Indians.* New York: Bonanza Books, 1967.

Nuytten, Phil. *The Totem Carvers: Charlie James, Ellen Neel and Mungo Martin.*
 Vancouver: Panorama Publications, 1982.

Reid, Bill. *Out of the Silence.* Amon Carter Museum of Western Art, 1971.

Reid, Bill, and Robert Bringhurst. *The Raven Steals the Light.* Vancouver/Toronto:
 Douglas & McIntyre; Seattle: University of Washington Press, 1984.

Steltzer, Ulli. *A Haida Potlatch.* Vancouver/Toronto: Douglas & McIntyre, 1984.

Stewart, Hilary. *Cedar: Tree of Life to the Northwest Coast Indians.* Vancouver/
 Toronto: Douglas & McIntyre; Seattle: University of Washington Press,
 1984.

Stewart, Hilary. *Looking at Indian Art of the Northwest Coast* Vancouver/Toronto:
 Douglas & McIntyre; Seattle: University of Washington Press, 1979.

INDEX